# THE ART & SCIENCE OF
# DRAWING

*Learn to Observe, Analyze, and Draw Any Subject*

BRENT EVISTON

The Art and Science of Drawing
*Learn to Observe, Analyze, and Draw Any Subject*

Brent Eviston

Editor: Kelly Reed
Project manager: Lisa Brazieal
Marketing coordinator: Mercedes Murray
Copyeditor: Joan Dixon
Interior design: Aren Straiger
Composition: Danielle Foster
Cover design: Aren Straiger
Cover Images: Brent Eviston

ISBN: 978-1-68198-775-0
1st Edition (1st printing, August 2021)
© 2021 Brent Eviston
All photographs © Brent Eviston

Rocky Nook Inc.
1010 B Street, Suite 350
San Rafael, CA 94901
USA

www.rockynook.com

Distributed in the UK and Europe by Publishers Group UK
Distributed in the U.S. and all other territories by Ingram Publisher Services

Library of Congress Control Number: 2021935017

This book is printed on acid-free paper.
Printed in Korea

*This book is dedicated to my son Eames who was born during the writing of this book. May you find lessons here that reach far beyond drawing.*

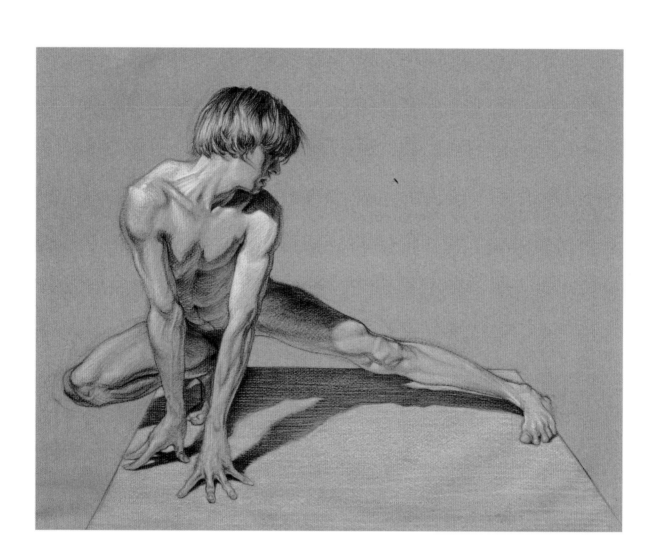

# TABLE OF CONTENTS

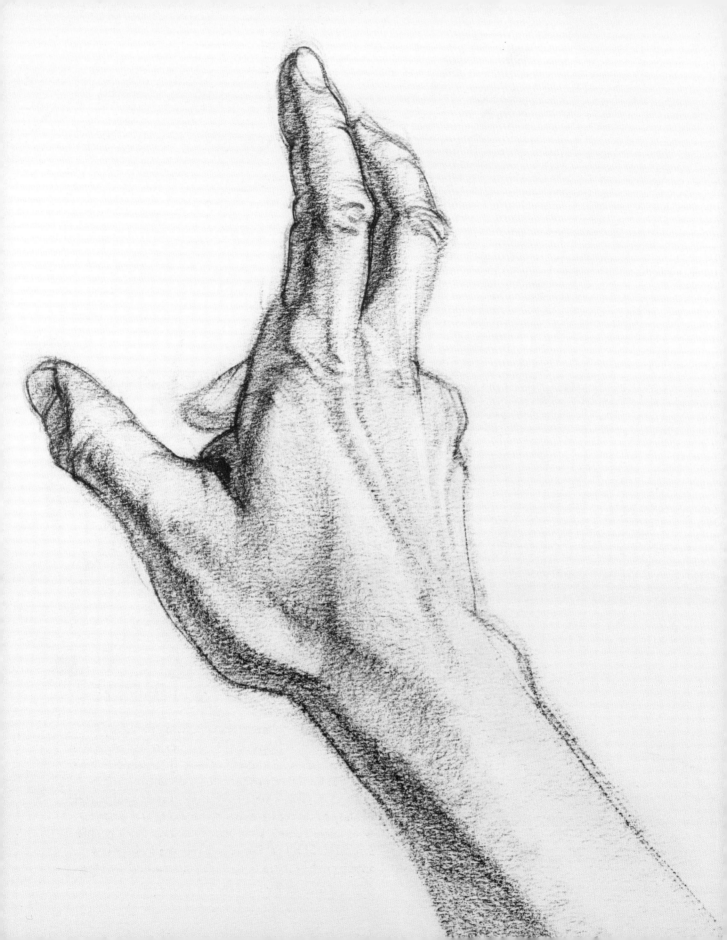

# ORIENTATION AND MATERIALS

## Drawing Is Not a Talent

As of the writing of this book, I have taught drawing for nearly 25 years. I have worked with thousands of students in face-to-face classes and tens of thousands of students online. These students have ranged from ages 5 to 87. It is true that some individuals learn to draw more quickly than others, but I have never encountered anyone with a natural ability to draw who hasn't had training and practice. If natural drawing talent existed, I am one of the most likely people to have encountered it. I haven't. But even if one day I discover a student who appears to have been born with preternatural drawing

abilities, this does not change the fact that drawing can be learned by nearly anyone willing to study and practice. The existence of some talented individuals would not change the fact that, just like writing and arithmetic, drawing is a teachable and learnable skill.

This book will teach you the fundamentals of good drawing. It begins with the most basic skills like how to hold the pencil and how to draw basic shapes before moving on to more complex subjects like three-dimensional drawing, contour drawing, measuring, and shading. By working through this book, you will learn the skills and processes necessary for good drawing.

There are many reasons people learn to draw. Some desire to be creative professionals while others simply want to experience the joy of artistic expression. Regardless of your creative ambitions, your path begins with drawing. Drawing is at the foundation of nearly every field of the visual arts including illustration, painting, graphic design, architecture, fashion design, product design, set design, character design, sculpture, and more.

Whether your goal is to paint landscapes, design video game characters, create costumes for films, illustrate children's books, design buildings, or illustrate graphic novels, you need to learn to draw. It is true that much of drawing is now done digitally, but that has not changed the fundamental principles behind good drawing. Whether you draw using charcoal on paper or a stylus and digital tablet, the fundamentals of good drawing remain the same.

This book is designed for the absolute beginner as well as more experienced artists looking to improve their skills and master the fundamentals. The fundamentals you will learn in this book will serve as a foundation upon which you can build new skills to suit your creative ambitions, whatever they may be.

Drawing is not a talent. It is a skill anyone can learn. Every day I work with people who *learn* to draw. These are ordinary people without special skills or advantages. With good instruction and dedicated practice, you can, and will, learn to draw.

# How to Use This Book

In the decade before I wrote this book, I set out to find the most effective and efficient methods of teaching drawing. In my face-to-face classes I tested numerous types of drawing instruction, from centuries-old classical techniques to contemporary practices. Based on my experiences I designed my own approaches to teaching. You are reading the results of this process. This book provides the most accessible, streamlined, and effective methods I have found for learning to draw. It is a mixture of tried-and-true techniques along with contemporary methods of my own design.

This is a project-based book. Each chapter contains a series of lessons and each lesson ends with a project. I recommend completing no more than one lesson and project per day. You need time to process the information you've learned and to develop the muscle memory necessary for these skills to become second nature. After completing your project for the day, if you want to keep drawing, I recommend repeating the project rather than moving on to a new lesson. The lessons in this book focus on fundamentals. You cannot practice fundamentals too much.

You are welcome to adapt this book to fit your schedule. If you can complete only one or two lessons per week, you will still learn to draw. The goal is to continue to move forward at whatever pace makes sense for your life.

This book is designed for students to go through the lessons in order. The skills in each chapter build upon the skills in the previous chapters. Many students will be tempted to skip to the skills they most desire to learn, like shading or figure drawing. But you can't learn to shade if you don't know how to properly draw basic volumes and you can't draw volumes if you don't know how to properly draw basic shapes. By the time you reach figure drawing you're expected to have developed a competence and comfort with all the skills you learned from previous chapters. Once you have completed the lessons and projects in this book in order, then you can go back and focus on the skills you want to develop further.

Even if you have some drawing experience, I still recommend going through the book in order. It is very common for students who have been drawing for years to have gaps in their knowledge and skill set. If parts of this book cover things you already know, take them as an opportunity to strengthen your fundamental skills. Revisiting fundamentals is critical even for advanced drawers. I've been drawing seriously for nearly 30 years and I still practice basic skills more than any other aspect of the drawing process.

Finally, practice is essential. It will be tempting to skip projects that seem simple or easy, but your growth depends on you practicing more, not less. In this book, I will give you the minimum amount of practice for each project. If you want to improve faster, increase your amount of practice. If you practice for 30 minutes a week, you will see modest improvement over time. If you practice three hours a day, your skills will improve much faster. Increasing the amount you practice for each individual project is a much better way to improve your skills rather than completing multiple lessons per day.

This book will guide you through the entire drawing process. It begins with the most basic skills, like how to hold a pencil and how to draw basic shapes. These basic skills provide a foundation for tools and techniques like volumetric drawing and shading. Once you've learned the fundamentals, you'll be introduced to figure drawing, one of the most sought-after drawing skills.

My hope is that you now know you *can* learn to draw and that you have a powerful resource to guide you. Now let's take a look at the drawing process and challenge some of the most common misconceptions about drawing.

# Drawing Demystified:
# An Overview of the Drawing Process

One of the most common misconceptions about drawing is that good artists get their drawings right the first time. People imagine that inspiration strikes, and the artist effortlessly draws line after beautiful line until an image magically emerges on the page. This is far from reality, but this misconception keeps many people from trying to draw at all.

I've been drawing seriously for nearly 30 years and I still make countless mistakes in every drawing I create. I am far from alone. Visit the studio of any drawing group and you can easily tell the amateurs from the pros. The amateurs will immediately draw dark lines with ill-founded confidence. The pros will hold back and carefully craft their drawings using very light lines. A dark line is a commitment, but a light line can be moved, altered, or erased with ease.

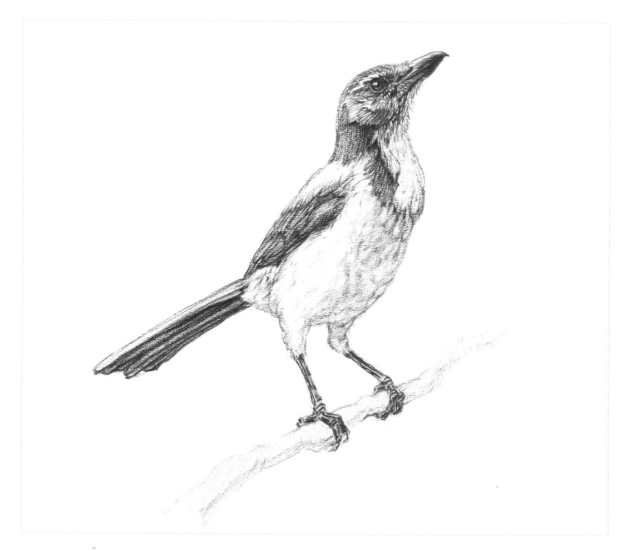

Experienced artists patiently draw and redraw their subject using light lines until they have captured its basic forms and proportions. This light drawing provides the foundation upon which they will build the rest of the drawing. Once the basic forms of their subject are properly and lightly drawn, they begin drawing dark lines, which are intended to be seen by viewer. By the time the drawing is completed the light foundational lines are hardly visible.

Look closely around the edges of this drawing. Surrounding this Scrub Jay you will find many light lines and marks. These light lines are my early and inaccurate attempts at capturing the form. For example, look at the end of the bird's tail and you can find multiple attempts at its length.

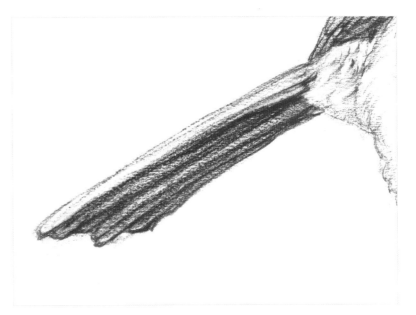

Look at the legs and feet and you will see numerous attempts at their shapes and placements.

These light lines are easy to miss but the more you investigate, the more you will find. Each of these light lines denote an early attempt that was inaccurate and required adjustment.

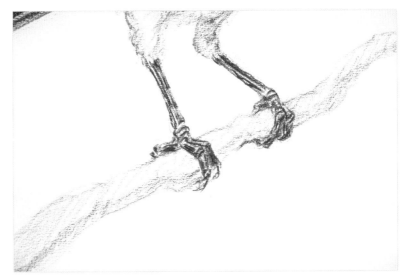

I began this drawing by simplifying my subject into basic shapes using light lines. Because I know these first attempts are going to be inaccurate, I draw them lightly so they can easily be adjusted or erased. From there I make adjustments to these shapes until I have captured the basic forms of the subject. Only then do I add the dark lines I intend for the viewer to see.

This is the process used by most master artists from the Renaissance to the present. This process works with traditional materials like pencil and charcoal as well as digital media. This is the process I will teach you.

Let go of the idea that you're going to make perfect drawings with few mistakes. You're not. Even the greatest masters of drawing made countless errors in their drawings. To draw well you need to be willing to make a lot of mistakes and learn from them. Mistakes are not to be scorned or feared. In fact, mistakes are an essential starting point. When properly leveraged, mistakes provide valuable clues as to our next steps in the drawing process. I find mistakes so valuable that I rarely erase them. This is why they can be seen in my finished drawings.

The difference between a master artist and an unskilled amateur is not the number of mistakes they make, but how they handle their mistakes. Amateurs get frustrated by their mistakes. Pros get to work making adjustments to their mistakes until they correct them, no matter how many attempts it takes. Once you understand this, mistakes and missteps just become an expected part of the drawing process that you can take in stride.

With this in mind, let's take a look at the drawing process overall. The process of drawing falls roughly into three phases. In phase 1 you will simplify your subject into its most basic shapes and volumes using light, soft lines. In this first phase you will work out the general proportions and placements of the various parts of your subject.

In phase 2 you will solidify your subject by establishing more specific contours. In this phase you will enhance the three dimensionality of your subject using descriptive line quality.

In phase 3 you will begin the shading process by first dividing your subject into its most basic patterns of light and dark and then slowly adding detail and texture. This final phase of the process continues until the drawing is complete.

Before you begin practicing, let's take a closer look at each phase of the drawing process.

# Phase 1:  Basic Shapes and Volume

One of the most common and easily avoidable mistakes students make is shading their drawings before working out the basic forms and proportions. Imagine you're drawing a figure. After spending hours shading every detail of the body and face, you realize that the head is too big for the body. You now have an unfortunate decision to make. You can leave it alone and hope nobody notices, abandon the drawing entirely, or erase the head and redraw it in proportion to the body. I have witnessed students in this exact situation countless times. We want to avoid this scenario at all costs. We need a process that allows us to work out the basic shapes and proportions of our subject before we invest any time in shading or detail.

Every subject, no matter how complex, can be simplified into basic shapes. When you begin a drawing, your first goal is to simplify your subject into simple shapes like circles, ovals, triangles, and rectangles. Your first attempts will rarely, if ever, be accurate. Therefore, you will begin every drawing with incredibly light lines and marks. For example, the body of this bird simplifies into a tilted oval. The head simplifies into a smaller oval. The beak simplifies into a triangle. We can easily change the proportions, positions, and sizes of these basic shapes until they accurately represent the subject.

Errors of proportion, placement, and axis are the most consequential errors you're likely to make in a drawing. Proportional errors include drawing the head too big or the legs too long. Errors of placement can include drawing the head too far from the body, or even starting the drawing too close to the edge of the paper so your subject won't fit on the page. Axis errors include drawing a part of the subject tilted too much or not enough. These kinds of errors, if not caught and corrected early, can result in the erasure of hours of work or even abandoned drawings. Fortunately, all of these issues can be worked out by using light lines at the very beginning of the drawing process before any details or shading are applied.

Even in this simplified sketch you can tell if the head is too big, a leg is too long, or a wing is not in the right place. Because

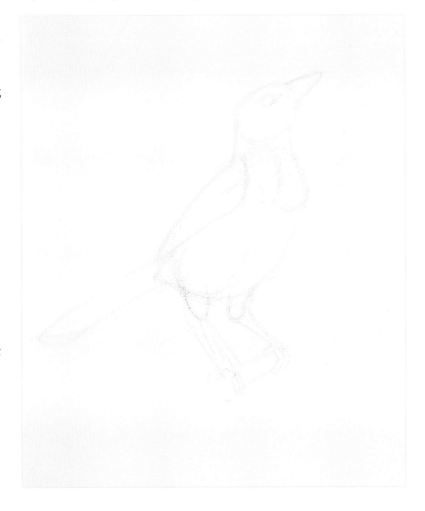

the shapes are simple and the lines are light, it's easy to rework these elements, shaping them as if they were clay.

The lines I use at this stage of the drawing are both light and soft. These light, soft lines are easy to adjust or erase as needed. If they make it to the end of a drawing, they are less likely to be seen by viewer. Hard lines and dark lines are difficult to hide or erase. The lines seen in this drawing are actually darker than the lines I normally draw at this stage. I intentionally made them darker here so you can see them. When I am not drawing for students, I draw so lightly at this stage that the lines are nearly invisible if you are not within 5 to 10 feet of the drawing.

It is critical that you do not move on from this phase of the drawing until you are certain that the fundamental forms of your subject are placed properly in relationship to one another and that they are the right size and at the right axis. If a head is too big or a leg is too long, we want to correct those issues now when they are simple, light shapes, not after hours of work have gone into rendering them.

The skills you need for this first phase of the drawing process are covered in "Chapter 1: Basic Skills."

Once we are confident that we have captured our subject simply and accurately using light lines and basic shapes, we can move on to the next phase of the drawing process.

## Phase 2: Contours and Mark Making

Once we have our simplified subject drawn lightly on the page, we can begin to solidify it using inner and outer contours. An outer contour is an outline that describes the outer edge of a form. Inner contours occupy the space inside the outer edge of the subject and help describe the topography of the form.

An outer contour simply outlines the subject and describe its overall shape. By itself, an outer contour produces only a flat, empty silhouette of the subject. Inner contours are required to describe the volume and surface features of the subject.

Inner and outer contours must work together to create the illusion of three-dimensionality. For example, we can see that the body of this bird is in front of the leg on our right. This illusion is created when the outer contour of the body overlaps the contours of this leg. You can also find numerous other lines and marks that make the bird appear more rounded and three-dimensional. For example, the legs appear cylindrical due to the ellipses drawn where the legs meet the feet.

We can also begin to communicate tactile sensations at this stage. Notice the lines used to draw the legs and feet are hard, thin, and dark, but the lines used at the right edge of the breast and stomach are softer, thicker, and lighter. This tells the viewer that the legs would feel hard and brittle to the touch while the breast and stomach would feel soft. The contours of the beak are also drawn with dark, sharp lines.

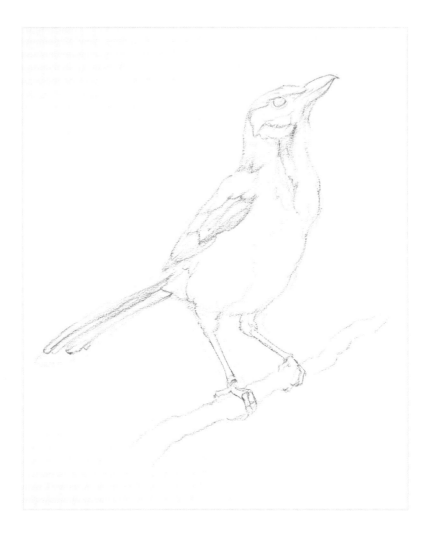

Because I am confident that the basic shapes were correctly drawn during the first phase of the drawing process, I can begin to break these big, simple shapes into smaller, more complex shapes. You can see that the triangular shape of the bird's wing is now divided into many smaller shapes. You can see this in the tail as well. Even as the forms become more complex, I am still thinking about the subject in terms of basic shapes. The shapes in the wing, for example, are based mostly on partial or modified triangles and ovals.

During this second phase of the drawing process, you become more familiar with your subject and you might notice issues with proportions, placement, or axes (plural of axis) that you missed in phase one. If the wing is too big or the legs are too long, we want to make the necessary changes now, not after we've spent an hour or more shading and drawing subtle details.

The skills required for this second phase of the drawing process are covered in "Chapter 2: Form and Space" and "Chapter 4: Mark Making and Contours."

Once you've solidified your subject using inner and outer contours, you'll be ready to add shading and detail.

# Phase 3: Shading and Detail

In phase one of the drawing process we simplified our subject into its most basic shapes. Now in phase three we want to simplify the patterns of light and shadow. Instead of rushing to capture every subtle shift in value, I will first simplify the lights and darks into two values: one light and one dark. You can see the dark value in the tail, wing, and head of the bird. The light value is represented here by the white of the paper. Once this is done, I added a third, middle value to represent the shadow on the right side of the bird's neck and body.

As with any subject, how you choose to simplify your values will change depending on the subject, but the goal is to keep a clear separation between light and shadow. This separation will help you avoid shading your subject into a bland, middle value.

Once we have determined the basic light and shadow patterns, we can finally draw all the tiny details that bring the drawing to life, like the highlight of the eye and intricate patterns of feathers on the bird's face. As we add details, we want to maintain a clear distinction between lights and darks. In the completed drawing on page 4, despite all the details, you can clearly see the basic pattern of lights and darks that was established in phase 3. Phase 3 continues until the drawing is complete.

This is a simplification of the drawing process. Drawing is not a rigid step-by-step system. There are many professionals and masters who use different processes. I rarely follow these steps precisely when I'm not teaching. But this is the most powerful process to work within when you are *learning* to draw. When you are comfortable and competent with this drawing process, you can alter it to fit your needs and goals. But until then, this is where you should begin.

Now that you have a basic understanding of the drawing process, it's time to for you to learn about drawing materials.

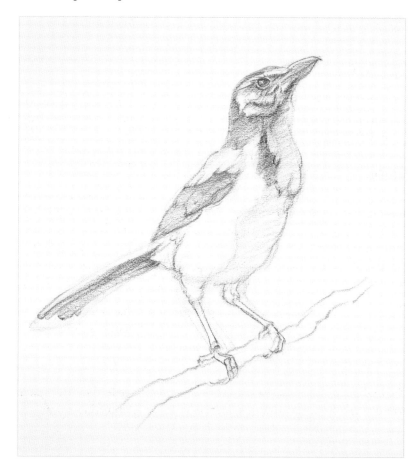

# Materials and Setup

Materials are important, but not as important as you may think. A skilled artist can produce a compelling drawing with the most modest materials: a cheap ball point pen on lined paper, a piece of chalk on a concrete driveway, or even a finger on a dirty windshield. Unlike oil painting, ceramics, or photography, which require specific and often expensive materials, drawing is truly open to anyone regardless of circumstances There is no barrier to entry. You can go through this book with whatever materials you have on hand. If all you have are some crayons and an old, lined note pad, you can still learn to draw. That being said, here is a primer on some of the most common drawing materials as well as my recommendations.

Before we discuss pencils and paper there are two categories of materials you should be aware of: archival and non-archival. Archival art materials, whether they be pencils, paper, or paint, do not degrade over time. For paper this means that no acid is used. For pencils this means that the pigment and binder are made from clay, minerals, or other materials whose properties do not change over time. In short, archival materials are made to last. A drawing done with archival materials will look the same today as it will 50 years from now. When you create a drawing you want to keep, you should use archival materials. This permanence comes with a premium price tag.

Non-archival materials, sometimes referred to as *fugitive* materials, are not made to last. They are cheaper to make and purchase but they decay over time, often quite quickly. Non-archival materials are great for practice but should not be used for drawings you want to keep.

## Pencils

A pencil has a rod of pigment housed inside a casing, usually made of wood. The rod can be made from graphite, charcoal, or a wide range of colored pigments. The pigments are mixed with a binder that determines how hard or soft the rod is. We draw with the exposed part of the rod called the *lead*.

### Graphite Pencils

Graphite pencils are common and inexpensive. They are a great option to start with when learning to draw. Graphite is a dark mineral that is powdered and then mixed with clay to create a hardened rod. This rod is usually encased in a wooden shaft. The less clay the mixture contains, the softer the lead becomes. Softer leads produce darker lines because they deposit more graphite on the drawing surface. The more clay the mixture contains, the harder the lead becomes. Harder leads produce lighter lines. Softer pencils become dull faster and require more frequent sharpening. Harder pencils keep a sharpened tip longer.

Near the end of a graphite pencil, away from the sharpened tip, you will usually find a number, and sometimes a letter, that indicates how hard or soft the pencil is. Although there is no rigid industry standard, generally speaking, pencils produced outside of the United States use a graphite grading scale with two broad categories: H pencils and B pencils.

The higher the number next to an H, the harder the lead is. The harder the lead, the lighter the line it will produce. The hardest, and therefore lightest pencil available is a 9H.

The higher the number next the B, the softer the lead is. The softer the lead, the darker the line it will produce. The softest, and therefore darkest pencil available is a 9B.

At the center of this scale, you can find a range of grades that are similar in hardness. H, HB, and B pencils are all considered to be in the middle of the range with H being harder than HB and B being softer than HB. Some pencil grades also have an F pencil referring to the fact that it maintains a fine tip.

American manufacturers use a grading scale that is different from European manufacturers. For example, a number 2 pencil in America is equivalent to an HB pencil on the European scale.

You can buy a full range of graphite pencils in a set. Because they are made from minerals and clay, they are considered archival and should not decay over time.

Most people have pencils around their house, which will most likely be in the middle of the scale, not too hard, not too soft. Graphite pencils are great for beginners.

As you will learn later in this book, there are times we want to draw with incredibly light lines and marks. If you have a heavy hand and struggle to draw lightly by adjusting the pressure of the pencil, you can always switch to a harder pencil in the H range. Conversely, if you have a light touch and struggle to make dark lines, you can switch to a softer pencil in the B range. But for the most part you should be able to produce lighter or darker lines simply by adjusting the amount of pressure you apply when drawing.

Although many artists use graphite pencils, I generally do not. This is because graphite forms a metallic sheen when it builds up on the surface of the paper that can interfere with dark values. But this is just a personal preference. You are more than welcome to learn to draw using graphite pencils due to their many benefits.

## Colored Pencils

Colored pencils contain a rod at their core that is made from colored pigment mixed with wax or oil. These colored pigments come from a wide range of materials both natural and synthetic. Together, the binder and pigments can be mixed to create pencils in any color.

Wax-based colored pencils are generally more common and less expensive than oil-based colored pencils. However, like graphite, the wax in these pencils can build up and form a hazy coating that can interfere with dark values.

I prefer to draw with oil-based colored pencils. Oil-based colored pencils are rich, creamy, and maintain their darkest values. In this book you will see drawings done with oil-based pencils in black, dark reds, dark browns, and blues. I recommend drawing with darker colors that can create the illusion of light and shadow. With bright red, orange, or green pencils, it is a struggle to create shadows because the mind will interpret them as bright colors instead of dark values.

I use Lyra Rembrandt Polycolor Pencils. They are oil-based colored pencils that put down rich, dark colors but smear less than softer pencils. Most drawings in this book were done with these pencils.

I also recommend Faber-Castell Polychromos Artists' Color Pencils, another oil-based colored pencil I frequently use.

I also recommend Derwent Drawing Pencils. They are very soft and put out dark, rich values, however they are hard to control and tend to smear if you're not careful. I recommend and use Derwent Drawing pencils for large scale drawings.

For colored or toned paper, you will need a white pencil to draw lighting effects. For this I recommend a White Derwent Drawing pencil.

## Ball Point Pen

Ballpoint pen can be a fun and inexpensive way to draw. Ballpoint pens do not need to be sharpened and they do not require any special care. They are cheap and easily transportable. They are my tool of choice when I draw in my sketchbook out in the world. The biggest issue with ballpoint pen is that you cannot alter the thickness or softness of their lines. You will learn more about the importance of line variation in "Chapter 4: Mark Making and Contours."

## A Note on Charcoal

I would not recommend using charcoal if you are a beginner. Charcoal is incredibly messy and difficult to control. If you want to learn how to use charcoal eventually, I recommend going through this book once using the recommended materials. After you have some skills and experience, go through the book again using charcoal.

## Erasers

In my experience, erasers are overused. Many beginners erase nearly as much as they draw. As you will learn, erasing is usually unnecessary at best and at worst it deprives students of essential learning opportunities. Erasers should be used sparingly. I tend to use them for only the worst mistakes, for general clean up at the end of a drawing, or to create lighting effects. You will not need erasers for mistakes nearly as much as you think. That being said, here are the types of erasers you should understand and own.

### Kneaded Erasers

Kneaded erasers are gummy and pliable. They can be used like Silly Putty to lift pigment off of the paper. They are generally used to lighten lines and values, not to erase them completely.

Lyra and Faber-Castell both make excellent kneaded erasers, but nearly any kneaded eraser will work.

### Viny and Plastic Erasers

Plastic and vinyl erasers come in small, firm blocks and cleanly erase a wide range of materials from a wide range of surfaces. They are a great alternative to rubber erasers, although rubber erasers work well enough, particularly for graphite. These erasers are used when you want to erase something as much as possible.

I recommend Magic Rub vinyl erasers by Prismacolor and Staedtler Mars Plastic erasers, although there are many good vinyl and plastic erasers on the market.

# Paper

Paper comes in all sizes. My smallest sketchbook is 3″ × 5″. My largest paper roll is five feet high and 33 feet long. When you're learning to draw, most professionals agree that 18″ × 24″ paper is an ideal size. This may seem big to beginners, but you're going to learn to draw using your entire arm, not just your wrist and fingers. As you acclimate to this way of drawing, the larger paper will feel more free and less restrictive.

The surface of paper has a texture often referred to as the *tooth*. The more tooth a paper has, the rougher it is. Like sandpaper, rough paper will remove more pigment from your pencil than smooth paper. Most papers will be labeled as having a smooth, medium, or rough texture.

Paper also has a weight that is usually expressed in pounds. A paper's weight refers to its thickness and stiffness. Generally speaking, the heavier the paper weight, the thicker and stiffer it is. A sheet of 30 lb paper will be thinner and more pliable than a sheet of 80 lb paper.

## Newsprint

Newsprint is ideal for practicing. As you learn to draw you will practice hundreds, if not thousands, of basic lines and shapes. Newsprint is cheap, which makes it perfect for the hundreds of practice pages you will go through. Newsprint is cheaper because it is non-archival. Open an old pad of newsprint and you may find it has become yellow and brittle. Do not do any drawings on newsprint that you want to keep.

Most newsprint will be around 30 lbs. Newsprint is available in rough or smooth textures. I use smooth, but this is just a personal preference. Rough newsprint can be harder to work with because of its visible texture and the fact that it removes more pigment from the pencil, which will often smear.

I recommend 18″ × 24″ Strathmore 300 Series Newsprint pads with a smooth texture. Nearly every paper company makes a decent pad of newsprint, so the specific brand is not important.

## White Drawing Paper

When you want to keep a drawing, you should use archival drawing paper. Archival paper may also be labeled as *acid-free*. Acid-free paper is less likely to degrade and is considered archival.

I recommend spiral bound pads of 18″ × 24″ white drawing paper. A spiral bound pad will allow you to turn the page and have the paper lay flat. Most of my demonstrations in this book are done on white drawing paper.

I recommend 18″ × 24″ Strathmore 400 series Recycled Paper Pads (80 lb, medium surface). This paper is bright white, and the spiral binding allows the pad to be opened and laid flat.

## Fine Art Paper

For your finest work you should use premium drawing paper. These papers vary in weight, texture, and color. Fine art paper is often sold in individual sheets or in packs. It is generally archival and is usually 100 lbs. or more. As you learn to draw, I recommend using only newsprint and white paper. Premium, fine art paper can come later after you have more skills and experience.

I recommend 19″ × 25″ Canson Mi-Teintes paper. It comes in white as well as a wide range of colors. Most finished work in this book was done on Canson Mi-Teintes paper.

# Drawing Boards and Clips

Although most pads of paper will come with a firm cardboard back, they generally require more support. I recommend you clip your pad of paper onto a drawing board. Most beginners draw with their paper flat on tabletops or desks, but as you will learn, we want our drawing surface perpendicular to our line of sight to avoid distortions when we draw. Drawing with your paper flat on a table may create distortions in your drawing if the paper is not perpendicular to your line of sight.

Masonite drawing boards are an excellent choice for beginners. They are firm, sturdy, and inexpensive. They come with clips on one side to hold your pad of paper in place. Masonite drawing boards come in a wide range of sizes, but generally, you want a board that is larger than your pad of paper. For an 18″ × 24″ pad of paper you will want a board approximately 23″ × 26″.

I use lightweight basswood drawing boards with metal edges. They are easy to transport and they provide a firm drawing surface that is a bit more yielding than hard Masonite boards. These drawing boards do not come with clips, so I recommend purchasing metal binder clip or plastic kitchen clips.

In a pinch, you can use any hard, flat, smooth surface as a drawing board. I've used oversized books as well as old pieces of plywood from my garage. Just remember that a smooth surface is critical. Even seemingly subtle woodgrain can show up on your drawing in relief.

When drawing with single sheets of paper on a drawing board, you may want to place a few sheets of paper underneath the paper you are drawing on. This takes the edge off the hardness of some drawing boards and minimizes any surface irregularities of the board that might show through in your drawings.

# Other Materials

## Dusting Brush

A dusting brush is used to gently clear your drawing of any dust, excess pigment, or eraser particles. The long, soft bristles minimize the smudging of most drawing materials with the exception of charcoal and soft pastel.

## Artist Tape

Artist tape is archival and has a low tack adhesive that reduces damage to the surface of paper. It can be used to secure individual sheets of paper to a drawing board as well as for mounting and matting finished drawings.

## Pencil Sharpener

Many artists use utility blades to shape their pencil leads into wedges or tapered points. You are welcome to explore this method, but I have always found that electric pencil sharpeners meet my needs. They are quick and easy to use. I like pencil sharpeners that bring the pencils to a longer point, but this is just personal preference.

## Basic Materials Recommendations

Here's a quick list of the materials I recommend for this book:

- 18″ × 24″ pad of newsprint
- 18″ × 24″ pad of white drawing paper
- Drawing pencil of some kind
- Kneaded eraser
- Vinyl or plastic eraser
- Drawing board and clips
- Pencil sharpener or utility blade

Keep in mind that my recommendations are just suggestions. Nearly any art materials will work, so if you can't find these specific materials, use whatever you can that's close to these materials or whatever you have on hand.

Many beginners want to use the *right* or *best* drawing materials. I empathize with the impulse. But there are so many good materials out there that serve so many different purposes that it's nearly impossible for me to assess what will best serve the needs of students and artists. I've made my recommendations here and have shared what I use in my studio, but the best way to learn what you like is to try out different materials.

Finally, remember this: Even the best materials in the hands of an unskilled novice will not improve their drawing skills. Conversely, a competent drawer can produce high-quality work with the shoddiest of materials. Materials are important, but not nearly as important as practice and skill building.

# Setup

Setup is an essential but often overlooked aspect of drawing. Fortunately, there are many suitable setups for drawing. I'll cover some of the most common setups and give you some pointers on how you can make nearly any setup work for you.

Regardless of how you set up your drawing station, you must make sure your drawing surface is perpendicular to your line of sight. To understand what I mean, let's take a look at one of the most common setups for drawing.

An easel holds your drawing surface upright. Most easels can be adjusted to suit your build and preferences. You can either sit or stand at an easel. I prefer standing but this is just personal preference. Whichever you choose, your drawing surface should be at a 90-degree angle from your line of sight.

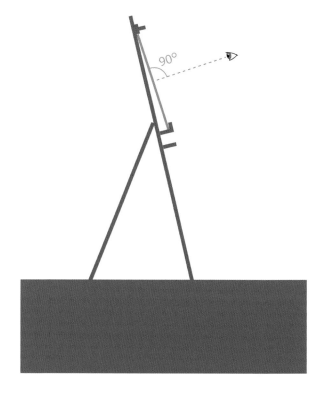

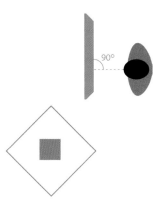

If the top of your drawing board is closer to your eyes than the bottom, or vice versa, distortions will occur in your drawing. This also holds true if we look at this setup from above. Here we can see that the drawing board is still 90 degrees from my line of sight.

If you are right-handed, as I am, I recommend placing your drawing subject on your left. This allows you to comfortably look back and forth from your drawing to your subject without your drawing arm getting in the way. You will also notice that, in this setup, I am slightly closer to the left side of my drawing surface. This ensures that the drawing board doesn't obscure my subject. When I draw, I position my paper closer to the left edge of the drawing board to get the edge of my paper as close to the subject as possible.

In this book, you will often be asked to draw objects from observation. We want to place our subject near the visual edge of our drawing board. In this setup I can comfortably rotate toward my drawing subject without stepping side to side as I go from observing my subject to drawing it. In this diagram I have placed my subject (a simple box) on a table. As I rotate toward it to draw, the subject is immediately to the left of the edge of my drawing board. To go back and forth from my drawing to my subject requires minimal movement. In this diagram (right) I show the whole body turning, but you are welcome to simply turn your head if that's more comfortable.

We want to avoid positioning the drawing board so that one side of it is closer to our eyes than another. Again, this will cause distortions in your drawing.

Here you can see my easel. Note that the drawing is closer to the left side of the paper, as I described above. The easel pictured here is a Richeson Dulce. It is one of many easels I own.

There are many different kinds of easels. It is important that an easel is sturdy and will not shake or move while you draw. Make sure your easel is for studio use and not a display easel. Display easels are lightweight and easily transportable, but they provide little stability when you draw.

The setup described above is what works for me, but this exact setup may not work for you. The most important thing is that your drawing surface is perpendicular to your line of sight, but as long as that requirement is met, you should feel free to experiment to see what kind of setup works best for you.

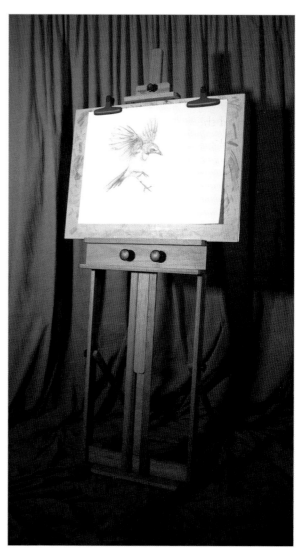

I frequently use a drawing horse. A drawing horse is common in art schools and ateliers. They're not the most comfortable option, but I developed an affinity for them when I was learning to draw. A drawing horse is named because of its shape and the fact that you straddle it like a horse. The drawing board can either be held in place on the bench of the horse or propped up on your thighs. I like to rest the board on my thighs as I draw. Just like an easel, it is critical that your drawing surface is perpendicular to your line of sight. When using a drawing horse, you can place your subject so that it appears right above the top edge of the board or off to the side. I often use a drawing horse when drawing in front of my computer. I pull it up to my computer desk so the computer screen appears above the top of my board.

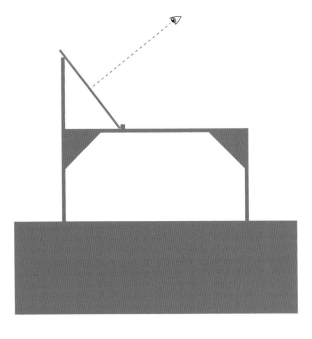

I have owned the same drawing horse for years. It was a hand-me-down from an atelier.

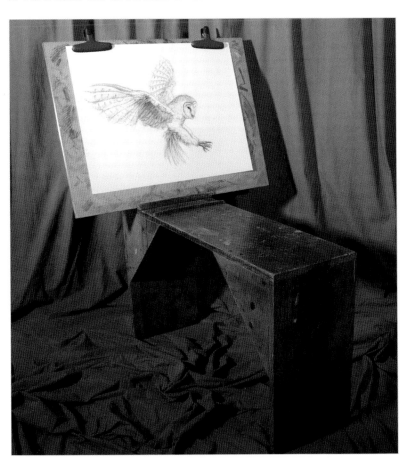

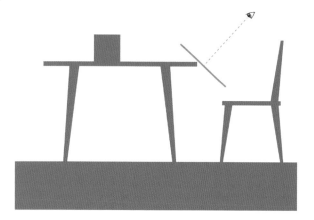

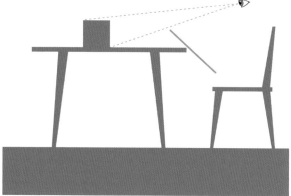

If you don't have an easel or drawing horse, not to worry. There are many other setups that will work. You can sit in a chair and lean your drawing board against a table or desk with the bottom edge of the drawing board resting on your thighs.

In this setup the subject you are drawing can be placed so it appears right above your drawing board as you draw, or off to the side.

You can even use two chairs, one to sit in while you draw and the other to hold your drawing board upright (right). Again, with all of these set-ups your drawing board should be perpendicular to your line of sight.

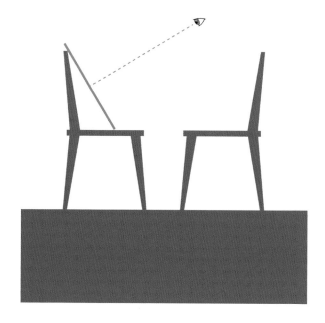

In addition to drawing from objects you observe in real life, you will also draw from diagrams and images found in this book. When drawing from pages in this book, make sure the book is perpendicular to your line of sight just like your drawing surface is. You may need to experiment to prop up the book in this way.

There is a near infinite number of ways you can set up to draw. I've covered some of the most common, but you're welcome to explore other methods. Just make sure that your drawing surface is perpendicular to your line of sight and that your subject appears near your drawing surface so you don't have to turn too far to see it.

As you learn to draw, I encourage you to explore different materials and setups to see what works best for you. Remember, there is no single *correct* way to setup nor is there a *best* set of materials. The more experience you gain, the more distinctions you will make about your needs and preferences.

Now that you understand the process, materials, and setup used for drawing, let's develop your basic skills.

CHAPTER 1

# BASIC SKILLS

Most people can't draw because they don't understand the processes and skills that yield successful drawings. To the untrained eye, watching an artist draw is like watching a magician perform a trick. You know there must be a logical explanation but to the uninitiated, drawing is indistinguishable from magic.

But drawing is not magic. Like the art of illusion, there are perfectly rational explanations.

In reality a drawing is built like a house. Underneath the surface, there is a sturdy foundation. Just like the foundation of a house, the foundation of a drawing is not intended to be seen once the drawing is complete. The foundation is covered up by the features and flourishes we want the viewer to see. But without the foundation neither a drawing nor a house can be reliably constructed.

The foundation of a drawing is built from simple shapes like circles, ovals, triangles, and rectangles as well as variations on these shapes. The foundation of basic shapes should be drawn with very light lines so it can be easily adjusted or erased. Therefore, our first task is to learn how to draw lightly.

# How to Draw Lightly

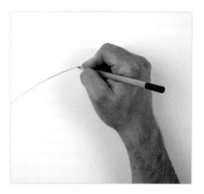

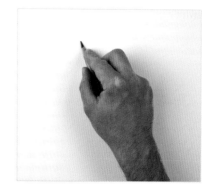

To draw lightly we first need to learn how to hold the pencil. Most people mistakenly assume that drawing is done with the same grip we use for writing, which is called the tripod grip. Although the tripod grip can be used for drawing, it comes with severe limitations. The tripod grip produces uniformly thin, dark lines made by applying steady pressure to the tip of the pencil. This kind of dark, uniform line is excellent for writing, but not for drawing.

When we begin a drawing, we want to draw light, soft lines that can be easily adjusted or erased if necessary. To draw soft, light lines we need to learn how to use the overhand grip, which is how most accomplished artists hold their pencils. The overhand grip engages the broad side of the pencil lead instead of the tip. This allows us to control not only how dark a line is, but how thick it is and how soft it is. The tripod grip only allows us to alter the darkness of a line but not its thickness or softness.

## How to Hold the Pencil Using the Overhand Grip

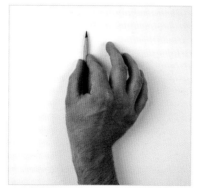

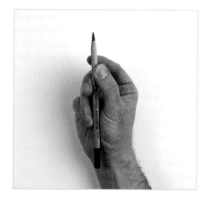

Place the pencil on a flat surface in front of you with the tip pointing away from you.

Using only your thumb and index finger, pick up the pencil just below the exposed wood of the sharpened end. The shaft of the pencil should extend toward your wrist.

Let your middle and ring fingers rest on the shaft of the pencil securing it gently against your palm. Your little finger can rest wherever it is comfortable, either on the pencil or against your palm.

This is the basic overhand grip. You can alter this grip by moving your fingers even closer to the sharpened tip of the pencil (this is how I draw) or move your fingers away from the tip. There are many variations on this grip that will work. With time and practice you will figure out how to use the overhand grip in a way that best suits you.

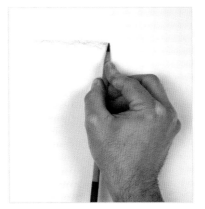

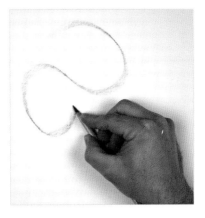

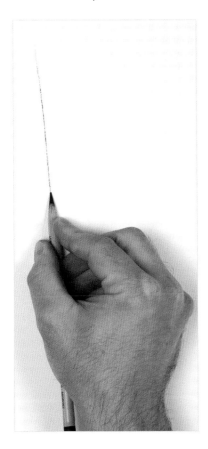

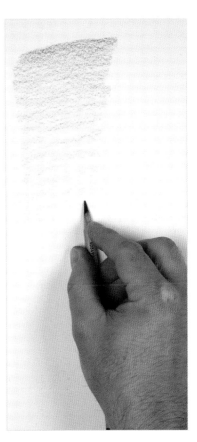

Using the overhand grip, when you draw in the same direction as the shaft of the pencil produces a thin, sharp line.

When you draw perpendicular to the shaft of the pencil you get a softer, thicker line.

Using the overhand grip, we can produce beautiful, calligraphic lines that can change from hard and thin to soft and thick in a single stroke.

The overhand grip can also be used to lay down washes of value called *graining*. This is called graining because the broad strokes reveal the grain, or texture, of the paper.

For a beginner, drawing lightly is one of the most critical skills to learn. Although drawing lightly is easy to master on its own, many students struggle to keep their lines light when they actually attempt to draw a recognizable subject.

The overhand grip does not allow you to easily move the pencil with your fingers like the tripod grip does. When using the overhand grip, most of the movement should come from your shoulder and elbow, not from your fingers or wrist. It is perfectly normal to feel some minor discomfort or fatigue in the shoulder while adjusting to the overhand grip, but this will diminish with time and practice.

Experiment with the overhand grip making different kinds of lines and marks. Don't try and draw anything in particular. Just familiarize yourself with the wide range of marks that are possible with the overhand grip. To learn to draw lightly, move your hand back and forth decreasing the amount of pressure you apply with each pass, until the lines you are making are extremely light and soft. Your goal is to be able to draw very light lines consistently and comfortably.

Practice making simple light lines as well as long, fluid curved lines. Drawing light figure eights is one of the best exercises I have found to practice making long, fluid strokes from the shoulder.

Many beginners tend to draw lines by making a series of short strokes, tiptoeing along in the direction they want. We want to avoid these kinds of lines. Our goal is to draw using long, fluid strokes originating from the shoulder. Long fluid strokes appear more expressive and confident.

One of my jobs as a teacher is to manage student expectations. Many students assume that the overhand grip should immediately be comfortable and instantly improve their drawings. It won't. In fact, you may notice your drawings getting worse before they get better when learning how to draw with this grip This is perfectly normal. Although the tripod grip may feel more comfortable, it is extremely limited in its mark-making capacity. All of the drawings in this book were done with the overhand grip and many of the techniques I teach can be done only with the overhand grip.

Many students resist switching to the overhand grip because the tripod grip feels so intuitive to them. However, when you first learned the tripod grip, was it immediately comfortable? No. It felt clunky and awkward. You've probably been using the tripod grip for years if not decades. You should not expect, as many students do, that the overhand grip will immediately feel as comfortable and intuitive as the tripod grip does now. Give yourself time to adjust to the overhand grip. I have never had a student who has regretted learning the overhand grip.

That being said, there are professional artist who primarily use the tripod grip. Ultimately, the grip you use is a personal choice. I recommend using the overhand grip because of the wide range of marks that can be made with it, but the grip you use is up to you. Just know that the tripod grip has many limitations when it comes to its mark-making capabilities.

# Practice Drawing Lightly for 15 Minutes

For 15 minutes, practice drawing lightly using the overhand grip. Remember to draw from your shoulder and elbow, not from your wrist or fingers. Your goal is to practice light lines until they become second nature. These lines should be clearly visible to you when you are drawing but should nearly disappear from about 10 to 15 feet away.

Once you are able to draw lightly using the overhand grip, you're ready to learn how to draw basic shapes.

# How to Draw a Circle

Set up your drawing station with a fresh sheet of paper. Pick up your pencil, preferably using the overhand grip, which I recommend. Place your hand over the center of the paper hovering just above the surface. Lock your fingers and wrist but keep your elbow soft. Rotating from the shoulder, pantomime the shape of a circle, continuously moving your hand around and around. Right now, you are just pantomiming the shape of a circle above the surface of the paper, not actually drawing the shape. The pantomimed circle should be approximately the size of an orange. Although it's best to keep your hand lifted entirely from the paper, if you touch it slightly for support, that's okay.

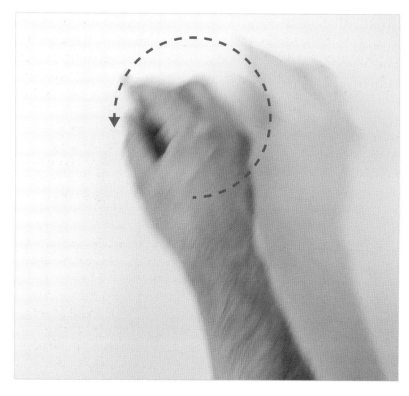

Most right-handed drawers draw their circles with a counterclockwise motion and most left-handed drawers draw them with a clockwise motion. Experiment to see which direction works best for you.

Each full revolution around the circle should take slightly less than a second. You want to get some momentum going, but do not move so fast that you lose control of the shape of the circle. As you pantomime, notice that you can visualize the size and shape of the circle your pencil would make if it were in contact with the paper. If you are moving quickly enough, you can tell whether or not the shape will be circular.

Pantomiming allows you to visualize the shape, size, and placement of the circle before you ever draw it.

Once you've had some experience pantomiming a circle, let's draw one.

When you are ready, pantomime the shape of a circle rotating from your shoulder, keeping your hand hovering above the surface of the paper. As your hand moves around and around make sure your circle is actually circular. Now, without stopping this motion, lower the tip of the pencil down onto the paper and make multiple passes around the circle, using light, soft lines.

No single pass will be perfectly circular, but with practice, the multiple passes should coalesce to create a reasonably round circle.

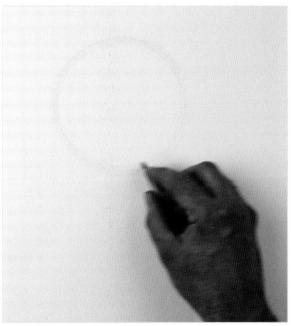

When drawing circles, I always pantomime the shape before drawing. This technique not only produces reasonably accurate circles, but also allows me to assess the size and placement of these shapes before I draw them, a skill you will later find to be essential.

Let me save you the suspense: Your first circles will not look like mine. That's normal and should be expected. But after practicing hundreds of circles, you will see your circles get tighter and more circular with less effort. After practicing thousands of circles this process will become comfortable and intuitive. Try to keep your expectations realistic. I've had students who expect this technique to immediately yield flawless circles without practice. These students often become frustrated when their circles are not perfect after three attempts. This is unrealistic.

You'll notice that my circles are obviously hand drawn and not as precise as a circle drawn with a compass or stencil. With practice, this technique produces adequate circles for most drawing purposes. It's actually quite rare that you will need to draw a perfect circle freehand. If you do need circular perfection you are welcome to use a compass or stencil. In my own work I prefer the dynamism of hand drawn circles to the sterile look of circles drawn using devices.

Legend has it that the only artist who was able to draw perfect circles freehand was the Renaissance artist Raphael. In current times there are freehand circle drawing competitions. People practice for years and compete to see who can draw the most perfect circle without the aid of devices. Be patient. Circle drawing, like all other drawing skills, requires practice and persistence.

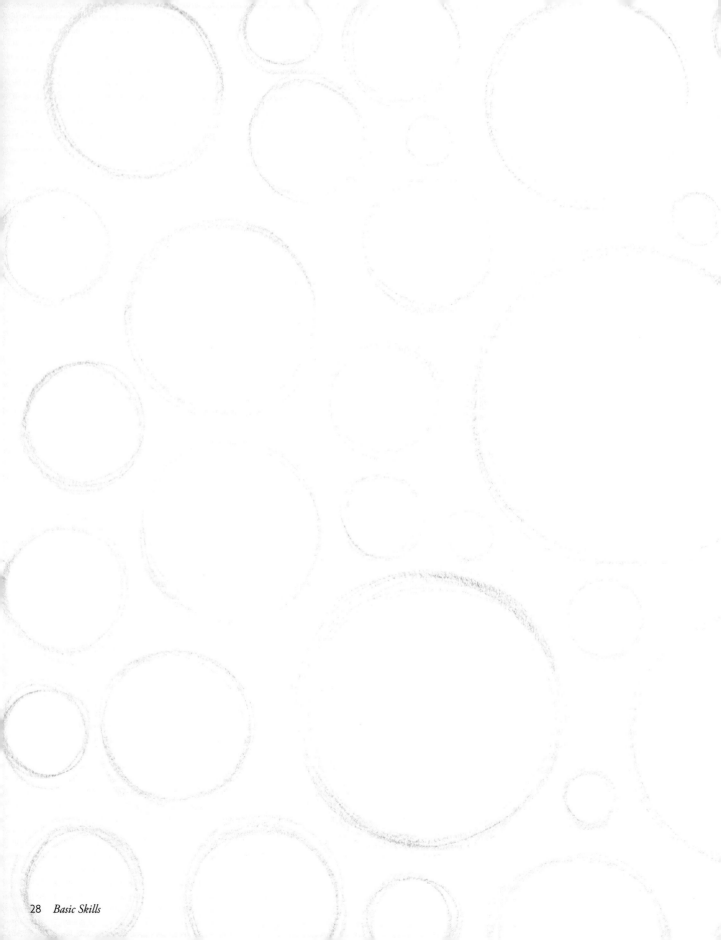

# Draw 100 Circles

Draw 100 circles at varying sizes using light, soft lines. Your circles can be as large as dinner plates or as small as buttons. I recommend doing this project daily until you can comfortably draw circles. This may take weeks or even months, but it is a valuable investment. Circle drawing is a fundamental skill, and you cannot practice the fundamentals too much. I've been drawing for more than 30 years, and I still regularly practice drawing circles just as I have described.

This project is also an excellent opportunity to practice using the overhand grip. It is one of the best ways to train yourself to draw light, soft, and fluid strokes in a controlled way.

# How to Draw an Oval

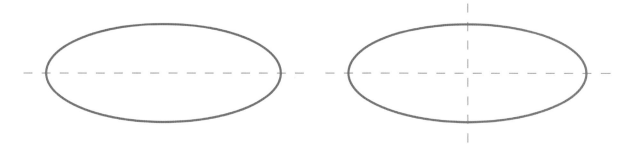

Before you learn how to draw an oval, we first need to learn what a proper oval looks like. Take a look at this oval. There is a line through the long axis of this oval. An axis is an imaginary line through the center of a shape or volume. Notice that this axis line acts as a line of symmetry. It divides the oval into two identical halves with the top section mirroring the bottom section.

In the diagram above, we see a vertical line that is perpendicular (at a right angle) to the long axis of the oval. This line also acts as a line of symmetry for the left and right sides of the oval. The oval is now divided into four equal parts. This is the hallmark of a properly drawn oval and what we will strive for.

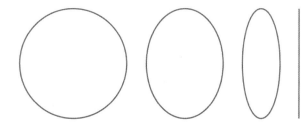

Unlike circles, which can change size but not shape, ovals can change their size *and* their shape. To understand what I mean, take a look at this diagram.

On the far left is a circle and on the far right is a line. Between the circle and the line, we see two ovals. The oval on the left is closer to a full circle and the oval on the right is closer to a line. The closer an oval becomes to a circle we refer to it as being more *open*. The closer it is to a line; we refer to it as being more *closed*. So, the oval on the left is more open than the oval on the right. The oval on the right is more closed. When an oval opens all the way up it becomes a circle. When an oval closes entirely it becomes a line.

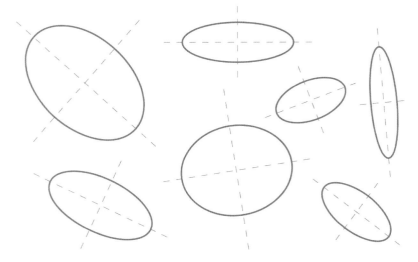

We can also change the axis of an oval by tilting it in any direction. Remember, when we tilt an oval, the axis lines still need to be perpendicular to one another and act as lines of symmetry. The following diagram shows ovals at various sizes, axes, and levels of openness.

Now that you understand the essential elements of a proper oval, let's learn how to draw them.

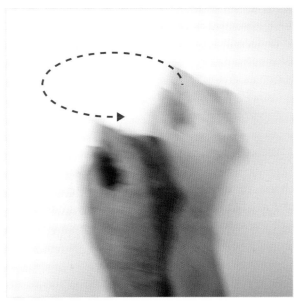

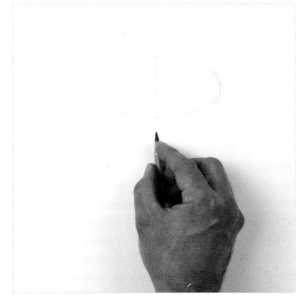

Ovals should be drawn using a method very similar to circle drawing. Just like circle drawing, you'll begin by pantomiming the shape of the oval, with your moving hand hovering just above the paper. With enough momentum you should be able to visualize the size, shape, axis, and location of the oval your pencil would draw if it were lowered onto the paper.

When you're ready, still making the motion of an oval, you will lower the pencil down onto the paper and make multiple passes around the oval. No single pass will be a perfect oval, but with practice, your lines will coalesce to form a reasonably accurate oval.

When drawing ovals, you are welcome to first draw perpendicular axis lines in advance in order to assess the symmetry of your oval and to establish the direction of the axis. Some students find this method helpful, others do not. Experiment to see what works best for you.

These perpendicular axis lines will also allow you to check your ovals for symmetry and make sure that all four parts of the oval mirror the other parts that share a line of symmetry.

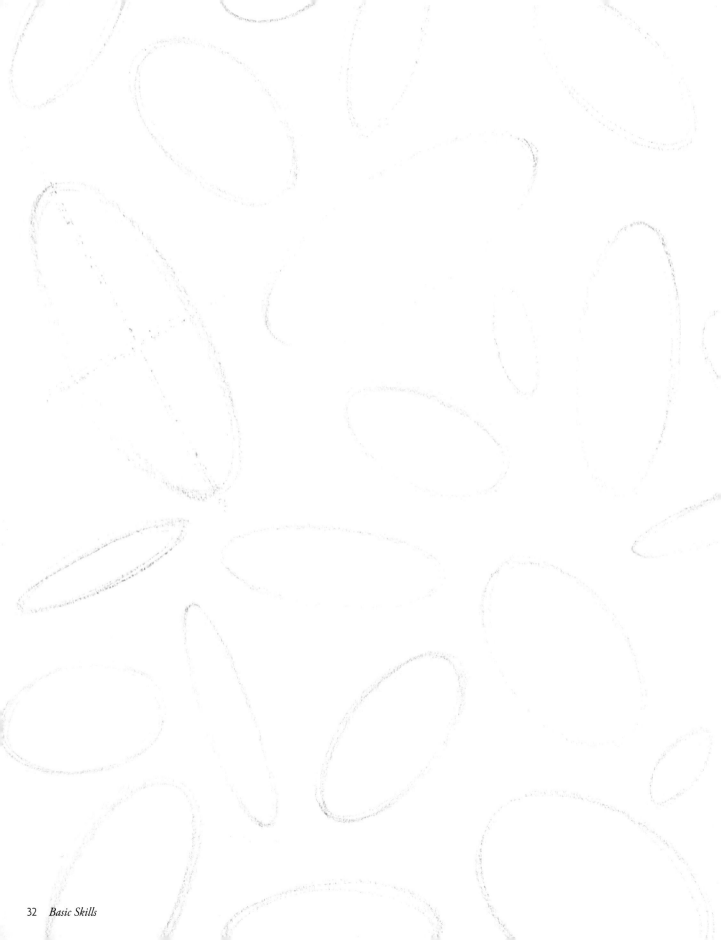

# Draw 100 Ovals

Draw 100 ovals at varying sizes, axes and levels of openness. You can draw perpendicular axis lines to help you assess the shape of the oval, making sure that your oval is symmetric along its long and short axes. As with circles, I recommend practicing ovals often. You will need to draw hundreds of ovals before you can consistently draw them properly.

# Drawing Other Curved Shapes

Circles and ovals are the most fundamental curved shapes, but there are many other kinds of curved shapes you will use regularly when drawing. Let's take a look at some.

## Ovoids

An ovoid is an ovular shape with one end more pointed than the other, like an egg. If we draw a line through the long axis of an egg, going through both the more rounded end and the more pointed end, you can see that this long axis acts as a line of symmetry, as one side mirrors the other. But unlike an oval, the perpendicular axis line of an ovoid does *not* act as a line of symmetry because the top and bottom are different.

To draw an ovoid I usually draw a light circle for the more rounded end but instead of darkening the entire circle, I apply pressure only to the half of the circle that will provide the contour for the ovoid. Darkening only part of a circle or oval is an essential skill that will help you draw many volumes later on.

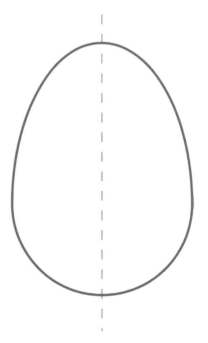

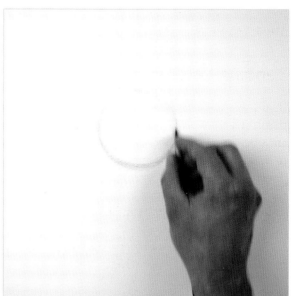

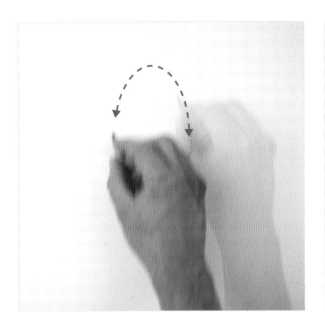

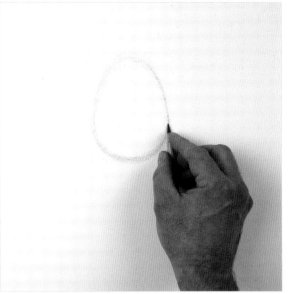

Once I have drawn the rounded bottom of the ovoid I then rock my pencil up and over the top of the ovoid, pantomiming back and forth, until I can visualize the line my pencil would make. When I am ready, I lower the pencil, without breaking this rocking motion, and draw the more pointed top of the ovoid.

Just as with circles and ovals, ovoids are hand drawn shapes and will not be perfect. That's totally normal, particularly when you are just learning. The goal is to practice making these shapes with fluid strokes coming primarily from the shoulder.

## Bending Ovals and Ovoids

Bent ovals and ovoids are incredibly common shapes, particularly when drawing people and animals. There are no concrete right or wrong ways to draw these curving shapes, but I recommend drawing with long, fluid strokes that originate from the shoulder. These shapes can be stout and squat or long and slender. They can bend a lot or just a little. The more you practice these kinds of shapes, the more likely you are to recognize them in your subjects later on in the drawing process.

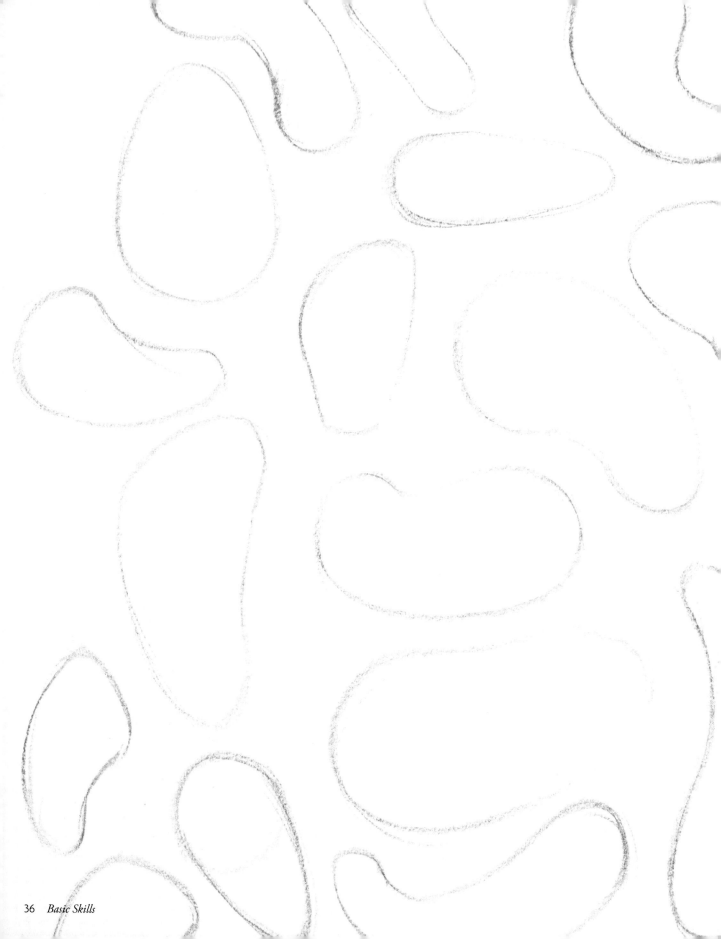

# Draw 100 Curved Shapes

Draw 100 curved shapes. This should include ovoids as well as bending ovals and bending ovoids. Experiment to see how many variations you can draw. Your goal is to draw these shapes using fluid strokes originating from your shoulder. Remember, these hand drawn shapes will not be perfect. That's to be expected. With time and practice your shapes will improve.

# How to Draw Straight Lines

In order to draw straight-edged shapes like triangles, squares, and rectangles, we first need to learn to draw straight lines.

We'll practice by drawing a horizontal line 4- to 5-inches in length. Begin by pantomiming this line just above the surface of the paper, moving your hand back and forth over the path you wish the line to take. Do this somewhat quickly. Just like drawing circles and ovals, speed is an important part of drawing straight lines. The slower you go, the more likely it is that the line will be shaky. As you move your hand back and forth you should be able to visualize the line your pencil would make. While pantomiming, you can make adjustments to your movements until it appears that your pencil is moving back and forth over the same straight path.

When you're ready, lower the tip of the pencil down onto the paper without stopping this back-and-forth motion. I draw my fist pass very lightly, just so I could see if I drew the line I intended. On subsequent passes I make any adjustments necessary.

Remember, these are hand drawn lines and will not be perfect. That's normal. If you need a perfectly straight, crisp line you can use a straightedge.

Straight lines can be horizontal, vertical, or oblique. They can be long or short.

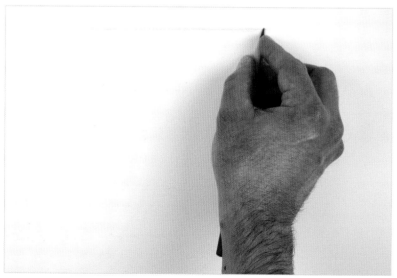

# Draw 100 Straight Line

Using the technique described, draw 100 straight lines. You should practice short lines (approximately 1 to 2 inches), long lines (6 to 8 inches), and lines that are anywhere in between. Your lines can be horizontal, vertical, or oblique. Your lines will not be perfect. That's to be expected. Just as with circles and ovals, you should practice straight lines regularly.

# Straight-Edged Shapes

Now that you've had some practice drawing straight lines, let's use them to draw straight-edged shapes. We'll start with a square.

A square is a four-sided shape with all sides being of equal length and all corners at right angles.

If we lengthen a square in one direction, it becomes a rectangle. A rectangle retains its right-angle corners, but it no longer has four equal sides.

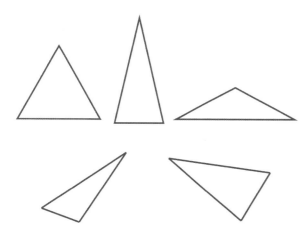

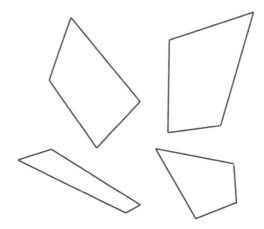

A triangle is a three-sided shape. Triangles can be short and wide, tall and slender, or anywhere in between. The sides of triangles can differ in length and come together at any angle.

A quadrilateral is any four-sided shape, but unlike squares and rectangles, quadrilaterals can have sides of any length and corners meeting at any angle.

Straight-edged shapes need at least three sides to enclose the shape but there is no limit to the number of sides a straight-edged shape can have. This is not a geometry lesson so you won't need to memorize and identify specific types of shapes, but it's important to have a common language we can use to talk about them.

# How to Draw Straight-Edged Shapes

We'll first learn to draw squares. Let's start by drawing one light, horizontal line and one light vertical line that intersect at a right angle. Notice that each line I've drawn extends beyond the corner. It's much easier to draw straight edged shapes using line segments longer than what we need. The corners of the shape are created when these lines naturally intersect. This way we don't need to worry about stopping the lines exactly at the corners. If desired, we can erase any excess lines after we complete the shape.

Now let's draw the top edge of the square, once again letting the lines extend beyond the left edge and naturally creating a corner at the intersection. This determines the height of our square.

Now we need one more line for the right edge. Our goal is to create a shape with sides of equal length. By pantomiming this final side before you draw it, you should be able to get a sense of where it should be placed. And by drawing lightly, you can easily erase the line if it is too close or too far from the left side of the square.

At this point we have drawn a square with light lines that extend beyond the corners. Before we darken any lines, let's take a look at the square and ask if there are any changes that need to be made. Perhaps one side is oblique and not horizontal or vertical. Or perhaps your shape is more rectangular than square. It is critical that we make the necessary changes to our square now, before darkening lines. Once any necessary changes have been made, we can darken the lines to complete our square.

Of course, you can use straight lines to draw any straight-edged shape including triangles and quadrilaterals. The exact order in which you draw the sides is unimportant. The important thing is to begin with light lines that are drawn longer than the intended edges of the shape so they can naturally intersect to create corners. It's much easier to darken the lines into the corners when you know where the corners are.

# Draw 100 Straight-Edged Shapes

Draw 25 squares at various sizes and orientations.

Draw 25 rectangles at various sizes, proportions, and orientations.

Draw 25 triangles of various sizes and types.

Draw 25 quadrilaterals that are not squares or rectangles

Now that you can draw these basic shapes, you are ready to learn to combine them to create recognizable objects.

# The Five Essential Drawing Questions

To draw something, we must translate our subject into the language of drawing—that is, into lines and shapes. For example, what shape most closely represents the body of this bird? If you strip away all of the details, textures, and subtleties of the bird's body, you're left with an ovoid. The top of this ovoid appears to be tilting toward the right. This basic ovoid doesn't capture the nuances of the bird's body, but it doesn't need to at this phase of the drawing process. What shape most closely represents the bird's tail? Most people would say a rectangle, or a quadrilateral. The beak is a triangle, and so on.

This is not just a rhetorical game. If you look at this subject and see *bird* you are seeing it as a symbol, rich with denotation and connotation. The bird may even evoke memories and emotions. But in order to begin

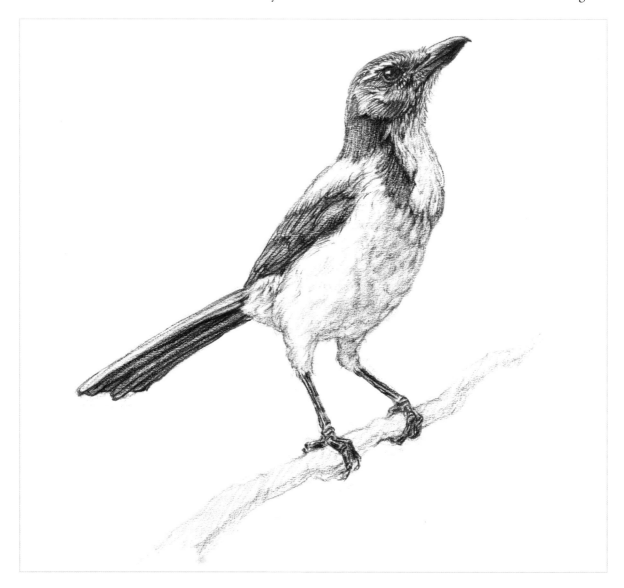

drawing this subject, we cannot see a *bird*. We must train our brain to first see our subject as a collection of lines and shapes. Only when we do this can we draw.

This can seem counterintuitive for many beginners who want to draw things because of the meaning and the emotions they invoke. But this process of seeing past a subject's meaning and seeing it only as a collection of lines and shapes is temporary. Later on in the drawing process we will draw more expressively.

All forms, no matter how complex, can be simplified into a collection of basic lines and shapes. I'm going to teach you five questions you can ask yourself while drawing that will help you translate any subject into basic lines and shapes.

## The Questions

Imagine you are set up to draw. Your subject is a scrub jay. You have a fresh sheet of paper in front of you. Where do you begin? Most students begin with any detail that catches their eye and move outward from there. This approach rarely yields good drawings. Instead, I recommend asking yourself a series of questions before you draw a single line.

There are the five essential questions you should ask throughout the drawing process. The first four should be asked before your pencil ever touches the paper:

**What is the biggest shape?**

**What is its axis?**

**How big should it be?**

**Where should it go on the paper?**

Once you know what the biggest shape in your subject is, its axis, how big it should be, and where on the paper it should go, you can make your first attempt at drawing the shape. After you have made your first attempt you should then ask the fifth question:

**What changes do I need to make?**

From here you can repeat this series of questions, changing the first question to: "What is the *next* biggest shape?"

You can repeat this process until you have captured the foundational shapes of your subject, working from the biggest to the smallest shapes.

Let's dive deeper into these questions and apply them to an actual subject: this drawing of a scrub jay.

## Question 1: *What Is the Biggest Shape?*

Generally speaking, we want to start a drawing by accurately capturing the biggest shapes first and then work our way down to the smallest shapes. This is not a strict system, just a broad guiding principle that helps us avoid getting mired in detail too early in the drawing process. So, when you look at this bird, what is the biggest shape you can find? The shape for the head? The body? The tail? Most people would say the body. As discussed earlier, the bird's body is an ovoid. But before we draw, we must proceed to the next question.

## Question 2: *What Is Its Axis?*

Every shape has an axis, or orientation in space. An axis can be horizontal, vertical, or oblique. What is the axis of the body of the bird? As you can see, it is not horizontal or vertical, but oblique. The top of the ovoid appears to be tilting toward the right at approximately 45 degrees. Now we know what shape we will start with as well as its axis, but before we draw, we proceed to the third question.

## Question 3: *How Big Should It Be?*

Because this is the first shape we will draw, its size will determine how big the drawing is on the paper. To help us make this decision we need to look at it in relationship to the other shapes we will draw. If we draw the ovoid for the body too big, we may not leave room for the head, tail, and feet. If we draw it too small, the final drawing may be dwarfed by the size of the paper. We need to visualize how big we want our subject on the paper and how big the ovoid for the body should be to achieve this size. Once we have a sense of this, we can proceed to the fourth question.

## Question 4: *Where Should It Go on the Paper?*

This question will help us think about composition. Do we want our subject in the center of the paper or off to one side? Do we want it closer to the top of the paper or the bottom? At this stage, while you're learning to draw objects, you don't need to worry about composition too much, but it's good to get in the habit of at least considering it. For this drawing, I will simply place the bird in the center of the paper. Because the tail extends out toward the left, I need more room on the left side of the ovoid than the right. This means that the ovoid needs to be drawn slightly to the right of center.

Now we know that the largest shape is the ovoid for the body of the bird. The top of this ovoid is slanted toward the right at approximately 45 degrees. We know that we need to leave ample room above, below, and to the sides of this ovoid for the head, tail, and feet. Finally, we know that the ovoid for the body needs to be drawn sightly to the right of center. We know all of this because we asked this series of questions before we attempted to draw anything. With all of this mind, I can now make my first attempt at the oval for the bird's body using very light, soft lines.

Despite our best efforts, the first attempt will rarely, if ever, be accurate. This is perfectly normal and should be expected. Now that our first attempt at the ovoid is on the paper, we can proceed to the fifth question.

## Question 5: *What Changes Do I Need to Make?*

Notice that this question does not ask *if* changes could be made; the question assumes there are indeed changes that *need* to be made. The presupposition helps reinforce the fact that changes are a normal part of the drawing process. Perhaps the ovoid was drawn too big and needs to be smaller. Perhaps the ovoid

was too slender or not tilted enough. These are common issues. We want to address these kinds of issues now, before we begin adding other shapes in relationship to this ovoid. Because we drew this first attempt using light, soft lines they will be easy to erase if necessary.

We can continue to refine this shape even as we add new shapes, but we want to get in the habit of checking shapes for accuracy as we draw them.

With any necessary changes made, we can now go back to the first of the five questions but change it to:

**What is the *next* biggest shape? From here we go through the list of questions again.**

The next biggest shape is the quadrilateral for the tail. What is its axis? While still oblique, it is closer to horizontal than the bird's body, which is more upright. We don't need to be too specific yet, we just need a general idea to get us started. It will be much easier to make adjustments once we make our first attempt and can actually see the two shapes in relationship to one another.

How big does the quadrilateral for the tail need to be? We decided the size of the ovoid for the body in relationship to the paper. But for the size of the quadrilateral for the tail we will compare it to the ovoid we have already drawn. Once again, we just need a general idea to start. For example, the quadrilateral for the tail is shorter than the long axis of the ovoid, and longer than the short axis of the ovoid.

Where should it go on the paper? The right side of the shape of the tail should connect to the bottom left of the ovoid for the body. With all of this in mind, we're ready to make our first attempt.

After the attempt is made, we can ask what changes need to be made. Maybe the shape for the tail is too thick or too short. Now that you have two shapes on the paper, you can make any necessary changes to either of them. We want to make any necessary changes now, before any details or shading are added.

These five questions can be repeated until the smaller shapes and forms of the subject have been drawn. The head is ovoidal. The beak is triangular. The eye is a circle. The legs are long rectangles. Each segment of the bird's feet are small rectangular shapes. The claws are curving triangles. In the drawing on the next page you can see this light collection of shapes that I drew by applying the five questions, working my way from the big shapes to the small shapes.

When you're just starting out, these five questions provide a framework for the drawing process so you will always know what to do next. When followed, this process will yield an accurate foundation upon which you can later add shading and detail.

If necessary, these basic shapes can be connected with lines. For example, the ovoid for the head has been connected to the ovoid for the body with two lines that denote the sides of the neck.

Lines can also be used in other ways. To draw the feet I first began by simplifying each toe into a line, capturing its curvature and length. I then drew each rectangular segment of the toes on top of this line.

There is, of course, much more to drawing than just these five questions. I don't want to give the false impression that drawing can be reduced to a rigid system. As an experienced drawer I often deviate from these five questions. But when you are just starting out, these five questions will give you an accessible framework for drawing. With these five questions you will always know how to begin a drawing and what to do at each step of the way. As you gain confidence and experience you can draw more freely, adding in any new tools and techniques you learn.

But even as you outgrow these five questions you should still hold fast to the following principles:

## Big to small

Start with the biggest shapes and forms of your subject and work your way down to the smallest.

## Light to dark

Start with incredibly light lines so you can easily make changes to your drawing and erase any lines you don't want in the drawing. You should only draw dark lines once you have worked out the basic forms and proportions of your subject.

## Simple to complex

Draw your subject simply, working out the basic forms and proportions before adding any complexity or detail.

# A Note on Mindset

How you talk to yourself in the privacy of your mind determines what ends up on the paper. This is why I teach students to ask themselves objective questions about their subject regarding shape, size, placement, proportion, axis, and so on. These kinds of questions help students focus, avoid distraction, and observe the characteristics of their subject without defaulting to incorrect assumptions.

But after talking with hundreds of students, many of them have revealed a much darker conversation they have with themselves as they draw.

Students report that they privately insult, berate, and degrade themselves as they draw. This issue is so pervasive that I address it on the first day of every beginning drawing class I teach. Do any of the following phrases seem familiar?

- *I'll never be able to do this.*
- *I'm the worst in the class.*
- *That was such a stupid mistake.*
- *I'm so stupid.*
- *Why did I ever think I could do this?*
- *I'm getting worse when everyone else is getting better.*
- *I should just quit.*
- *My drawing is so ugly.*
- *I'd be so embarrassed if anyone saw this drawing.*
- *What a waste of time.*
- *This is easy for everyone but me.*
- *Everyone else is better than I am.*

If someone spoke any of these phrases to a child, we would immediately recognize them as verbally abusive. But many students habitually and unquestioningly engage in this type of negative self-talk. Right now, I am asking you to make a commitment to refrain from saying anything to yourself that you wouldn't say to a friend, a family member, or a child learning to draw.

There is no space in drawing, or in life, to abuse yourself for not immediately mastering a difficult new skill. Drawing is hard. It takes a lot of practice. I've been drawing for over thirty years and I still make countless mistakes in nearly every drawing I do. The difference is that I view these mistakes as normal and expected parts of the drawing process. I go so far as to view mistakes as valuable because they often reveal what needs to be done to move a drawing forward. I get excited when I make a mistake because I know my drawing is about to get better.

You will tend to answer any question you ask yourself. If you ask, "Why can't I do this?" you will generate numerous reasons for your lack of skill and convince yourself that you will never improve. But if you ask, "What changes do I need to make?" your mind will generate a to-do list you can immediately set to work on.

By all means, make objective recommendations on how to improve, be honest with yourself about your mistakes and how they can be corrected. But be kind to yourself while doing it.

# Simplify Birds into Basic Shapes

In the following pages you will find numerous drawings of birds. Draw these birds using the five questions you just learned. Start with the simpler birds and work your way up to the more complex birds. Each drawing is accompanied by the basic shapes I used to simplify each subject, but remember, there is no single, *correct* way to do this. You are encouraged to simplify the birds into the shapes that make the most sense to you.

At this stage of your drawing education your goal is not to produce completed drawings with detail and shading, but simply to capture the basic shapes and forms of your subject using light, soft lines. This is one of the most essential but overlooked skills in the drawing process. You'll learn much more about shading, detail, and texture later in this book.

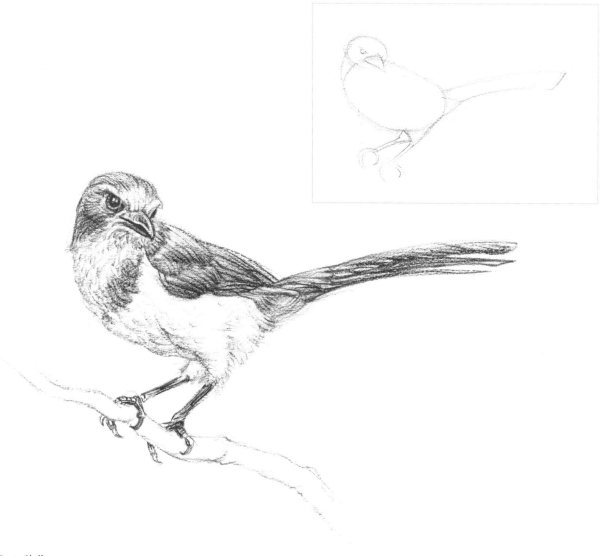

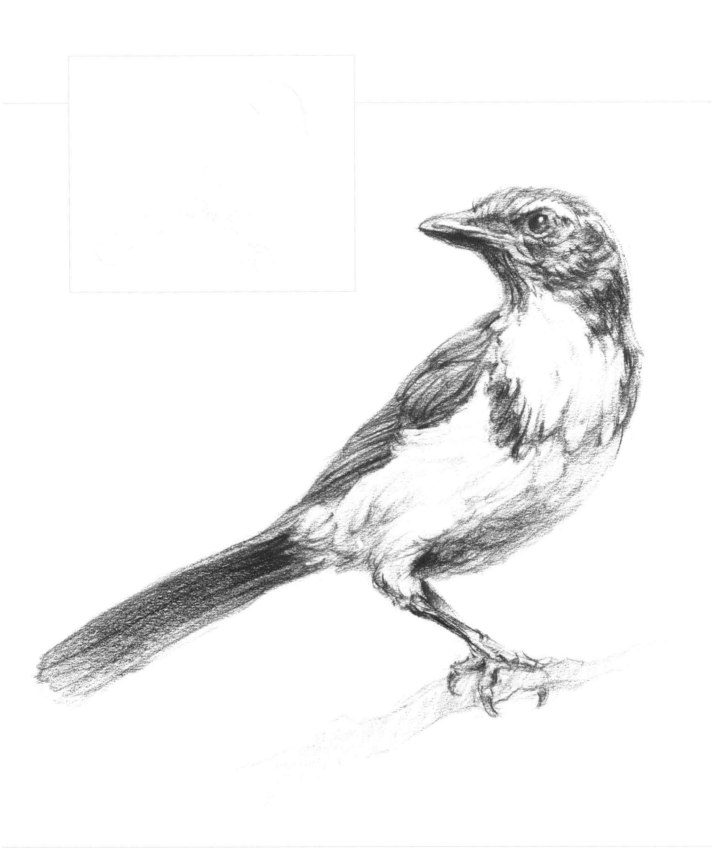

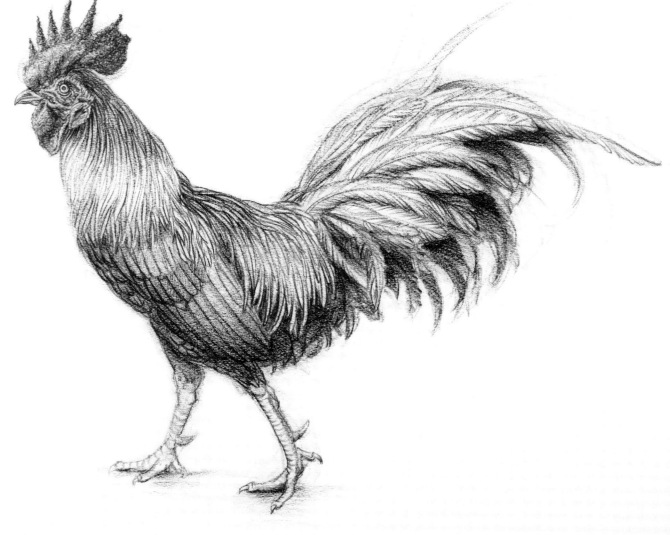

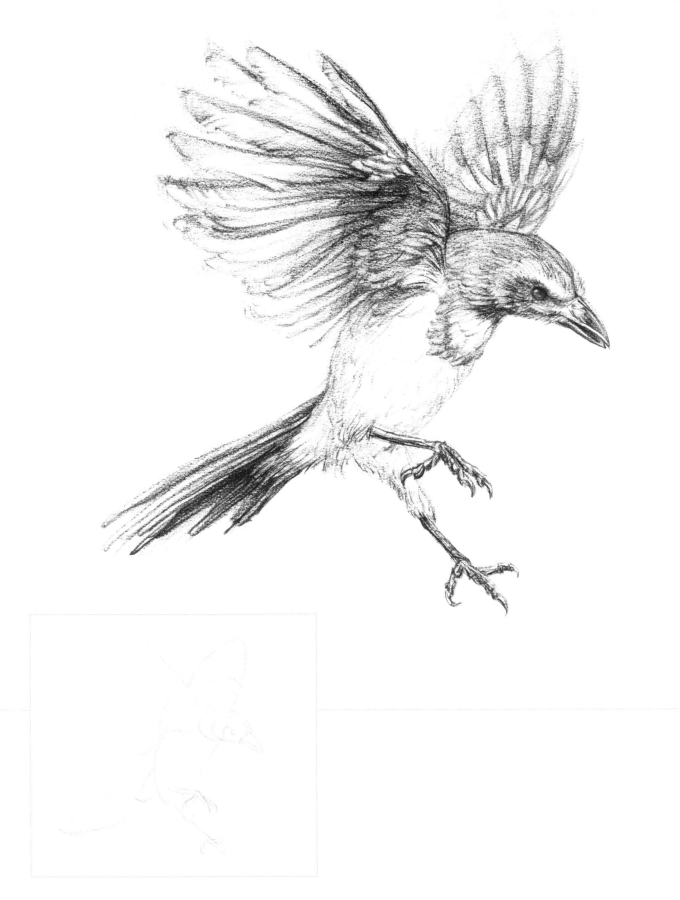

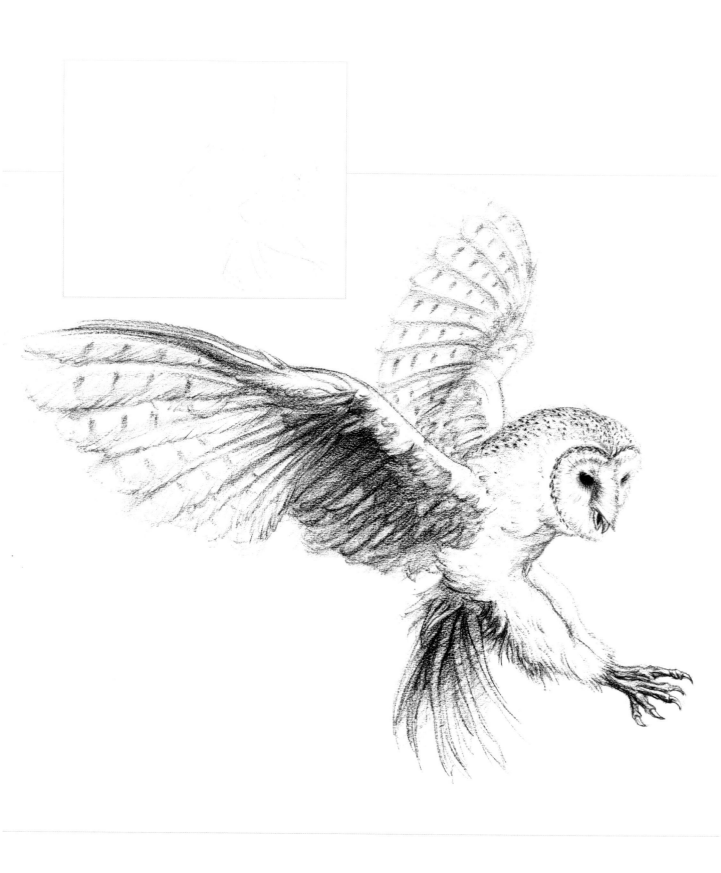

CHAPTER 2

# FORM AND SPACE

It's hard to imagine something flatter than a piece of paper. And yet, our goal is to create the illusion of three-dimensional objects on this flat surface. To do this we need to employ a series of illusions to trick the eye into seeing our drawings as three-dimensional.

# Primary Volumes

In the previous chapter you learned that all forms, no matter how complex, can be simplified into basic shapes. While this is true, it is only the beginning of the story. To create the illusion of three dimensions we will use the basic shapes from "Chapter 1: Basic Skills" to construct three-dimensional volumes. Making the shift from thinking in terms of flat shapes to thinking in terms of volumes is one of the most important shifts you need to make.

Most people are familiar with the concept of primary colors—that every color imaginable is derived from red, yellow, and blue. For example, green is made by mixing blue and yellow, violet is made by mixing blue and red, brown and black are made by mixing all three primary colors together in different ratios, and so on.

Three-dimensional form works in a similar way. All form is derived from three primary volumes: the sphere, the cylinder, and the cube. By understanding how to draw these basic volumes we can learn to combine and modify them to draw any three-dimensional form, no matter how complex. With this skill, you'll be able to draw any subject, observable or imaginable, in three dimensions.

We'll begin to learn about three-dimensional drawing by exploring the sphere.

# The Sphere

In chapter 1 you learned how to draw straight lines, circles, and ovals. None of these elements communicate volume on their own, but I'm going to show you how to combine them to create the illusion of a three-dimensional sphere.

Let's begin with a circle. A circle does not communicate any volume on its own. It simply lays flat on the page. This is because a circle only gives our eye one path to follow that depicts the outside contour.

A simple circle

When we draw a latitude line curving over the surface of the sphere from one side to another and a longitude line curving up and over the surface of the sphere top to bottom, suddenly this flat circle appears to have volume. These curved lines give the illusion of roundness in three dimensions. Our eye is given paths to follow that appear to curve over the surface of the sphere thereby creating the illusion of volume. This sphere now appears to turn toward our left and point slightly upward. When drawing volumetric objects like this it is important to emphasize the lines that communicate volume and de-emphasize lines that communicate flatness. We can achieve this on the sphere by making the lines curving over the surface darker than the outer contour. I'll talk much more about this concept later in this book.

The following diagram illustrates how we can create the illusion of volume while making the sphere appear to turn in different directions by opening and closing the ovals used for the latitude and longitude lines. In this diagram, the longitude lines of the spheres in the vertical row are straight while the latitude lines are curved. The latitude lines of the spheres in the horizontal row are straight while the longitude lines are curved.

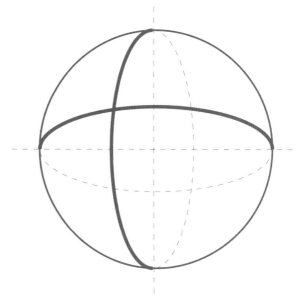

A volumetric sphere

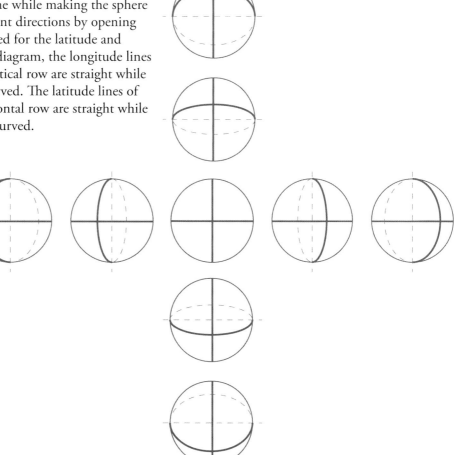

In this diagram both the longitude and latitude
lines are curving over the surface of the spheres.

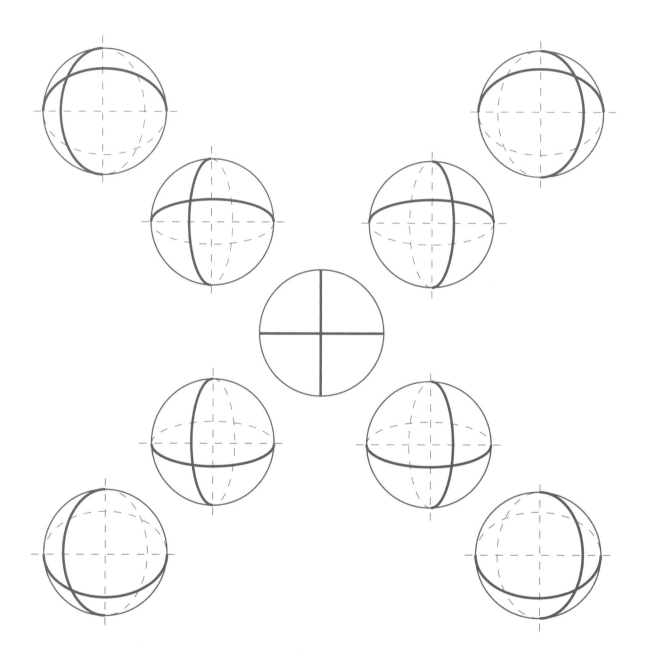

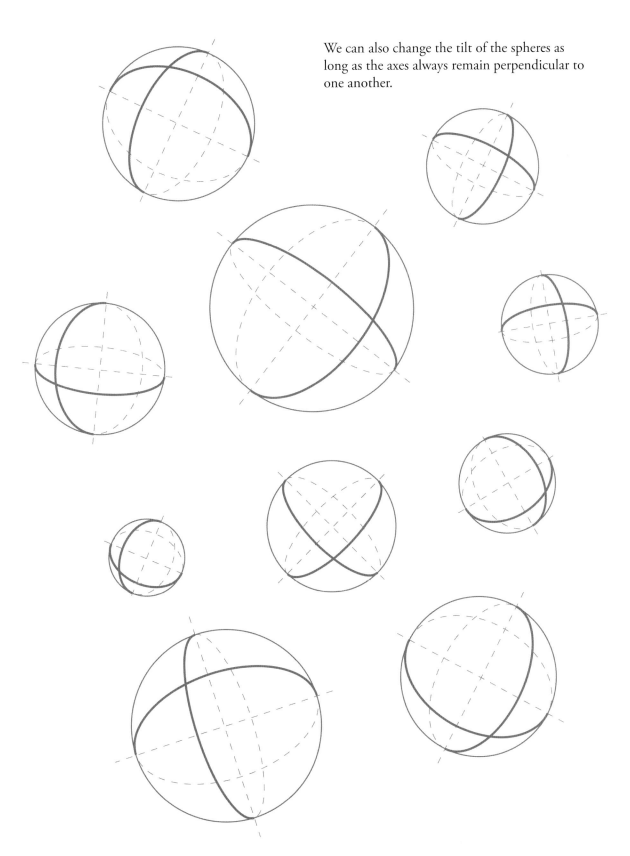

We can also change the tilt of the spheres as long as the axes always remain perpendicular to one another.

# How to Draw a Volumetric Sphere

In this demonstration I will draw a sphere transparently. Transparent drawings help us understand objects in the round and will also help us to accurately draw them. You'll see me draw using light construction lines. A construction line is an imaginary line used to help draw the shapes that make up a volume. A good example of a construction line is the axis line of an oval. It helps us determine the direction of an oval and also helps us determine that the oval is symmetric. Construction lines should be drawn lightly as they are merely aids to help us draw but are not intended to be seen by viewers in a finished a drawing.

To draw a sphere, first draw a light circle using the technique you learned in chapter 1.

Next draw a light, horizontal line bisecting the circle into two equal halves. This line will be used as an axis line for the ellipse we will draw in a moment.

Next draw a light vertical line bisecting the circle. The circle should now be divided into four equal parts with the vertical and horizontal lines at a right angle (perpendicular) to one another.

Using the oval drawing technique from chapter 1, draw a light oval using the vertical line as its central axis.

Using the oval drawing technique from chapter 1, draw a light oval using the horizontal line as its central axis.

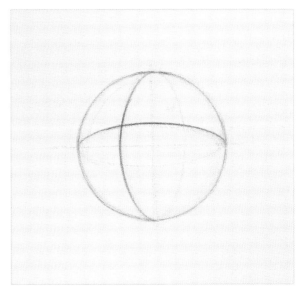

Darken the lines intended to be seen by a viewer including the contour of the circle and one side of each oval. Notice that the lines for ellipses are slightly darker than the contour of the circle.

You are welcome to erase the faint construction lines if you desire, but it is not required.

PROJECT

# Draw 50 Volumetric Spheres

Draw 50 volumetric spheres at various sizes and orientations in space. In addition to changing the sizes of the spheres you can change their tilt in space by tilting the axis lines. But remember, no matter how the axis lines tilt, they must always remain perpendicular to one another.

You can also open or close the ellipses to make the sphere appear to be tilted more or less. Use the spheres drawn here for inspiration.

Remember, these spheres will be hand drawn and will not be perfect. The success of your spheres will be based in your ability to draw circles, ovals, and straight lines. If you are struggling with sphere drawing, go back and practice the basic shapes taught in chapter 1.

You are welcome to observe and draw the spheres in the diagrams provided in this section.

# The Cylinder

The next fundamental volume you will learn about is the cylinder. A cylinder has a rounded shaft with flat, circular planes at the top and bottom. If we view a cylinder directly from above or below, we only see its circular edge.

When we view a cylinder directly from the side, we do not see the circular planes at the top or bottom. From a side view the cylinder appears to be mostly rectangular. We only see subtle indications of its roundness as the top and bottom bow slightly outward as they round toward us.

It is only when we see both the top and the side of the cylinder simultaneously that we can see its volumetric qualities.

Before we learn how to draw a cylinder, let's explore this volume through some diagrams.

Each cylinder you draw will have three axis lines. One traveling vertically down the center of the shaft of the cylinder and two horizontal lines: one for each of the ellipses. Here, these axis lines are dashed. In the diagram on the right we are slightly above the cylinder looking down upon it so we can see the circular top, shown here as an oval. When a circle goes into perspective and appears ovular, we call the oval an ellipse. There is also an ellipse at the bottom of the cylinder, but we only see the bottom half of this ellipse. The remainder of the bottom ellipse is shown as a dashed line.

The ellipse at the bottom of this cylinder is farther away from us than the ellipse at the top. This results in two important differences between the two ellipses. Because the ellipse at the bottom of the cylinder is farther away from us than the ellipse at the top, the bottom ellipse appears smaller. And because it is farther below us, the bottom ellipse also appears more open than the ellipse at the top.

You can see this phenomenon more clearly in this diagram. Notice that these stacked cylinders get smaller the farther down they go. The sides of these cylinders taper inward as they travel down but each ellipse becomes more open than the one above it. This can be seen most clearly by comparing the ellipse at the top of the stack of cylinders to the ellipse at the very bottom. The ellipse at the top of the cylinder is a larger overall because it is closer to us. The ellipse at the bottom is smaller but more open than the ellipse at the top.

The diagram below shows how cylinders change as they tilt toward or away from us. In the column on the left we see the first cylinder directly from the top, so it appears as a simple circle. But as the cylinder rotates downward, we see more and more of the shaft and the ellipses become more and more closed until we see only the straight edges of the sides of the last cylinder.

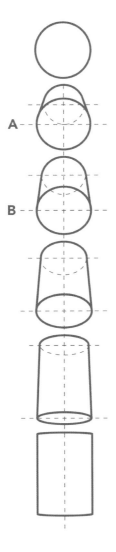

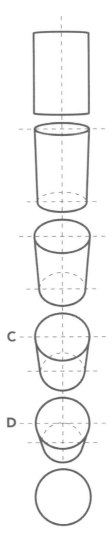

In the column on the right, we begin by seeing the cylinder directly from the side so the circular planes at the top and bottom are not visible. As the top of the cylinder tilts toward us we see the ellipses open up more and more and we see less and less of the straight sides of the cylinder until we see only the circular top of the last cylinder in the row.

Note that in some views we see mostly the circular top of the cylinder and little of the shaft (as shown in figures A, B, C, and D). When this happens, the ellipses at the top and bottom may overlap one another.

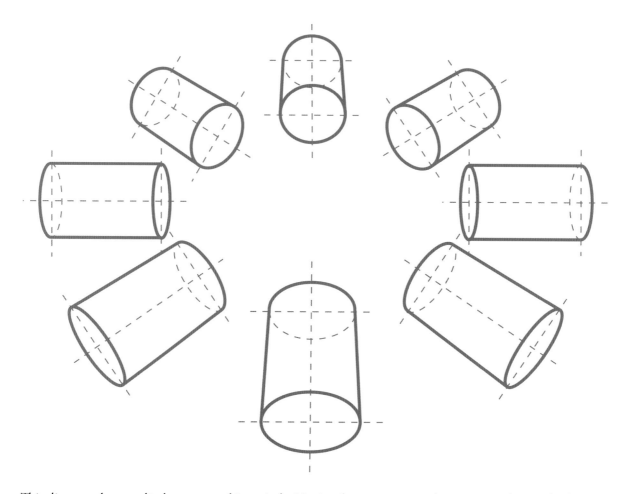

This diagram shows cylinders arranged in a circle. Notice that, no matter what position these cylinders are in, they maintain the same basic elements. Each has three axis lines. The axis line for the shaft of each cylinder runs down the center, and the axis lines for the ellipses at the top and bottom of each cylinder are parallel to one another and perpendicular to the axis line for the shaft of the cylinder.

Study these diagrams so you understand how cylinders operate in space. For an added challenge try copying these diagrams by hand.

# How to Draw a Cylinder

Begin by lightly drawing a vertical axis line for the shaft of the cylinder.

Lightly draw a horizontal axis line for the top ellipse. This line should intersect the vertical axis line for the shaft of the cylinder just below the top.

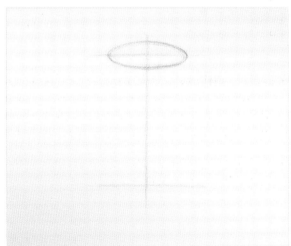

Lightly draw a horizontal axis line for the bottom ellipse. This line should intersect the vertical axis line for the shaft of the cylinder just above the bottom.

Using the horizontal axis line at the top, lightly draw an ellipse. Remember, the axis line should divide the ellipse into two equal halves.

Using the horizontal axis line at the bottom, lightly draw an ellipse. The axis line should divide the ellipse into two equal halves. Remember, this ellipse should not be as wide as the ellipse at the top of the cylinder but should be more open.

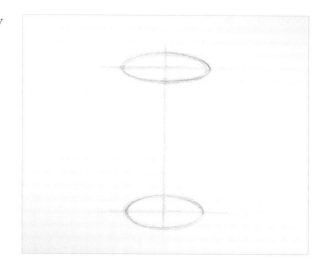

Lightly draw the two sides of the cylinder. These lines should connect with the sides of the ellipses and taper inward as they travel down.

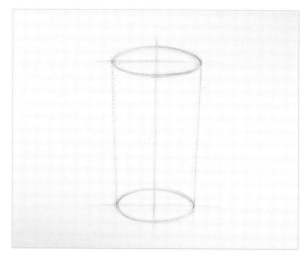

Darken the full ellipse at the top of the cylinder. Next, darken the sides of the cylinder and the bottom half of the ellipse at the bottom of the cylinder.

This process can be used to draw any cylinder regardless of its orientation in space.

Once you understand how to draw a cylinder you can use this strategy to practice drawing cylinders of any dimensions and in any orientation in space.

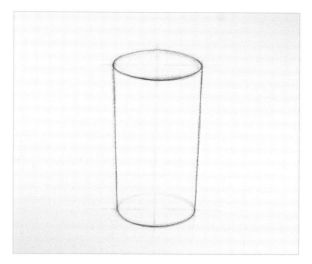

# Draw 50 Cylinders

Draw 50 cylinders at various sizes, in various dimensions, and in various orientations in space. If you need a visual guide on how cylinders operate in space, feel free to review the cylinder diagrams in this section.

Remember, you should not expect perfection from hand drawn volumes. Even basic volumes like the cylinder take much more time and practice than most students realize, but with patience and practice you will become more competent and comfortable with cylinder drawing.

# The Cube

The final fundamental volume you will learn to draw is the cube. A cube is a volume with six flat, square planes. These square planes meet at right angles. Before we explore the cube, we need to understand a few basic concepts about linear perspective. Linear perspective is a system used to represent objects on a flat surface, so they appear to be volumetric objects existing in space.

First, we need to understand the horizon line. Imagine looking straight out in front of you, not up or down, but directly outward. You are likely indoors right now, but if you were outside on a beach or in a vast, flat field you would find that the horizon line appears directly in front of your eyes. It appears exactly at the level of your eye when you look straight out in front of you. For this reason, it is also referred to as *eye level*. We can see the horizon line represented here as a horizontal line.

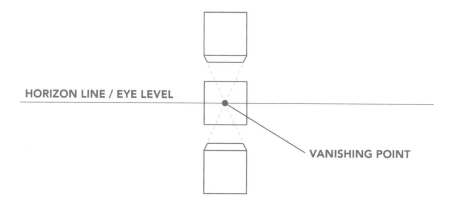

We are not usually in a location where the horizon can be observed, but nevertheless, the horizon line still exists and will determine the position and appearance of objects in space. The horizon line is always at our eye level even if we can't see it. Although you can move the horizon line up or down in a drawing, for the sake of simplicity, we'll begin with the horizon line in the middle of the picture plane.

Objects can be above the horizon line, below the horizon line, or on the horizon line, also referred to as being at eye level. Their location in relationship to the horizon line determines how they will appear.

For example, the diagram above depicts three cubes. The middle cube is on the horizon line, or at eye level. One cube is above eye level, and one cube is below eye level. We see only the front plane of the cube that is located at eye level. Therefore, it only needs to be drawn as a simple square.

Now look at the cube below eye level. It appears to be resting on the ground. We can see the front plane as well as the top plane of this cube. While the front plane appears as a square, the top plane is in perspective, meaning that it appears to get smaller as it travels away from us. Notice that the sides of the top plane angle toward one another as they travel back in space. These lines eventually converge on the horizon line at what is called the *vanishing point*. A cube like this can be drawn with a single vanishing point.

Now take a look at the cube above eye level. This cube appears to be hovering above us. We see the bottom plane of this cube, but not the top. Once again, this view can be drawn using a single vanishing point.

Now let's see what happens when we turn the cube.

# The Cube in Two-Point Perspective

In this diagram, take a look at the cube at eye level. We can now see two side planes of this cube. The center, vertical edge of the cube is closest to us and the two sides recede in space, each toward their own vanishing point. Rather than one vanishing point at the center of the horizon line, here we see two vanishing points, one at either end of the horizon line. Whenever we can see two side planes of a cube, we must use two vanishing points. This is known as two-point perspective.

Now take a look at the cube below eye level. In addition to the two sides of the cube we can also see the top plane. Notice that each edge of the top plane of the cube leads back to one of the two vanishing points.

In the cube above eye level, we see the bottom plane of the cube, but not the top plane. Here, each edge of the bottom plane leads back to one of the two vanishing points.

No matter how a cube is turned we will never see more than three of its six planes.

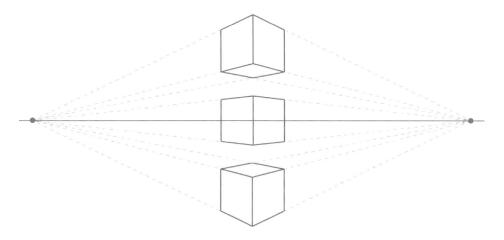

Now let's move the cubes out of the center of the image. Even though the cubes are turned more, each edge still leads back to one of the vanishing points. Notice that one side plane of each cube is turned more toward us and appears larger than the other side plane.

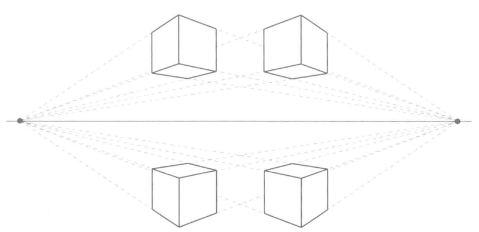

## Which Lines Lead Back to Which Vanishing Points?

When we see two planes of a cube at eye level, we simply extend our perspective lines from the top and bottom of the vertical edge (shown here in blue) toward the two vanishing points. Here you can see the two magenta edges going back to the vanishing point on the right and the two orange edges going back to the vanishing point on the left.

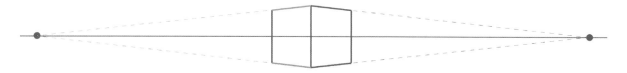

When we see three planes of a cube that is above or below eye level, we must draw three lines back to each vanishing point. Take a look at the three vertical lines of this cube, shown here in blue. In two-point perspective these lines will remain vertical (although this will change when you learn about three-point perspective). Now take a look at the set of three magenta lines. These three lines lead back the vanishing point on the right. Finally, the set of three orange lines leads back to the vanishing point on the left. Understanding which lines lead to which vanishing points is critical when drawing cubes and boxes in perspective.

The dimensions of the cube can be altered as long as the sets of lines lead back to their proper, respective vanishing points.

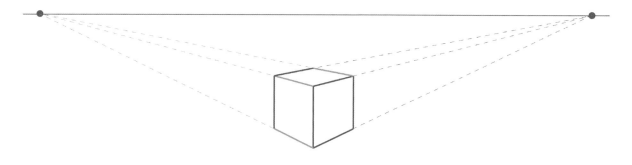

# Draw a Cube in Two-Point Perspective

For this exercise you are welcome to use a ruler. As you get more comfortable drawing in perspective you should also practice freehand.

Begin by drawing a light horizontal line. This line will represent eye level. Now draw two vanishing points, one at either end of the horizon line.

Draw a vertical line below eye level. This line will represent the front edge of the cube. It should be centered between the two vanishing points.

Draw perspective lines going from the top of the vertical edge of the cube to the two vanishing points. These are just construction lines and should be drawn lightly.

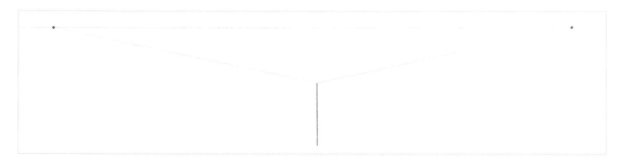

Draw perspective lines going from the bottom of the vertical edge of the cube to the two vanishing points. These are just construction lines and should be drawn lightly.

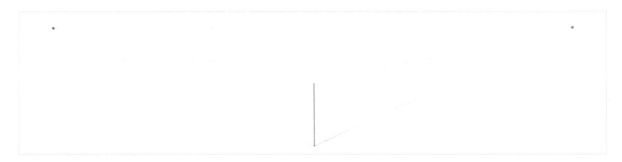

Draw two vertical lines representing the vertical edges at the sides of the cube.

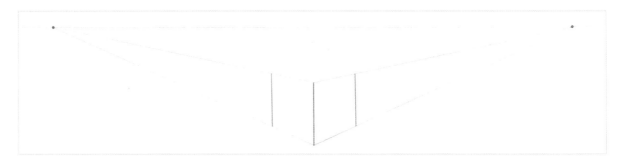

Draw a perspective line from the top of the right vertical edge of the cube to the vanishing point on the left. Next, draw a perspective line from the top of the left vertical edge of the cube to the vanishing point on the right.

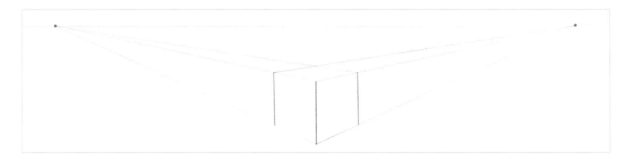

Darken the lines of the cube and lighten the perspective lines with an eraser.

This process can be used to construct cubes and boxes of any dimensions. Depending on the needs of your drawing, the order of operations can be flexible. The most important thing is to make sure the edges of the cube are all going back to their proper vanishing points.

## Changing the Dimensions of a Cube

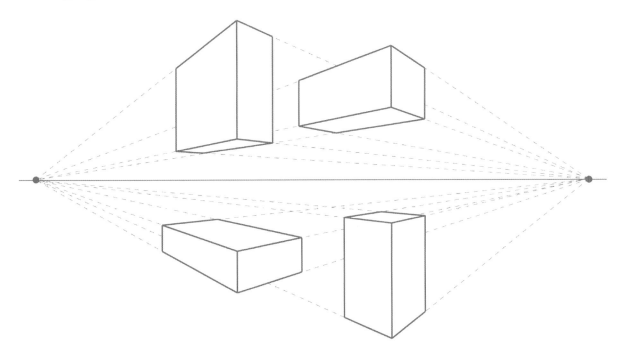

To change the dimensions of a cube we simply need to shorten or extend any set of three lines. This diagram shows boxes of various dimensions. While the vertical edges of each box remain vertical, the other two sets of lines still lead back to their respective vanishing points. While each plane of a cube is an identical square, a box can have planes of differing dimensions.

## A Note about the Third Vanishing Point

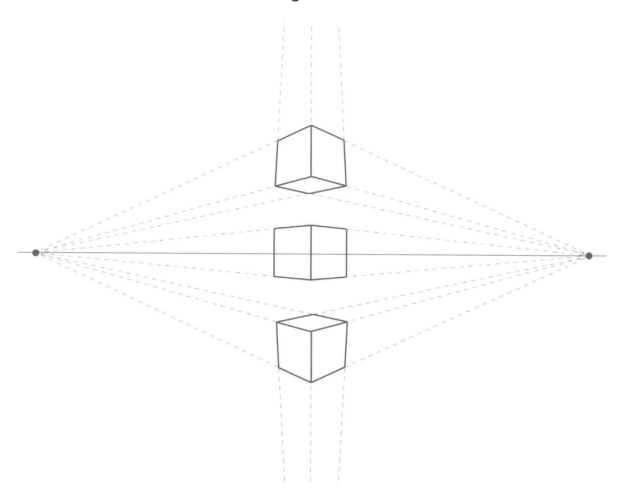

Two-point perspective will help you draw most box-like objects in perspective. But just like you learned with the cylinder, when we look down upon a cube or box, the front corner of the top plane is closer to us than the bottom corners. This means that, in reality, the vertical sides of the cube will taper slightly as they lead down to a third vanishing point far below the object.

Take a look at the diagram above. When we view a box above eye level, the vertical sides would go toward a vanishing point far above the object. When we view a box below eye level, the vertical sides would go toward a vanishing point far below the object. Because the third vanishing point would be so far above or below the cube, it is impractical to draw the point. I rarely, if ever, draw using an actual third vanishing point, but this is an important phenomenon to understand. In most drawings I fake the third vanishing point by slightly tapering the vertical edges of the cube. This will give your drawing a subtle, but heightened sense of realism. Note that a box that is at eye level, or extends both above and below eye level, should be drawn using two-point perspective.

# Tilting Boxes

If we want to tilt a cube or box we simply need to construct it as previously demonstrated but with a tilted line for the eye level. This takes some practice but will become intuitive with experience.

A single drawing may contain multiple tilted boxes, each at a different orientation in space. You can imagine each tilted box as having its own corresponding horizon line.

One of the best ways to learn to draw boxes is to draw them from observation. Shoeboxes, books, or any other box-like objects make excellent subjects. Observing how boxes operate in space in real life is one of the best ways to learn to draw them.

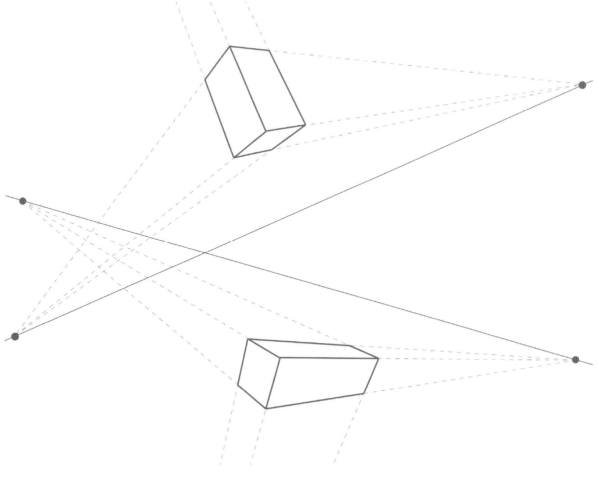

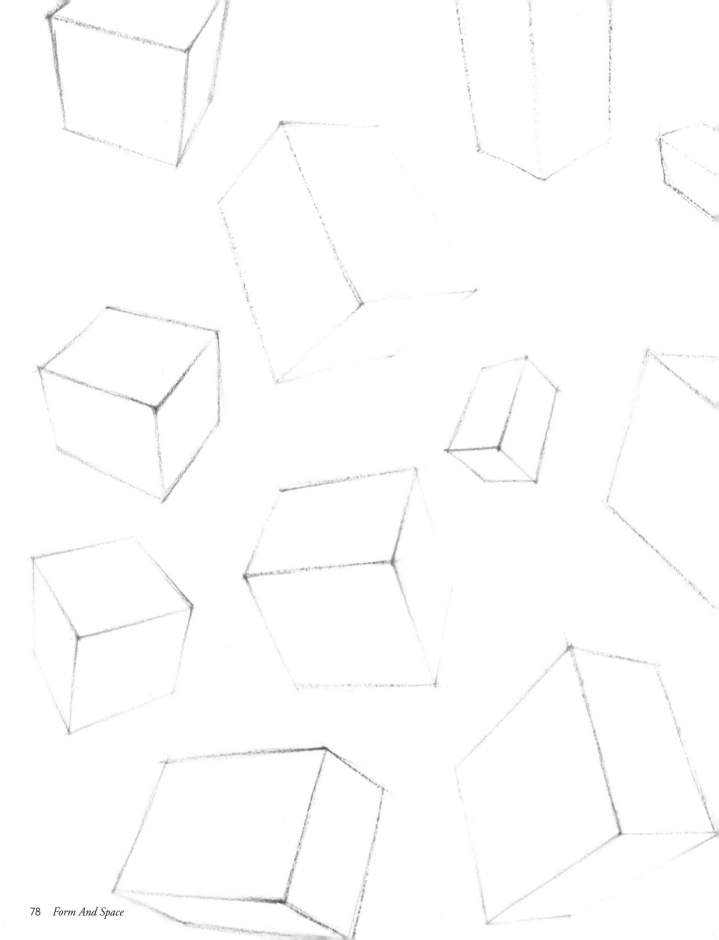

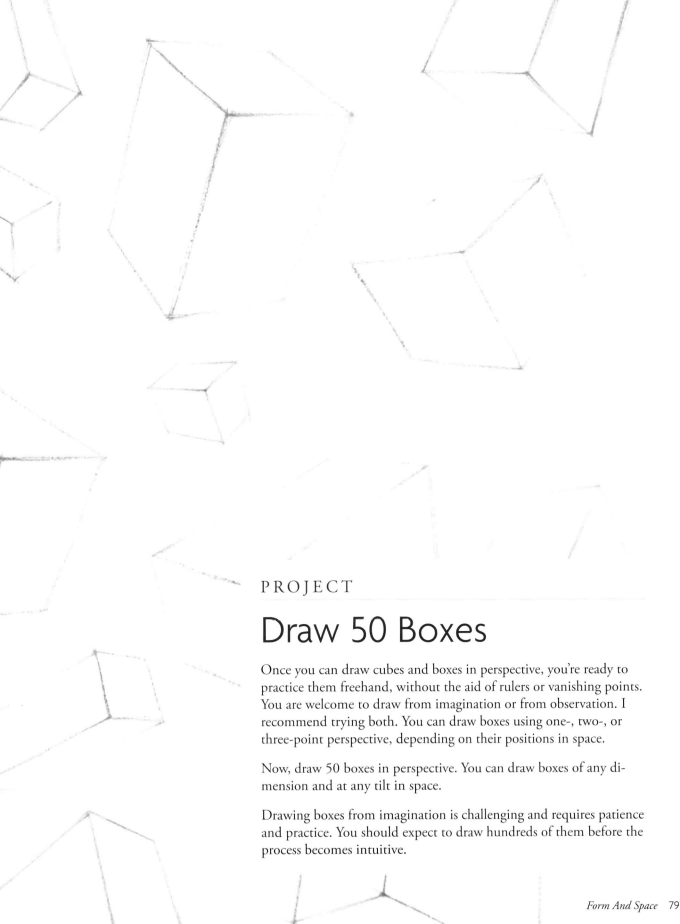

# Draw 50 Boxes

Once you can draw cubes and boxes in perspective, you're ready to practice them freehand, without the aid of rulers or vanishing points. You are welcome to draw from imagination or from observation. I recommend trying both. You can draw boxes using one-, two-, or three-point perspective, depending on their positions in space.

Now, draw 50 boxes in perspective. You can draw boxes of any dimension and at any tilt in space.

Drawing boxes from imagination is challenging and requires patience and practice. You should expect to draw hundreds of them before the process becomes intuitive.

## Beyond the Box

Cubes and boxes can be modified further to achieve a wide range of volumes with flat planes. Let's explore some ways we can modify cubes and boxes.

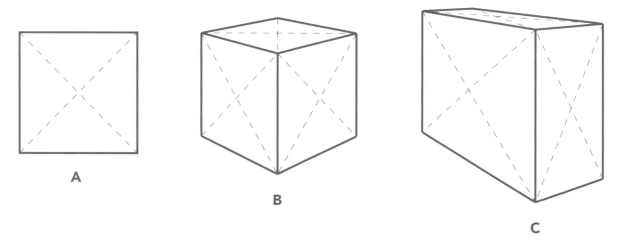

**A**

**B**

**C**

You can find the center of a square or rectangle by drawing two lines diagonally from corner to corner (A). This same strategy can be used to find the center of any square or rectangular plane in perspective (B). This works with boxes of any dimensions (C).

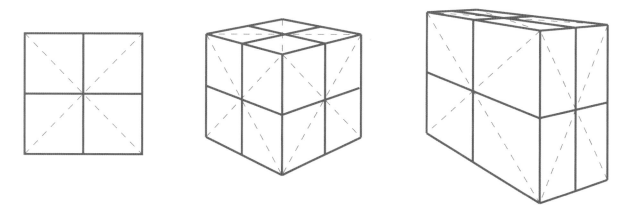

Once we know where the center of a plane is, we can draw vertical and horizontal lines to divide the box. Notice that the vertical line is parallel to the vertical edges of the box and the horizontal line leads back to the same vanishing point as the corresponding edges of the box. We can do this for each visible plane.

Although these diagrams are in two-point perspective, this technique will work in one-, two-, and three-point perspectives.

# Slicing Boxes

Once boxes have been divided in this way, we can use these lines to slice into them and create new, more complex volumes in perspective. In this first diagram, the box has simply been sliced along the diagonal line running from the top left to the bottom right of the plane on the left side of the cube. This volume is in three-point perspective, but this method will work with one- or two-point perspective as well.

This next box has a block-like segment cut out of it. Notice how the edges of the new planes still lead back to the same vanishing points used to create the initial cube.

This box has a triangular section removed. The triangle was sliced along the diagonals of the left plane of the cube.

# Slice a Box

Begin by drawing a box in perspective. This box can be in any orientation in space and have any dimensions. The box shown here is taller than it is wide, it is below eye level, and it is in three-point perspective. You are welcome to draw your box in one- or two-point perspective.

Find the center of each visible plane by drawing diagonal lines from corner to corner.

Divide each visible plane into four parts as shown. The new dividing lines should correspond to the established vanishing points.

Slice into the box to create a new volume. In this drawing I have removed two wedges from the top of the box; one from the left side and one from the right. Feel free to experiment with different ways of slicing your box.

There is a near infinite number of new volumes you can create using this strategy. Each new volume you create will be a puzzle you need to solve. You will need to think your way through each new variant and figure out how to properly draw it in perspective. This is a challenging but powerful exercise that will force you to grapple with the logic of perspective. You should expect that this exercise will take a lot of time and practice before you are able to competently and comfortably draw variants of boxes properly in perspective.

# A Simple Still Life

One of the best ways to learn to draw volumetrically is to observe and draw real objects from life. Here you can see a simple still life containing a book, a coffee cup, and an orange.

Each of these objects must be understood as a basic volume before any further detail can be added. The book is simply a box. The orange is a sphere, and the cup is a cylinder. Here you can see that these objects follow the rules of perspective you just learned about. In particular, note that the book is in three-point perspective.

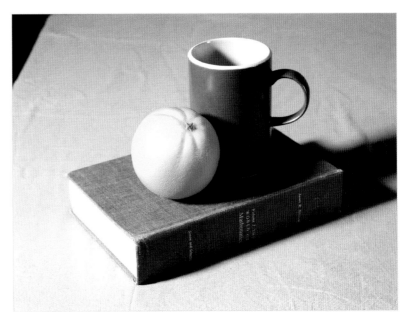

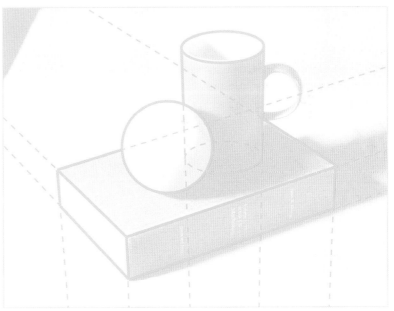

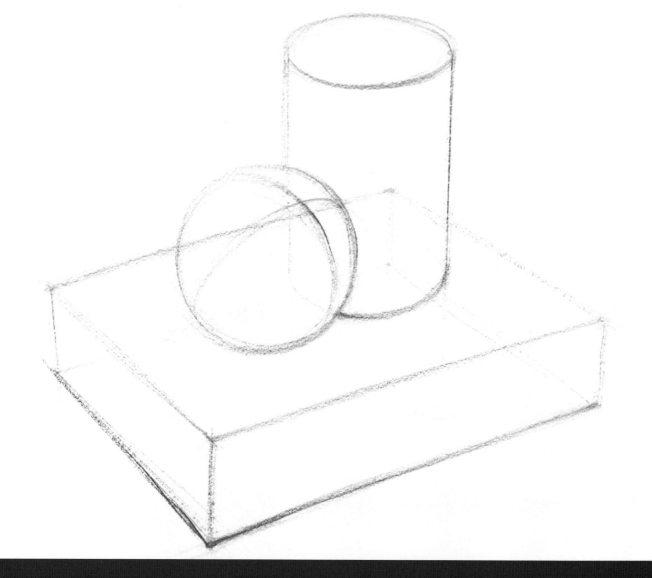

# A Simple Still Life

Find three objects, one spherical, one cylindrical, and one box-like. Arrange these objects on a surface. Draw these three objects as basic volumes. Do not add any details. Focus only on capturing these volumes properly in perspective. Use the five questions you learned about in "Chapter 1: Basic Skills" to help with placement and proportion.

# Compound Forms

Now let's explore how basic volumes can be combined to create compound forms. Compound forms are made up of two or more basic volumes. When drawing compound forms, you'll often find that the basic volumes you learned about must be altered. Cylinders may taper into cone-like volumes, spheres may be cut in half, or boxes may be sliced.

Take a look at this butternut squash. All too often, when students are confronted with more complex or organic forms, they abandon volumetric drawing and revert to outline drawing. But remember, all form, no matter how complex, can be understood as a series of basic volumes. The large, bulbous end of the squash on our right simplifies into an ovoid. The neck of the squash is a cylinder that tapers slightly. The left end of the squash is a half sphere. Even the stem can be simplified into a cone-like volume and a cylinder. There is not a single volume or shape here that you don't already know how to draw. A simplified drawing of this squash can be seen on the next page.

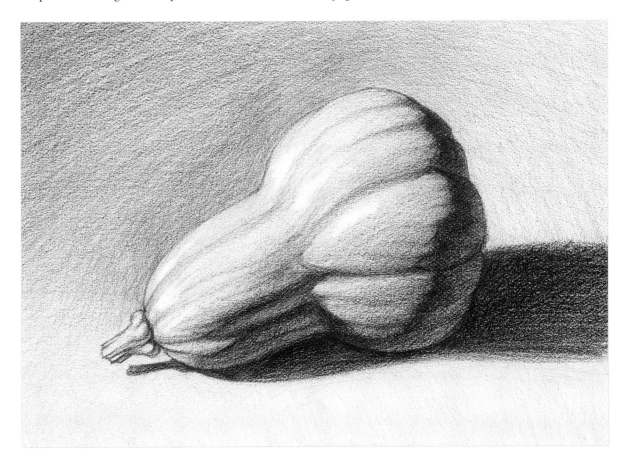

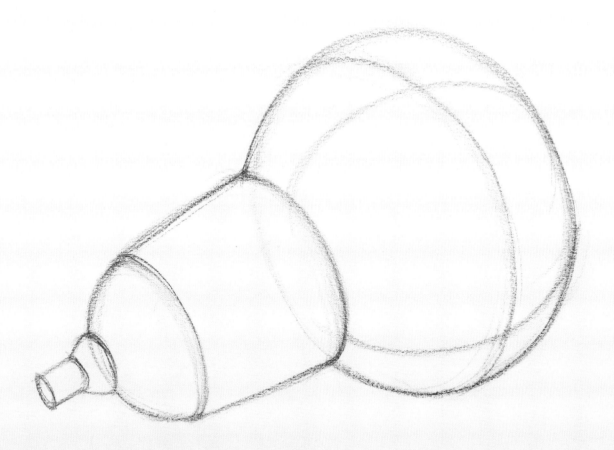

# Draw a Compound Form

Find and draw a compound form from observation. Make sure your subject is not too complex. Fruits and vegetables make excellent subjects. Simplify your subject into its most basic volumes as I did with the butternut squash.

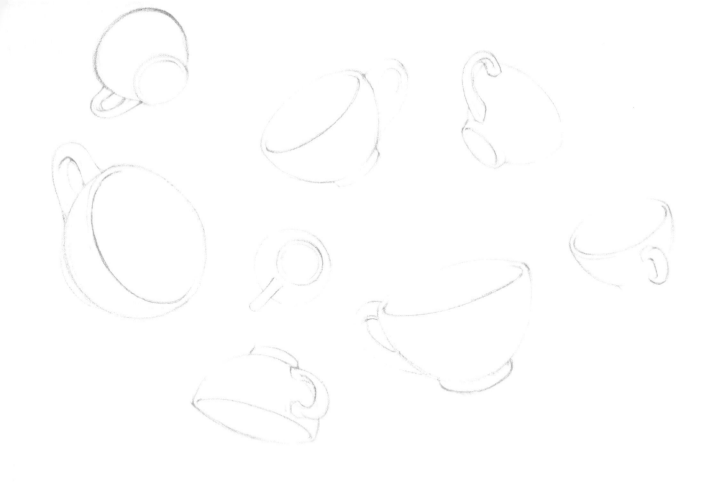

# Drawing Objects in Three Dimensions

Once you have some experience drawing basic volumes, you can use them to construct actual objects.

Always remember: All things, no matter how complex, are made up of basic volumes like spheres, cylinders, and boxes. This includes people, plants, animals, landscapes, and human-made objects. Your ultimate goal is to draw all objects as three-dimensional volumes occupying space. To this end you should strive to understand the volumes that make up the subjects you are drawing.

Here, you can see numerous drawings of a teacup. The largest volume of the teacup is a sphere that has been cut in half. This half-sphere is hollowed out, so we see a visible rim around the edge of the half-sphere. This visible rim is created by drawing half of an ellipse just inside the larger ellipse of the outer edge of the opening. The base at the bottom of the teacup is a short cylinder. The curving volume for the handle is somewhere between a cylinder and a box. Like a cylinder, the handle is always rounded, but like a box we can see that the handle has distinct sides, a top, and a bottom. The contour lines of the handle delineate its sides from its top and bottom as it curves through space. You'll learn more about contours in "Chapter 4: Mark Making and Contours."

Note that you can see the construction lines I used to draw these objects. For example, to properly draw the cup, I began by drawing a sphere just as I demonstrated earlier in this chapter. I then used a latitude line to cut the sphere in half. I used the vertical axis to align the half sphere of the cup with the cylinder of the base.

Here, you can see numerous drawings of a top hat in various orientations in space. The largest volume of the top hat is a cylinder that is slightly flared at the top and open at the bottom. To draw this cylindrical volume, I used the same axis lines you learned about earlier in this chapter. The brim of the hat is derived from ovular shapes. Like the teacups, I used the contours of the brim to show how it curves through space. The band around the hat is drawn with a simple ellipse that corresponds to the principles you learned about earlier in this chapter.

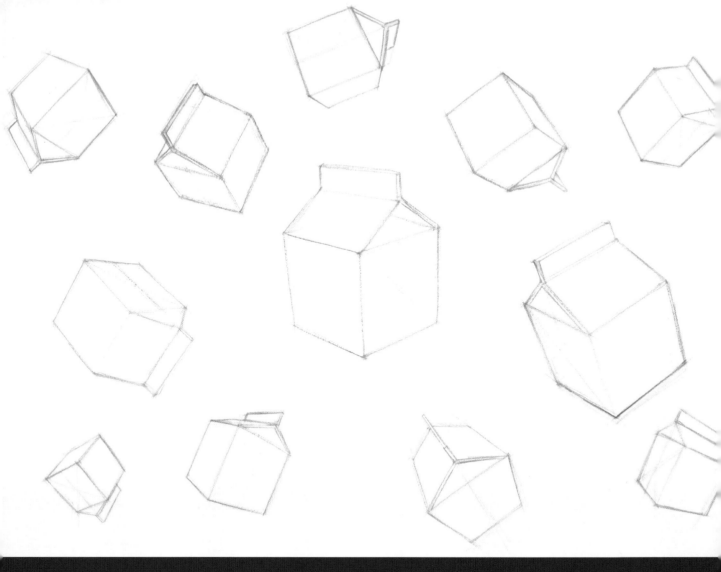

Here are numerous drawings of a milk box in various orientations in space. The primary volume of the milk box is, of course, a box. Although I have not explicitly used vanishing points for each box, I have drawn the boxes believably in three-point perspective, just as you practiced earlier in this chapter. To construct the triangular wedge at the top of each box, I found the center of the plane below it and pulled the vertical line upward to the peak of the wedge. The flap at the top is simply a long, slender box that corresponds to the same vanishing points established for the larger milk box.

I have drawn each of these objects by simplifying them into their basic shapes and volumes. Hopefully, you can see the direct relationships between these objects and the volumes you learned about earlier in this chapter. Even these basic objects cannot be properly drawn without understanding the basic volumes that comprise them. As your drawing skills increase you will be able to understand and draw more complex volumes. The human figure is one of the most complex subjects you can draw, but, as you will learn later in this book, even the human figure can be simplified into a combination of spheres, cylinders, and boxes.

One of the most common mistakes beginners make is attempting to draw objects that are too far beyond their skill level. This can result in frustration and bad habits. Be patient. Start by drawing basic objects and work your way up to more complex objects. Each of the objects drawn here contain familiar volumes you know how to draw but they also have some unique elements that will challenge you.

# Draw in Three Dimensions

Select three objects: one that is primarily spherical, one that is primarily cylindrical, and one that is primarily cubical or box-like. A quick search around your house should reveal a wide range of options. I recommend drawing while observing the actual objects so you can analyze their volumes and see how they operate in space.

Draw these objects a minimum of three times each. Vary the viewpoints of these objects. To fully understand these objects in three dimensions you should draw them from familiar viewpoints, as well as unfamiliar viewpoints. This forces you to think your way through the entirety of each object in the round. For example, you can see I drew all three of my subjects upside down and from underneath.

As I demonstrated, draw the volumes in their entirety, even when you don't see the entire volume. For example, even when the brim of the top hat obscures part of the cylinder, I still drew the entire cylinder before attaching the brim.

As with all new skills, it's important to remember it will take time and practice before you get good at this process. It's also important to realize I am giving you the minimum amount of practice required to learn these skills. To speed up your progress you can double, triple, or even quadruple the amount of practice you are doing. Instead of drawing an object only three times, try drawing it a dozen or more times, even if this means repeating views. Your success as an artist depends on you doing more practice, not less.

# Conclusion

Many people assume that shading is what makes an object look three dimensional. While shading is an important element of three-dimensional drawing, an object must first be properly constructed in three dimensions before shading should be attempted.

No single book can lead you through the exact steps to draw every object in proper perspective. Nor should a book attempt this. For one thing, there is no single, *correct* set of steps to arrive at a particular end point. There are numerous possible processes you can use to properly draw any subject. Also, as your subjects become more complex, the volumes can become more subjective. For example, when drawing the human figure, you can conceive of many forms of the body as more rounded or more box-like. Either approach can work. What this chapter has striven to do is introduce you to the basic building blocks of three-dimensional drawing and to give you some strategies you can use to think your way through a subject.

For most students, learning to draw in three dimensions will be one of the most challenging aspects of the drawing process. You should expect that mastering this craft will take hundreds of hours of study and practice. I say this not to discourage you but to keep your expectations realistic. Many students assume that after two or three tries their cylinders and boxes should look like mine. This is unrealistic. But with a commitment to consistent and mindful practice, you will see improvement over time.

Volumetric drawing is something you come to feel. When you think and draw in three dimensions you can almost feel your pencil moving back and forth in space along with your subject. As challenging as volumetric drawing can be, mastering it is one of the most important and profound shifts you will make as an artist.

CHAPTER 3

# MEASURING AND PROPORTION

The five questions you learned about in chapter 1 are an excellent way to capture the general proportions of your subject. But for a higher level of accuracy, you need more precise measuring techniques. In this chapter, I will teach you how to observe and analyze the proportions of your subject.

One of the most common and useful measuring techniques is to compare the dimension of one part of a subject to another part to determine their proportional relationship. This is referred to as *comparative measuring* or *proportional measuring*. Proportion refers to the size relationships between different parts of your subject. When a drawing accurately reflects the relative sizes of all parts of a subject it is *in proportion*. But if parts of a drawing are too big or too small

in relationship to other parts, it is *out of proportion*. Common proportional errors include drawing a head too big for its body or drawing the legs too short.

To create drawings that accurately reflect the proportions of a subject we need to measure as many parts of the subject as possible and compare them to one another. Before we apply proportion to the drawing process, let's explore the concept of proportion on its own.

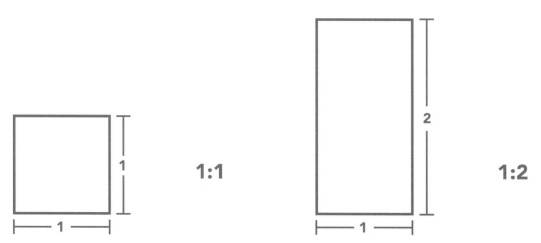

Let's start with a square. The distance from one side of the square to the other is its width. The distance from the bottom of the square to the top is its height. The width and height of a perfect square are equal to one another. Therefore, the ratio of width to height is 1:1.

If we double the height of this shape the height becomes twice as long as the width. The ratio of width to height is now 1:2. The number for the width is on the left side of the colon and the number for the height is on the right.

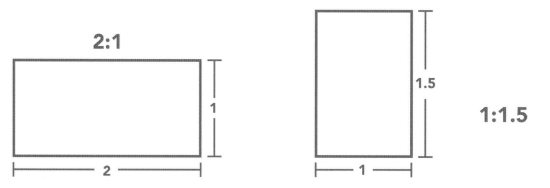

Here is a shape that is twice as wide as it is tall. The ratio of width to height is now 2:1.

Here is a rectangle that is one-and-a-half times higher than it is wide. The ratio of width to height can be expressed as 1:1.5.

Now let's apply these ideas to an actual subject. There is no single, *correct* process to use when measuring. What I will demonstrate is just one plausible way to measure and compare the dimensions of your subject, thereby determining its proportions. I could have gone through a number of alternate processes, even using the same measurements. The goal is to compare the measurements of the various parts of your subject to one another and to use the proportions you discover to draw your subject on the page.

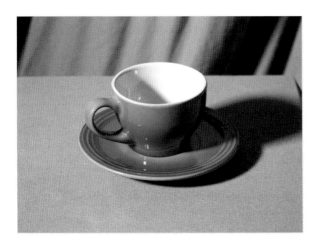 

Take a look at this coffee cup and saucer. We can clearly see that, together, they are wider than they are tall. But by how much? To find out we will measure and compare the various dimensions of the subject. To do this you can use any straight, rigid object. I'll demonstrate this using the end of my pencil. A fresh pencil works best as a measuring tool. As your pencil becomes shorter from use and sharpening, it may not be long enough to capture the proportions of larger subjects. Aluminum knitting needles, slender paint brush handles or any other straight, rigid object will work.

Set up your drawing station as you normally would with your subject placed a few feet away. During the process of measuring, you will remain at your drawing station. All measurements will be taken from a distance. At no point will you come into physical contact with your subject.

While measuring, you need to get your body into position. Hold your measuring tool straight out in front of you with your arm extended and your

elbow locked. Tilt your head toward the shoulder of your measuring arm. Close one eye. Hold your measuring tool up to the subject. You can capture the width or height of any part of the subject on your measuring tool and then compare that unit to any other part of your subject to see how it relates. Once you begin measuring you need to remain in one position. If you lean side to side or raise or lower your position relative to the subject, your point of view will change along with the proportions of your subject.

Now I will demonstrate how to capture a measurement on my pencil using this technique. I will measure the height of the outer ellipse of the rim of the coffee cup. To do this I'll position my measuring tool so that one end of it appears to touch the top of the ellipse. I will then move my thumb down the shaft of the pencil until it appears to mark the bottom of the ellipse. It's important to note that, as I measure, I remain at my drawing station and take these measurements from afar.

The height of the outer ellipse equals 1 unit of measurement. I will compare this unit of measurement to all other parts of this subject.

I chose the height of the ellipse of the rim of the cup because, generally, it is easier to compare smaller units to larger ones, rather than the other way around. But I could have chosen nearly any dimension on the subject to compare with others.

Remember, the goal is to compare various proportions of your subject to one another, but there is no concrete process you must follow.

Here you see me comparing the height of this ellipse to its width. With the height of the ellipse still marked on my pencil, I turn the pencil horizontally and position it so my thumb appears to be touching the far right side of the ellipse.

This shows me how far 1 unit of measurement goes across the width of the ellipse.

I then make a mental note of where the end of the pencil is and then move the pencil until my thumb is now where the end of the pencil was a moment ago.

Here, we can see that the ellipse is slightly more than twice as wide as it is high, or slightly more than 2:1. Although this is not a precise measurement, it is more information than we had before. It's important to get used to approximating because proportional relationships are often imprecise.

Now let's compare some other proportions. With the height of the ellipse still marked on my pencil with my thumb, I can see how many of these units it takes to go from the top of the coffee cup to the bottom of the saucer.

Using the same technique I just demonstrated to arrive at the width of the ellipse, I will march my unit of measurement down the height of the coffee cup, from the highest point at the top of the el-lipse, down to the lowest point at the bottom edge of the saucer. Here we can see that I can fit two full units within the height of the cup and saucer. But they do not reach the bottom edge of the saucer. If we add an entire third unit, it reaches far below the bottom edge of the saucer. I need to know what portion of my unit of measurement will get us to the lower edge of the saucer.

Let's pause here for a moment. Even though I am not currently looking for the location of the bottom of the cup, you can see above that it is just below the 2-unit mark. While measuring, you will likely have a number of these happy accidents. This is one of the things that makes comparative measuring so useful. The process of comparing measurements will likely reveal useful information you weren't even looking for.

Now, back to the height of the cup and saucer. As you can see, an entire unit of measurement drops far below the bottom of the saucer.

I need to know what portion of this unit will get us to the bottom of the saucer. As you learn to measure, it's important to be able to visualize what fractions of a unit look like. Ask yourself: What portion of the unit of measurement would get us closest to the bottom of the saucer? One third? Perhaps a bit too short. Two thirds? Perhaps a bit too long.

Hopefully, you can see the remainder is approximately one half of one unit, or 0.5 units. We now know that the height of the cup and saucer is slightly more than 2.5 units of measurement.

We now know the height and width of the ellipse as well as the height of the cup and saucer together. How about the width of the saucer at its widest point? By using this same method and my same unit of measurement I find that the width of the saucer is 3.5 times as long as the height of the ellipse of the cup. This tells us that the ratio of the entire subject at its farthest edges is 3.5:2.5

By comparing the height of the ellipse to other parts of the subject I was able to determine the width of the ellipse, the height of the cup and saucer together at their highest and lowest points, as well as the width of the saucer at its widest points.

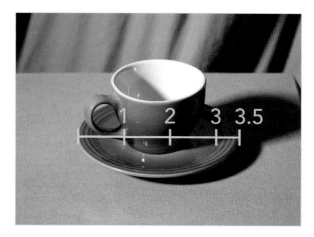

# Applying Proportions

Now I'll demonstrate how to use these proportions in a drawing. To determine the proportions of the cup and saucer I used the height of the coffee cup's ellipse as my unit of measurement. As I compared this unit of measurement to other parts of the subject, I found the following:

- The width of the ellipse of the coffee cup is slightly more than 2 times the length of my unit of measurement, or 2:1.

- The height of the cup and saucer together are slightly more than 2.5 times the length of my unit of measurement.

- The width of the saucer at its widest point is approximately 3.5 times the length of my unit of measurement.

In order to draw the cup and saucer using these proportions, our first goal is to create a box that will contain the entire subject. It will be 3.5 units wide and slightly more than 2.5 units high. This box will mark the edges of the cup and saucer at their highest and widest points. Once you know the width and height of a subject, constructing a proportional box is an excellent way to apply these proportions to your subject.

The primary volumes of the cup and saucer are symmetrical (not including the handle) so I'm going to begin my drawing with a centerline. The centerline will help me make sure that the shapes and volumes making up the subject are properly aligned and evenly divided in half. As you learned from drawing the axis lines for ellipses, a centerline helps reveal whether your drawing is symmetric or not. Of course, not all subjects are symmetrical and will not require a centerline.

I have drawn my centerline longer than I need it to be. This way I have room to move with the size and placement of my final drawing.

Here I have marked the top of the ellipse of the coffee cup.

Now I need to mark the bottom of the ellipse thereby establishing its height. Once marked, this dimension will be used to establish all other proportions in the drawing.

I can make my drawing as big or as small as I like as long as I maintain the proportional relationships I determined. If, in my drawing, I make this unit of measurement 1 inch, the drawing will be approximately. 2.5 inches tall and 3.5 inches wide. If I make this unit 1 foot, the final drawing will be approximately 2.5 feet high and 3.5 feet long.

I know the height of the entire subject is 2.5 of these units. I will try and visualize what this will look like on the centerline. I want the length of this initial unit to be big enough so that when I add the additional 1.5 units the drawing fills the page, but not so big that it goes off the page. In the image on the left you can see I've marked the bottom of the ellipse. Hopefully you can see that I have left ample room for the remaining 1.5 units. Try and visualize the remaining 1.5 units below the unit marked.

Now I will add a second mark on the centerline creating another unit that is the same length as the first. To do this, I place my pencil on my drawing surface with the end of the pencil touching the top of my unit of measurement and my index finger marking the bottom of the unit of measurement.

I then move my pencil down the centerline, so the top of the pencil is now touching the bottom of the first unit. My index finger now indicates where the second mark should go.

I will pick up the pencil, keeping my eyes on the location my index finger was, and make the mark for the bottom of the second unit of measurement.

This may require multiple attempts. You can see that I made an initial attempt that was too high and then I made the mark slightly lower. It is very common to make a number of attempts before you get the marks in the right places.

Finally, I will mark the bottom of the subject. To do this I only need half of the length of my unit of measurement. I will first divide one of the units in half so I can see what a half unit looks like.

Once again marking the length of the unit on my pencil with my index finger, I will then add this half unit to the bottom of the centerline.

Now, from the top mark on the centerline to the bottom is 2.5 units. The top unit marks the top and bottom of the ellipse of the coffee cup and the bottom line marks the bottom of the saucer.

Now that I have the height of the subject established, I need to determine its width. We know the width of the entire subject is 3.5 units of measurement. If we divide 3.5 in half, this means we need to add 1.75 units to either side of the centerline.

On our centerline we have marks that indicate the length of one unit of measurement as well as a half unit of measurement. To arrive at .75, or three quarters of a unit, we need to know how long 1 quarter of a unit is (.25 units). To find out, I can simply divide a half unit in half again thereby arriving at .25, or one quarter, of a unit of measurement.

By adding a quarter of a unit to a half of a unit I now know the length of three quarters of a unit or .75 units.

To construct the proportional box for the cup and saucer I will first draw a horizontal line extending out from either side of the centerline. Ultimately this line will be 3.5 units long with 1.75 units on either side of the centerline. For now, I will draw this line longer than I need it because I do not yet know exactly where the ends will be.

Let's pause for a moment so we can see what proportions we currently have marked on the centerline.

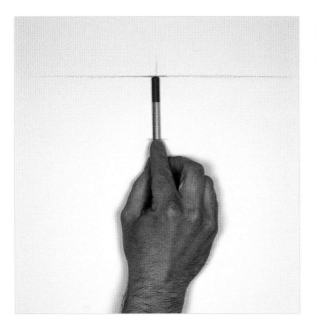

First, I will mark one unit of measurement on my pencil using my index finger.

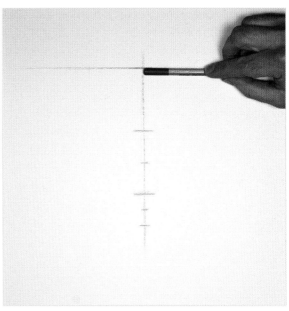

Next, I will turn my pencil horizontally and hold it up to one side of the horizontal line.

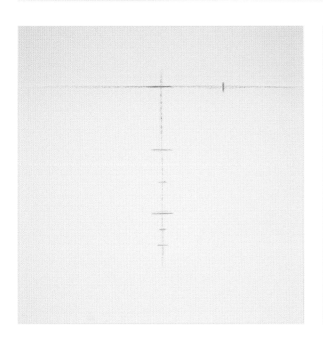

I will keep my eye on the location of my index finger and then mark the length of one unit.

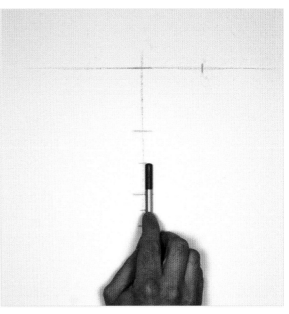

Next, I will mark the length of .75 units on my pencil with my index finger. To do this I am combining a half unit (0.5) with a quarter unit (0.25).

Now I will turn my pencil horizontally and hold it up to the far edge of the horizontal unit of 1.

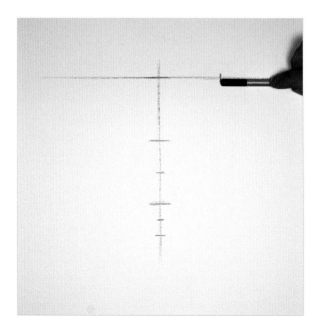

I will keep my eye on the location of my index finger and then mark the length of three quarters of a unit (0.75 units).

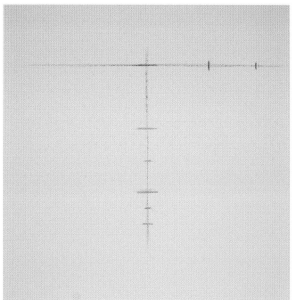

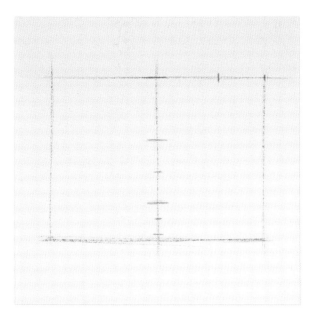

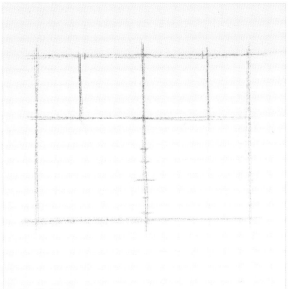

I can now mark the entire length of 1.75 units on my pencil and transfer this length to the other side of the centerline. Once done, I can construct a proportional box that is 3.5 units wide and approximately 2.5 units high, or approximately 3.5:2.5. To do this I will draw vertical lines down from the 1.75-unit marks at the ends of the horizontal line and draw the bottom horizontal edge of the box. Remember the distance from the top of the ellipse of the cup to the bottom of the saucer is slightly more than 2.5 units. Therefore, I will draw the horizontal line for the bottom of the box slightly lower than the 2.5-unit mark.

Next, I will draw the box for the ellipse of the coffee cup. I already have the bottom of this box marked on the centerline. This, of course, was the mark for the bottom of the first unit of measurement. I now need to draw the vertical sides of the box for the ellipse. I already have 1 unit of width marked on the right side of the centerline. I will mark one unit on the left side. But remember, the width of the ellipse was slightly more than 2 units wide so I will draw the vertical sides of the box just slightly wider than the 2 units of width. I am careful to add the same small amount to each side to make sure the box is centered on the centerline.

Before I actually draw the cup and saucer, there is another measuring technique I'd like to show you.

# Vertical and Horizontal Alignment

Proportional measuring is by far the most common measuring technique, but it is not the only one. You can also look for vertical and horizontal alignments in your subject. For example, here we can see that the right edge of the cup handle, where it connects at the top of the cup, is directly above the left edge of where the handle connects at the bottom of the cup. These two points are vertically aligned. This is useful information.

We can also search for horizontal alignments. For example, we can see here that the bottom of the ellipse of the cup is horizontally aligned with the locations where the ellipse of the saucer disappears behind either side of the cup. Again, this is useful information.

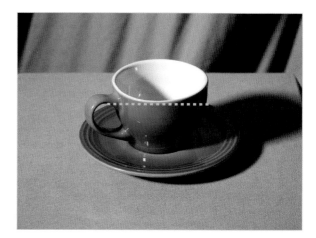

Perfect alignment isn't necessary for this technique to be useful. For example, if we drop a vertical line down from the left edge of the handle of the cup, we can see that it is a little bit in from the far-left edge of the saucer. Now when I draw the handle, I have an idea how far out it should project form the cup.

With all of this in mind, I will now bring together all of this information to draw the coffee cup and saucer. Here you can see I have drawn the two most prominent shapes: the ellipse for the saucer and the ellipse of the coffee cup. Note that the ellipse for the saucer is drawn so that it will dive behind the cup in horizontal alignment with the bottom of the ellipse of the cup.

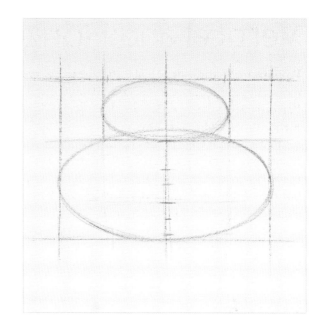

Here is my final drawing of the coffee cup and saucer.

As I completed this study, I continued to evaluate the proportions of my subject and look for vertical and horizontal alignments. But the first steps I demonstrated provided me with the most funda-mental proportions needed to draw the subject. There are many other ways I could have used proportions to construct this drawing of a cup and saucer. I could have used the height or width of the cup handle as my unit of measurement, or even the distance from the bottom of the cup to the bottom of the saucer.

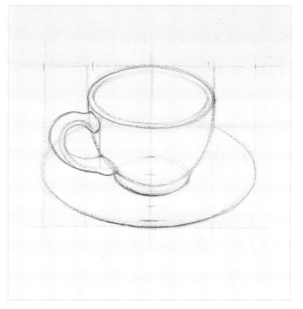

Every subject you draw will reveal numerous opportunities for proportional comparisons. This flexibility makes proportional measuring a powerful tool. There are more advanced measuring techniques you can learn like angle sighting and triangulation, but proportional comparisons along with vertical and horizontal alignment are a great place to start and should meet the majority of your drawing needs.

When you draw from observation you always have the option of analyzing proportions by eye, or by employing measuring techniques like the ones I have described in this chapter. How much measuring you do in a drawing is entirely up to you. Some artists prioritize accuracy and measure nearly every dimension before they draw it. Other artists prioritize expression or exaggeration and measure very little, if at all.

I like to measure just enough so my drawings are believable. The word *believable* is key. Perfect accuracy in a drawing done by hand is nearly impossible to achieve, nor is it necessarily desirable. I don't think the goal of drawing is to create a perfect facsimile of reality. I think the goal of drawing is to communicate what you think is interesting or beautiful about a subject to a viewer. This often means ignoring aspects of your subject, or even exaggerating the proportions for effect. We'll discuss this further in the chapter on figure drawing.

Once you understand how to measure and compare proportions you can apply this technique to any subject. This is one of the most commonly used measuring techniques in drawing. I demonstrated these techniques with a simple object, but they can be scaled up to meet the complexity of any subject. Measuring, proportion, and alignments are particularly useful for figure drawing.

You don't need to draw a proportional box around your subject. Even a simple width-to-height comparison done on the fly can be immediately put to use in your drawing.

Some students love proportional measuring and find this technical way of thinking both logical and straightforward. Others do not. You may need to spend some extra time with this chapter to grasp the process I demonstrated. This is perfectly normal. With slow and careful reading this demonstration will eventually make sense.

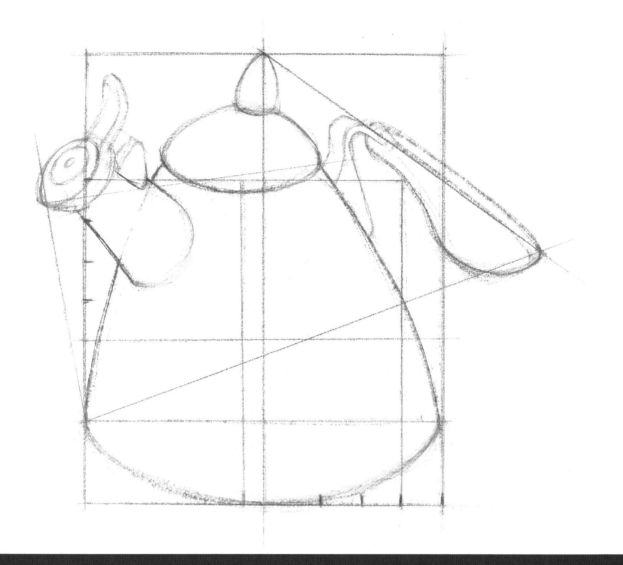

# Determine the Proportions of a Simple Object

Select a simple object like a cup. Use the proportional measuring techniques you learned in this chapter to measure and compare the dimensions of the various parts of your subject. Beginning with a simple subject is critical. Once you understand the basics of measuring and proportion you can scale this process up to meet the demands of more complex subjects.

# Conclusion

Constructing a drawing using measuring techniques is a much more technical process than simply using your eyes to determine placements and proportions. Some artists measure often, others rarely measure at all. How much you use these techniques is entirely up to you. If accuracy is paramount in your work, I recommend measuring often.

I know measuring can be frustrating for some students, but it does get easier with time and practice. Practicing measuring techniques like the ones taught in this chapter have an added benefit. The more you measure, the more you train your brain to make these kinds of evaluations on its own before you even apply measuring techniques. Measuring by hand improves your ability to measure by eye alone. Over time, you'll find that you rely less on going through the process of measuring, but nevertheless, your drawings will appear more proportional and believable.

Measuring is a technical process that requires a lot of study and practice. It is very common for students to need to go through this information multiple times before they have absorbed all of these methods. Each new object is a measuring puzzle to be solved. There is no one-size-fits-all approach. Once you develop the skills necessary to take measurements, you can be creative with how you apply them.

Finally, it's important for you to remember that technical accuracy is only one aspect of the drawing process. If you were to compare my drawings side by side with their actual subjects, you would find there are numerous errors, exaggerations, and other differences between my drawing and reality. A drawing is not a facsimile. Perfect accuracy is not the point. You need to determine how important accuracy is for the work you want to do and use measuring techniques accordingly.

CHAPTER 4

# MARK MAKING AND CONTOURS

A finished drawing contains hundreds, if not thousands, of individual lines and marks. Even though each line is a very small part of a larger whole, each individual stroke has the power to evoke emotion, convey tactile information, or communicate a sense of depth and volume. How you make your lines and marks says just as much about you as an artist as what you choose to draw. In this chapter we will explore the power of lines and marks and how they communicate with viewers.

When we view drawings up close, mark making takes on a life its own. The lines and marks look like works of abstract, expressionist art. Even though these lines appear abstract, they still communicate with viewers. Every line has a set of qualities or characteristics that can evoke ideas and emotions in the viewer. Soft and subtle lines can bring a sense of calm. Dark, hard, and angular lines can create a sense of tension and even hostility. Quickly drawn calligraphic lines can evoke a sense of joy and excitement.

Line quality is similar to tone of voice. When we speak, how we say something is just as important as what we say. When we draw, how we make lines and marks is just as important as what we draw. All too often aspiring artists draw boring, uniform lines that sit idly on the page. Instead, we want to take full advantage of the possibilities of mark making by varying our line quality as often as we can.

Drawing with a uniformly thick, dark line is like speaking in a monotone voice. Instead, we want our lines to look the way an expressive voice sounds. We want moments that are visually quiet and others that appear loud. We want our lines to appear soft when appropriate and at other times harsh or aggressive. We want our lines to communicate with viewers with a sense of drama.

Each line has a minimum of two functions. The first function is to help describe the objective form of our subject. The second is to communicate something about our subject. This can range from an emotion to a tactile sensation.

Our lines communicate with a viewer whether we intend them to or not. Let me give you an example. Beginners commonly draw outlines of their subject by tiptoeing around the edge with their pencil, making short, stubby strokes, each one overlapping the one preceding it. This kind of line communicates timidness to the viewer and ignores the unique characteristics of the subject. These kinds of lines tell the viewer that the artist is scared of messing up and is clinging to the edge of the subject for dear life.

Compare this to a line drawn quickly that changes from hard and dark to light and soft. This kind of line soars over and through the subject, communicating confidence and freedom. It can also describe the tactile qualities of a subject.

Before we explore how lines communicate information, let's first explore what a line is.

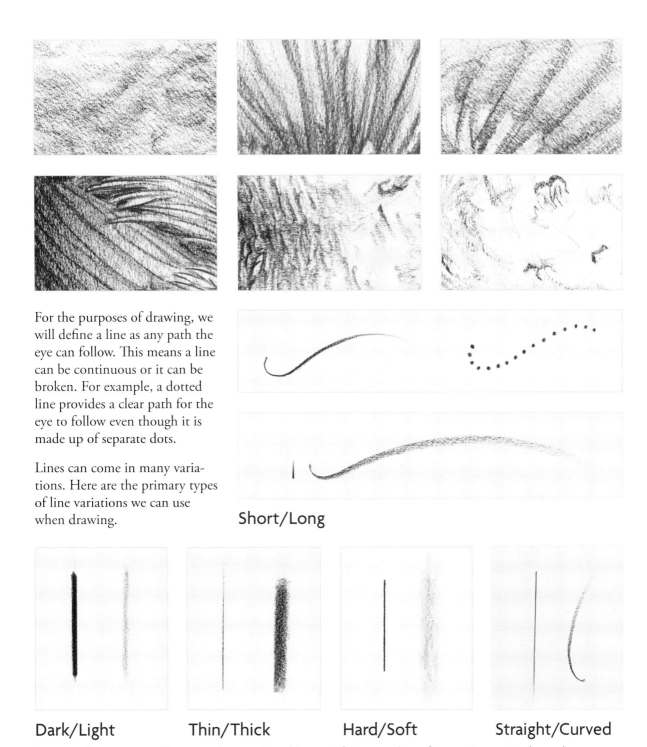

For the purposes of drawing, we will define a line as any path the eye can follow. This means a line can be continuous or it can be broken. For example, a dotted line provides a clear path for the eye to follow even though it is made up of separate dots.

Lines can come in many variations. Here are the primary types of line variations we can use when drawing.

**Short/Long**

**Dark/Light**       **Thin/Thick**       **Hard/Soft**       **Straight/Curved**

These different types of lines can be combined in an infinite number of ways. Even a single stroke can change as it moves across the paper. Before we learn to communicate with lines and marks, we first need to explore mark making on its own.

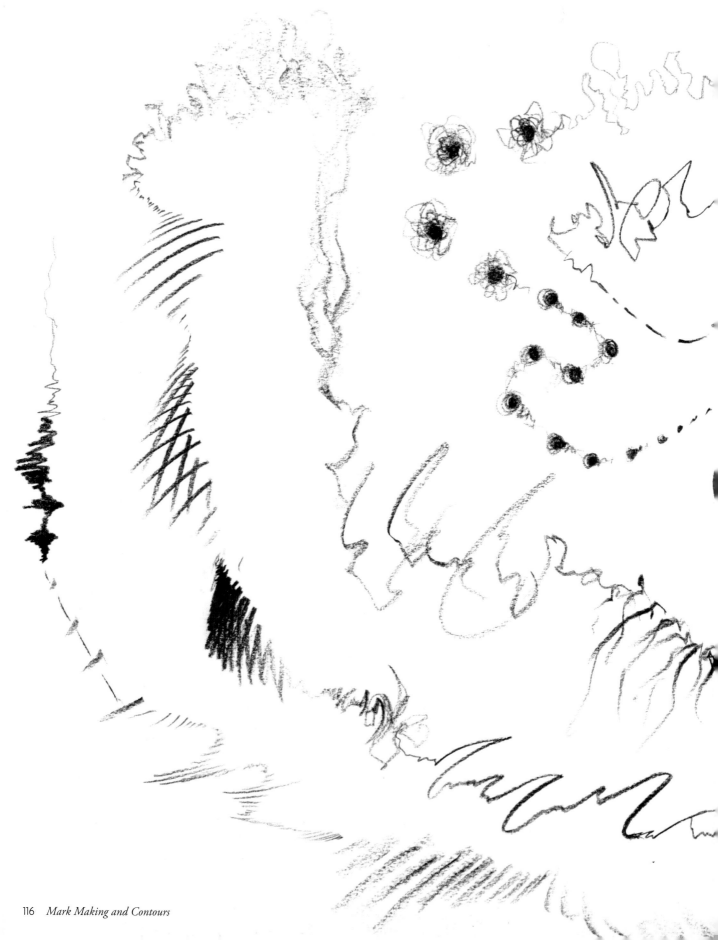

# The Ever-Changing Line

For this project you will explore and experiment with line quality and mark making. On a clean sheet of paper, draw a line that continually changes in quality and character. You can begin this line anywhere you like. The line can wander around the surface until the paper is filled. Don't worry about how these lines might be used in a representational drawing. The goal here is to make as many different kinds of lines and marks as possible.

Experiment with different ways of holding the pencil and different ways of moving your arm, hand, fingers, and pencil. Alter the pressure you apply to the pencil. The more pressure you apply, the darker the line will be. You can also experiment with how the pencil comes into contact with the paper.

I have done this project hundreds of times and each time I try to challenge myself to find new ways of making lines and marks. In my search for new kinds of mark making I have drawn with my non-dominant hand, drawn with my feet, and even put the paper on the ground and dropped the pencils onto it. I'm not suggesting you need to try these techniques, nor am I suggesting that the resulting marks are always useful. But I do want to expand your idea of what mark making can be.

In "Chapter 1: Basic Skills," you learned how to draw using the overhand grip. Hopefully, you've continued to use it, but many students revert back to the tripod grip when the overhand grip is not immediately comfortable. If you're still using the overhand grip, cheers! But if you have reverted back to the tripod grip, I encourage you to try the overhand grip again. The tripod grip mostly produces a uniform line, exactly the kind of boring line we want to avoid when drawing. The overhand grip will allow you to vastly expand your mark making vocabulary.

Once you have completed the "Ever-Changing Line" project, think about how these lines and marks might be used in a representational drawing. Not all of them can be used, but keep your mind open.

# Line Quality in Action

At this stage many students express doubt that expressive line quality has a place in representational drawing. Before we move on, I want to make it clear why mark making is so important.

Here are drawings of two contrasting subjects: a pillow and a rock. I have tried to use lines and marks that capture the unique characteristics of each subject. Let's first look at the pillow. If you were to describe a pillow, what adjectives would you use? Most people would say things like soft, comfortable, or cozy. Now take a look at the lines used to draw the pillow. There is not a dark, hard, or heavy line in this drawing. Instead, we find light, soft, thick lines flowing smoothly around the drawing. The lines used to draw the pillow communicate softness, roundness, and calm.

Contrast the pillow drawing with the drawing of a rock. Most people would describe a rock as heavy, hard, or jagged. Nearly every line in this drawing is dark, straight, and hard. Lines come together at jagged angles. The lines and marks are darkest and heaviest near the bottom suggesting the intense weight of the object. These lines communicate hardness, heaviness, and angularity.

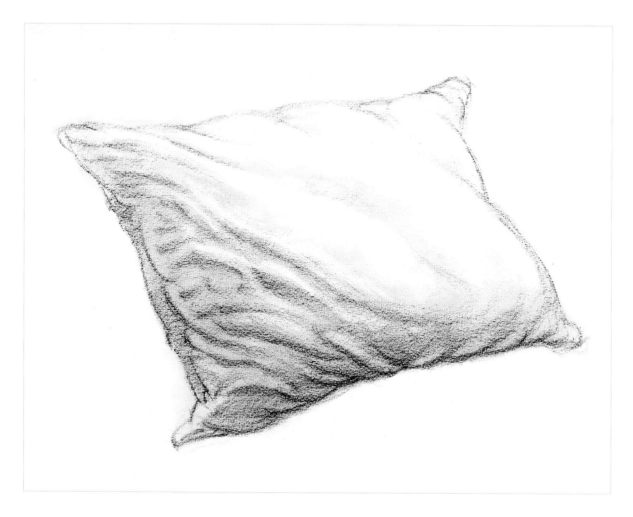

The lines and marks in each of these drawings communicate completely different concepts. They give the viewer a sense of what these objects feel like. It's important to note that these are stylistic decisions. It's not as if these kinds of lines and marks are actually visible on the object. I am not simply copying what I see but I'm choosing to communicate the characteristics of these objects using mark making.

I am not suggesting that the right way to draw a rock is to use hard lines and the right way to draw a pillow is to use soft lines. There are a near infinite number of ways you could draw either of these subjects, but I wanted to give you a sense of how different line qualities tell the viewer different things about your subjects.

Now that you understand the communicative power of line quality, let's look at three of the most fundamental kinds of lines you will find on your subjects.

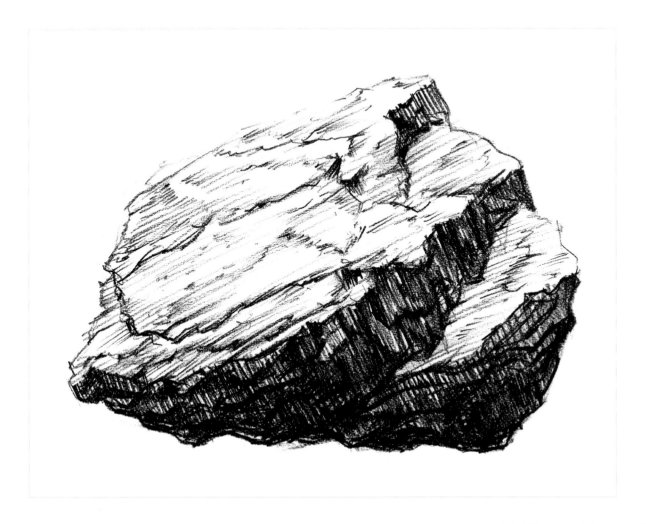

# Contours

There are three primary types of lines we will use when drawing. Each of these lines serves a specific purpose. When used together they create a powerful illusion of form and volume. We'll explore these three types of contours through a drawing of an acorn squash.

## Outer Contours

An outer contour is the outline of an object. An outer contour delineates the boundary between the object we are drawing and everything else. Outer contours are what most beginners focus on when drawing. Although they are essential, outer contours are extremely limited on their own. Even a detailed and descriptive outer contour can only produce a flat shape. In this drawing, you can see that the outer contour on its own creates only a flat outline of the acorn squash.

## Inner Contours

Inner contours are any contour that is located within the boundary of the outer contour. Inner contours depict the topography of a form and create a sense of volume. Combined with the outer contour you can see how well the inner contours describe the form and volume of the squash. The inner contours are what describe the curving segments and the stem.

You'll notice that most inner contours in the drawing actually begin as outer contours that dive inside the form. When an outer contour dives inside the form and becomes an inner contour, it creates an overlap. The outer contour must be continued by a new line. Overlaps are one of the most useful and powerful forms of contour drawing because they create depth by depicting what parts of the subject are in front and which are behind. Overlaps also help describe the topography of the subject. When used together, inner and outer contours do a remarkable job at describing form.

To see overlaps in action follow any outer contour on the edge of the acorn squash and it will either dive inside the form and become an inner contour, or it will be overlapped by another contour line.

## Cross Contours

Cross-contour lines are essentially topographic lines that run over the surface of an object. Cross contour lines can be a challenge to learn because they are not directly observable on most subjects. In this drawing the cross-contour lines are placed somewhat artificially on the surface of the form, but as you will see later in this chapter, there are a wide variety of more natural ways you can use cross-contour lines in your drawings.

The best way to think about cross-contour lines is to visualize the path your eye would take as it moves across the surface of an object in a straight line, traveling up and over any hills or valleys on the surface of the object.

# Contour Drawings

Here is a collection of drawings that show how line quality and contours can work together to describe an object. The subjects include an heirloom tomato, a head of garlic, a bell pepper, and a sweet potato. Fruits and vegetables are excellent subjects for line quality studies because they provide a wide range of shapes and textures. For each subject, I have included a bare-bones cross-contour drawing as well as a contour drawing with descriptive line work. Doing a cross-contour study of your subject before you draw it will help you understand its topography and how line quality can be used to communicate volume.

It is important to note that the following drawings do not contain any shading. The volume, form, and texture are all communicated through line quality and contours.

## Heirloom Tomato

You can see a number of lines and marks in this drawing, each performing a different function. The outer contour of the tomato is darker at the bottom, making the tomato feel grounded. The outer contour is made from a number of curving lines that overlap one another as they dive inside the form and become inner contours. These overlaps create a hierarchy showing which parts of the tomato are in front and which are behind.

The tomato is fundamentally spherical. Notice that the inner contours run over the surface of the tomato just like longitude lines run over the surface of a sphere. This becomes clear when you compare this drawing of the tomato with the cross-contour drawing. These longitude lines give us a sense of the roundness while depicting the subtle segments of the tomato. Because the segments of a tomato are much more subtle than those of an acorn squash they are drawn with light, soft lines. At the top, where these inner contours converge, they dive inward, depicting a depression at the top of the tomato. We see slender, leafy forms emerging from this depression. These leafy parts were drawn with darker, thinner lines to differentiate them from the surface of the tomato.

Even in this seemingly simple drawing, we find a wide range of line qualities depicting volume, weight, and the various tactile sensations one might feel when touching a tomato.

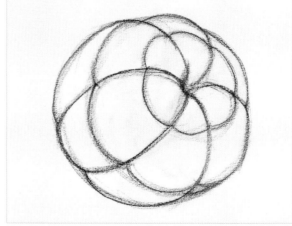

# Head of Garlic

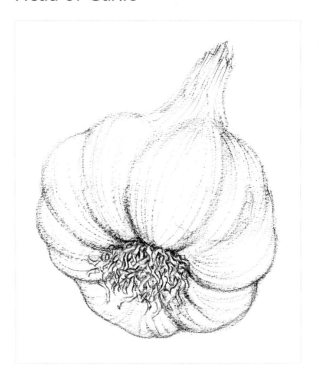 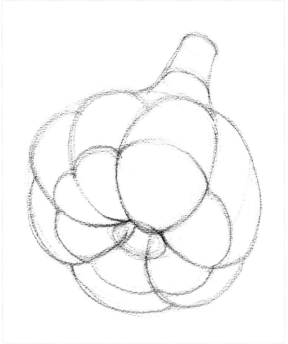

Here we see more pronounced overlaps depicting the individual segments of garlic. I have used soft, thick inner contours to show the individual segments of garlic underneath the skin. I've tried to give a sense of the thin, paper-like quality of the skin by using light, thin lines. These thin lines travel over the surface of the garlic reinforcing its round, bulbous quality. Note that these lines follow the longitude lines from the cross-contour study. The light, thin lines of the skin travel over the soft, thick lines of the individual garlic segments. This gives a sense of the subtle transparency of the skin of the garlic. I have used darker, thinner lines to depict the tangle of roots at the bottom of the garlic. When you compare this drawing of garlic to the tomato you can see that the use of line quality differentiates the two subjects. They look and feel different from one another.

# Bell Pepper

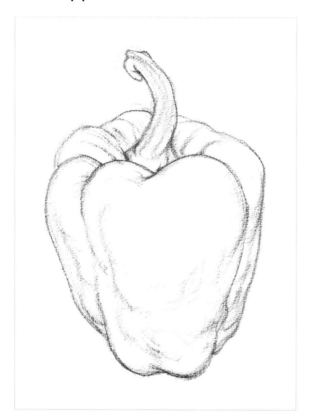
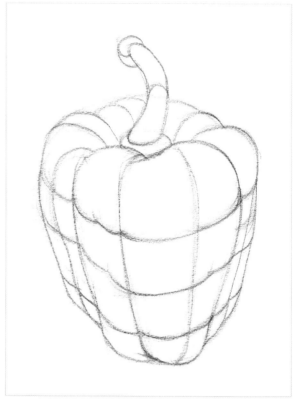

In addition to the overlaps of the segments of the bell pepper, you can also see more attention placed on the uneven surface of the pepper. Notice how often these light, soft lines on the skin of the pepper follow the pattern of cross-contour lines. Once again, the darkest, heaviest lines are at the bottom of the pepper, grounding it. The stem of bell pepper is similar in look and feel to the pepper itself, so I have drawn them both using similar lines.

# Sweet Potato

In this final drawing, I have focused on the textured surface of the potato. This includes the craggy skin, many lumps and bumps, surface scars, and other marks and blemishes.

You will notice that the textural lines and marks reinforce the cross-contour grid shown in the study. In particular, I have emphasized the ellipses to show volume.

In addition to showing the weight of the potato at the bottom by making it darker, I have also used atmospheric perspective by drawing the closer parts of the potato darker, bringing them forward. The farthest parts of the potato were drawn using lighter, softer lines, letting them recede into the distance.

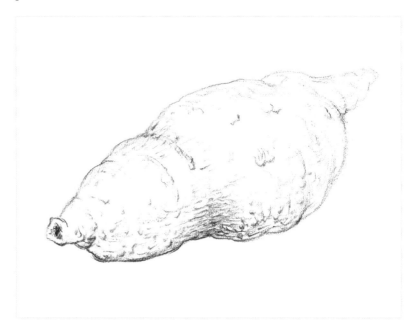

I want to be very clear. These demonstrations are not the *right* way to depict these subjects; they are just some possible solutions. There is no single *correct* way to use line quality. I used lines and marks to depict the characteristics of these subjects that struck me as interesting. Other artists may have focused on different aspects of these same subjects. Line quality is a tool you can use to communicate with your viewer. What and how you communicate is ultimately up to you. Finally, I'd like you to note how much information can be communicated using line quality and texture alone, without any shading. Contours and line quality are a powerful pair that are often overlooked by artists, but by mastering them you will be able to communicate with your viewer in a whole new way.

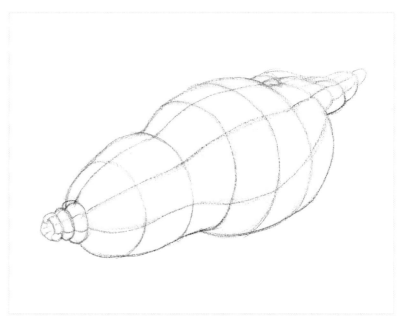

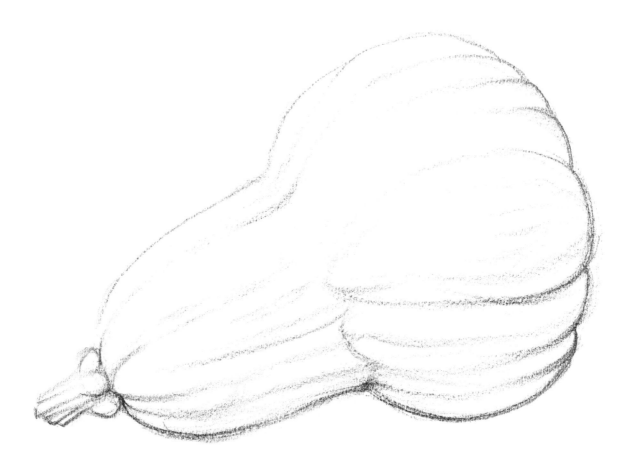

# Contour Drawings

Select an organic object like a fruit or vegetable. Do a contour drawing of your subject taking full advantage of line quality and mark making. Try to give the viewer a sense of what the object might feel like to the touch. This is an opportunity to experiment with line quality and to discover the possibilities of mark making.

For an added challenge, try a cross contour drawing of your subject. If you are not able to visualize the cross-contour lines, try actually drawing cross-contour lines over the surface of your subject with a marking pen. Just make sure not to eat the subject afterward!

# The Block-In

When drawing organic or irregular forms, basic shapes and volumes may not be enough to capture their unique characteristics. In these cases, I begin with basic shapes, but I then use a technique called the *block-in*. The block-in is a method of translating curves into straight lines and angles. This gives structure to the curves and will help you to better understand and draw them.

Beginners tend to oversimplify complex curves. They often think that curves are not as specific as straight lines and angles. This couldn't be further from the truth. Curved lines should be drawn with as much care and attention to detail as every other part of a drawing. This will be even more evident once you get to figure drawing.

Organic or irregular curves can seem unstructured and unpredictable. The block-in technique allows us to structure these curves before drawing them, allowing us to capture their specific attributes. To understand this technique, let's take a look at this pear.

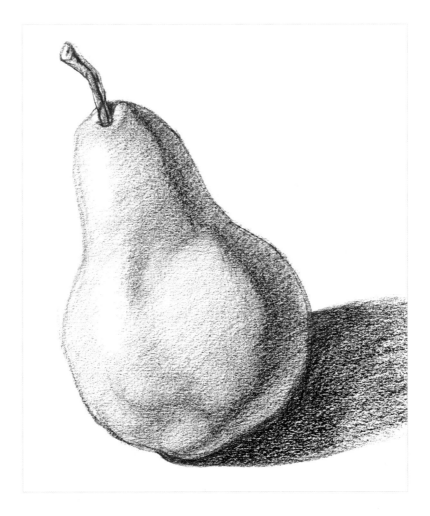

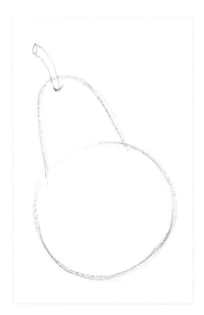
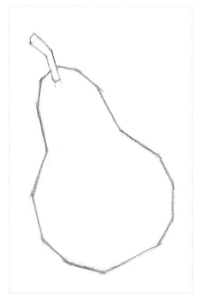
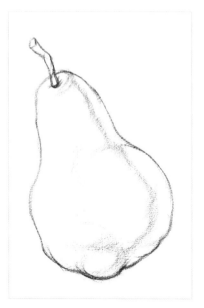

I began this drawing with a basic sphere for the bottom section and a partial ovoid for the top. The stem is a curving rectangle. On their own, these basic shapes only capture a generic pear shape. But we want to capture the specific qualities of this individual pear.

Before attempting to capture the complex contour of the pear I will first break down the curves into angles. I ask myself, "If I had to draw this subject using only straight lines, how would I best accomplish this? How long would each line be? Where would it meet other straight lines and at what angles?" There is not a single *correct* way to block in any particular subject, but you may be surprised to find what the block-in reveals about

the structure of your subject. In this demonstration I have drawn the block-in much darker than I usually do so that you, the student, can see it. When used in a finished drawing the block-in should be drawn incredibly lightly so as not to be seen in the finished drawing.

While blocking in a form you will often find that the contours are not as curvaceous as you initially believed. Compare the contour drawing of the pear (right) with the block-in (above). The block-in reveals the underlying structure of the curves. As you compare these two drawings, notice how often the finished contours are just barely curved and how often a subtle curve aligns atop a straight line. These are details you are likely

to miss if you aren't looking for them.

Once you have lightly blocked in the contour using straight lines and angles, it's easier to then draw more organic and curvaceous lines over the top of the block-in. Hopefully you can see how the block-in helps capture the specifics of the irregular shape of the pear.

Ultimately, the block-in provides a scaffolding for curvaceous and dynamic contours to flow over it. The block-in is just one tool in your drawing toolbox. Many students find it incredibly helpful, others do not. It's up to you whether or not you use it in your own drawings. If you're struggling to draw organic objects, the block-in technique may help.

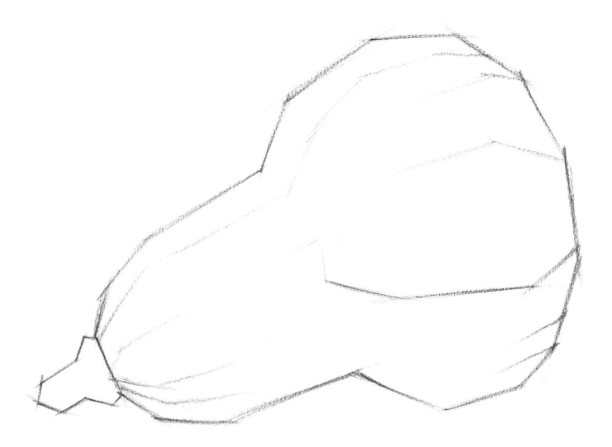

# The Block-In

Select an organic object like a fruit or vegetable. Do a drawing of this object using the block-in technique, translating the curves of the object into straight lines.

# Foreshortening

The final skill I will teach you in this chapter is *foreshortening*. Foreshortening is a technique that creates the illusion of an object receding into the distance. All three-dimensional objects are foreshortened to some degree; however, the term foreshortening is usually reserved for objects that project strongly toward the viewer. For the illusion of foreshortening to be successful, the viewer must believe that parts of the subject are much closer and others are much farther away. This poses some unique challenges on a flat piece of paper.

Understanding foreshortening is particularly useful for subjects that are much longer than they are wide. We will explore foreshortening using a banana that has cross-contour lines applied to its surface. Let's first look at a banana from the side, with little to no foreshortening.

A banana is a long, slender, curving object. When viewed from the side, no part of the banana appears much closer to us than any other part. There are not many opportunities to communicate volume as all of the cross-contour lines appear somewhat straight. There are also not many opportunities for overlaps. The full length of the banana is on display with little to no foreshortening. There's nothing wrong with this drawing, it just doesn't communicate much depth or volume.

Now take a look at the foreshortened banana on the left.

As the banana turns, its overall length appears to decrease. You can also see that the cross-contour lines begin to curve into ellipses showing the cylindrical quality of the banana. The end of the banana that is closest to us appears much larger than the end that is farther away.

Finally, look at the foreshortened banana on the right. It is turned completely toward us. The foreshortening of this banana is extreme. The closest end of this banana eclipses most of the rest of the banana. We see almost none of the length of the banana, only its width. The farthest end of the banana is very small when compared with the closest end.

Creating the illusion of foreshortening in a drawing is an essential skill, particularly if you want to draw the figure or animals whose limbs often project toward the viewer.

## Atmospheric Perspective

I have also used a technique called *atmospheric perspective* to create the illusion of depth in the two foreshortened banana drawings. Atmospheric perspective uses line quality to convey deep space. In the drawings of the two foreshortened bananas, the ends closest to use are drawn with dark, hard lines, but as the bananas recede in space, their contours become lighter and softer. This gives the appearance that the far ends are out of focus.

The technique of atmospheric perspective is taken from a phenomenon you can observe in reality. In this photo taken in a forest you can see that the trees in the front are high in contrast, with bright colors and rich darks. The trees farther away lose their color and contrast. They appear hazy and soft edged.

In reality, you would never see atmosphere perspective over a very short distance, such as the length of a banana. But we can use this technique to trick the eye and mind into perceiving depth on the flat surface of the paper.

In "Chapter 1: Basic Skills" I asked you to translate my drawings of birds into basic shapes. I encourage you now to go back to chapter 1 and look at my bird drawings in terms of their line quality. Each drawing contains a wide range of lines and marks including fast and flowing lines; sharp and hard lines; and soft, downy textures.

Mark making is one of the most overlooked parts of the drawing process, and when it is combined with contour drawing it is one of the most exciting. Contour drawing is fascinating because contour lines are not actually found in the real world. You do not see a dark outline around the edge of objects. Contours are an invention that is unique to drawing. Drawing contours dynamically allows us to communicate with viewers in powerful ways. We can show depth, texture, tactile sensations, and even emotion. Rather than simply outlining your subjects, experiment to see what you can convey in your drawings.

# DRAMATIC LIGHT AND SHADOW

Shading is the skill that students desire to learn most. While shading is of critical importance, it is equally important that you are able to perform all previous skills taught up to this point in the book. Shading should not be applied to a drawing until you are reasonably certain the shapes, volumes, and contours of your subject have been properly drawn. If you are a beginner and have skipped to this section of the book, I highly encourage you to go back and participate in the projects leading up to shading.

Assuming you're ready to learn how to shade, let's dive in. In previous chapters I introduced the idea that all form, no matter how complex, can be distilled down to fundamental shapes and volumes like spheres, cylinders, and boxes. By understanding how to draw

these volumes we can use them to draw any subject. Each of the fundamental volumes interact with light in specific and predictable ways. By understanding how to shade these basic volumes, we will understand how to draw light and shadow on any subject, no matter how complex.

In this chapter you will learn how light operates on each of the three fundamental volumes. You will then learn a shading process that can be applied to any subject. Finally, you will learn how fundamental patterns of light and shadow can be used to shade complex objects. Before I demonstrate the shading process, there are some key ideas you need to understand.

# How to Light an Object

When we draw an object, we are not simply drawing the object itself, but we are drawing the effect of light on the object. For example, a sphere that is in direct sunlight will appear different from a sphere in a room lit by candles. Each condition would result in a very different drawing. The only part of the sphere that would remain constant would be the circle of its outer contour.

When we draw, we want to create the illusion of three dimensions on the flat surface of the paper. Light and shadow should be used to enhance the three dimensionalities of our subject. The best way to do this is to light objects using a single light source. This technique has been used since the Renaissance. Lighting objects with a single source of light creates a full range of values and a clear division between light and shadow. This kind of lighting emphasizes the roundness of spherical and cylindrical objects, the flatness of planes, and the structure of complex forms.

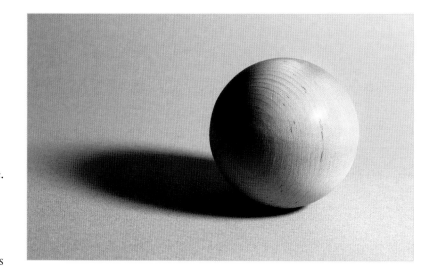

To illuminate the volumetric qualities of an object we want approximately two-thirds of the object to be in light, leaving approximately one-third in shadow. Here is a sphere that is lit in this way.

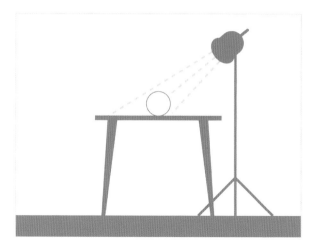

Let's take a closer look at how to achieve this lighting with some simple diagrams. Here we see a sphere sitting on a table with a single light source shining down on it at an angle.

The light source can be raised or lowered but, generally speaking, we want to keep the light shining down at an angle, not directly from above or directly from the side.

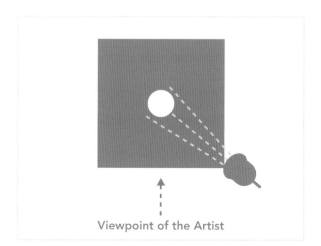

Viewpoint of the Artist

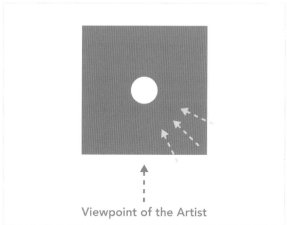

Viewpoint of the Artist

Now let's view this setup from above. The light is placed off to the side and is coming from the front of the sphere. Once again, we want the light shining on the subject from an angle.

We can move the light source more toward the front or more toward the side, but we don't want the light coming entirely from the front or entirely from the side.

By keeping our light source within the range illustrated, we will ensure dramatic light and shadow that will best describe the three dimensionalities of most objects.

Now let's take a look at the specific effects of light on a sphere.

# Light and Shadow Conditions on a Sphere

Most of what you need to know about light and shadow can be learned by observing light on a sphere. Later in this chapter I will teach you how light operates differently on cylinders and cubes. At any point in the following discussion, if you are having trouble seeing a particular light or shadow condition, it can be useful to squint your eyes or to let your eyes go softly out of focus. This will simplify the values into broad, more easily recognizable shapes and patterns.

Shadows fall into two fundamental categories: form shadows, which are shadows on the object itself, and cast shadows, which are cast by an object onto an adjacent surface. Form shadows are created when parts of an object face away from the light source and do not receive light directly. Cast shadows are created when an object blocks light from reaching adjacent surfaces.

First, let's focus on the shadow cast by this sphere onto the surface the sphere is sitting upon. The cast shadow contains the darkest value called the occlusion shadow. The occlusion shadow is located directly underneath the sphere where light is blocked entirely from hitting the surface the sphere is sitting upon. The cast shadow gets lighter the farther it travels from the sphere, but the entire cast shadow is quite dark.

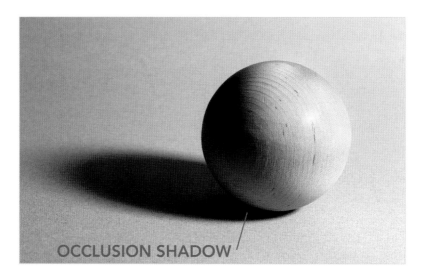

OCCLUSION SHADOW

The length of the cast shadow is determined by how far above or below the object the light source is. Even though the edge of the cast shadow is soft and diffused, we can follow a line from the far edge of the cast shadow, over the top edge of the sphere, and on toward the light source.

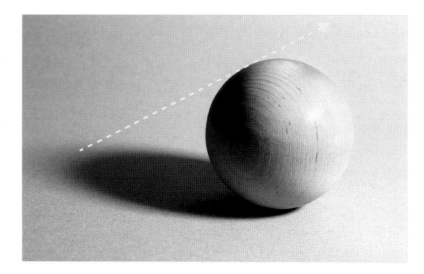

If we lower the light source, the cast shadow becomes longer.

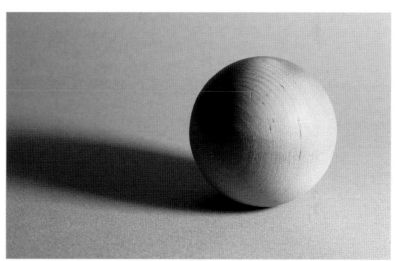

If we raise the light source, the cast shadow becomes shorter.

If we move the light source more toward the front, we can see the cast shadow begins to angle upward in the picture plane. Also note that when the light is coming too much from the front, we lose most of the shadows.

Any part of the sphere that is not receiving light directly from the light source is considered to be in shadow. Many people assume there is a long, slow gradation from light to dark as a sphere transitions from light into shadow, but this is not generally the case. Although the boundary between light and shadow is diffused, we can still divide the sphere into two distinct areas, a lit side and a shadow side. The line separating light from shadow is called the *line of termination*. It is where light terminates, or ends, and shadow begins. Here, the line of termination appears as a curved line. This helps reinforce the curving surface of the sphere in our drawing.

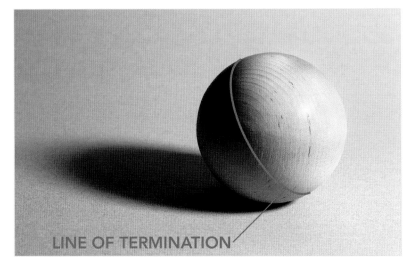

LINE OF TERMINATION

This curved line of termination is half of an ellipse, exactly like the longitude lines on spheres you studied in "Chapter 2: Form and Space." If we were to complete this ellipse, its axis would be perpendicular to the line from the top of the sphere to the edge of the cast shadow. This remains true even when the light source is raised or lowered.

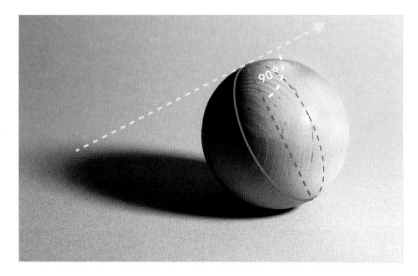

Now let's focus our attention on the shadow side of the line of termination. There are two shadow conditions on the sphere we need to understand: *reflected light* and the *core shadow*. The core shadow is a dark band of shadow that appears on rounded objects immediately to the shadow side of the line of termination. It can be most easily seen in this dark triangular area. Notice that one edge of the core shadow is at the line of termination.

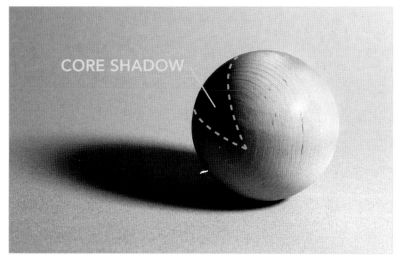

A more subtle area of the core shadow curves down to the bottom of the sphere. Although not as visible as the triangular area of the core shadow above it, this dark band is essential to include in your drawings.

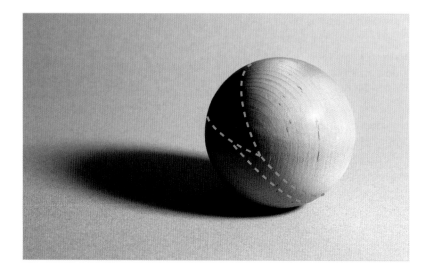

The core shadow is darker than the rest of the shadow side of the sphere because light from the light source ricochets off the surface the sphere is sitting upon and reflects onto the underside of the sphere. This lighter area is called *reflected light*. It's important to note that reflected light is still considered a shadow condition because it is not receiving light directly from the light source. Together, the core shadow and reflected light make up the shadow conditions on the sphere itself. Without reflected light, the entire shadow side of the sphere would be a single dark value.

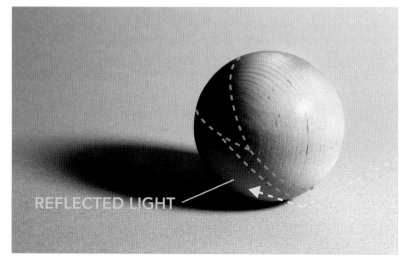

REFLECTED LIGHT

Now let's shift our focus to the lit side of the line of termination. Everything on the lit side of the line of termination is being hit with light directly from the light source, but this does not mean it is all the same value. The lit side of the sphere gets gradually brighter as it turns more toward the light source with the brightest area on the upper-right edge of this sphere, closest to the light source. This transition can be subtle and difficult to observe. To better see this phenomenon, take a

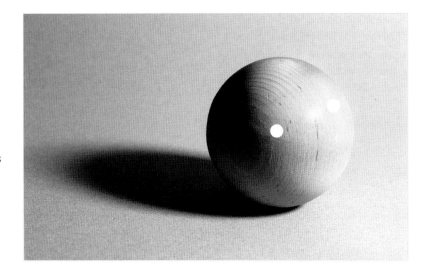

look at these two circles placed on different parts of the lit side of this sphere (above). In reality, these two circles are the exact same color and value, but the circle next to the line of termination appears brighter than the circle next to the right edge of the sphere. This is because the right edge of the sphere is facing the light source more directly and is therefore much brighter, making the circle appear less bright as a consequence. As the surface of the sphere curves away from the light source, it gets dimmer, making the circle next to the line of termination appear brighter by contrast. The bright area of the sphere near the light source is called the *center light*. The center light gets dimmer as it approaches the line of termination.

Finally, let's look at the highlight. The highlight is a bright reflection of the light source. Highlights are generally found on curved objects like spheres and cylinders. A highlight occurs when light from the light source ricochets off the surface of the sphere and travels directly into the eyes of the viewer. The highlight is the brightest value in a drawing.

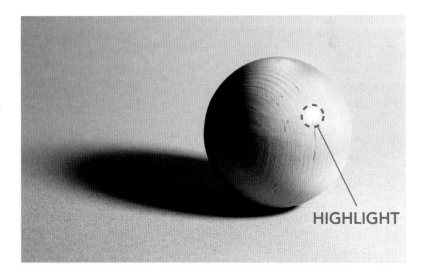

**HIGHLIGHT**

Because the highlight is a literal reflection of the light source on the surface of the sphere, the location of the highlight can change as you change your viewing position. This phenomenon occurs for the same reason the reflection in a mirror changes when you change your viewing position. On a more reflective sphere the highlight may appear sharper edged. On a matte surface like wood the highlight will have a softer edge.

These are the essential light and shadow conditions you need to understand in order to properly draw and shade an object. Now that you have an understanding of how light and shadow operate on a sphere, let's learn about value.

The word *value* refers to the degree of lightness or darkness of a color. There are light values and dark values. The word *value* encompasses the entire spectrum of light to dark from the deepest darkest shadows to the brightest, blinding highlights. These values can be arranged on a scale from dark to light. The best way to understand value as it relates to drawing is to make value scales.

# Create a Value Scale

For this project you'll be working with a 5-step value scale. Lightly draw five boxes of roughly equal size. Each box should be approximately one inch wide. You are welcome to use a straight edge. The exact size and shape of each box is not important.

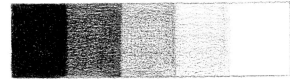

For the darkest value on the left, use the tripod grip to bear down on the tip of the pencil. Create the darkest value you can with the drawing tool you are using. I use the tripod grip to draw the darkest values because bearing down on the tip using the overhand grip is likely to break the pencil lead. Fill the far-left box completely and evenly with the darkest value you can make. To do this you will need to go over this value multiple times, each time changing the direction of the pencil strokes. This darkest value will be our #5 value.

Next, determine your #1 value, which is the lightest value. When using a white piece of paper, the #1 value will simply be the color of the white paper. If we were drawing on a toned or colored piece of paper the paper could be any of the other four values. You'll learn more about this in just a moment.

Here's a value scale drawn on toned paper. The #1 value of the toned paper was created using white pencil. The # 2 value is the value of the paper.

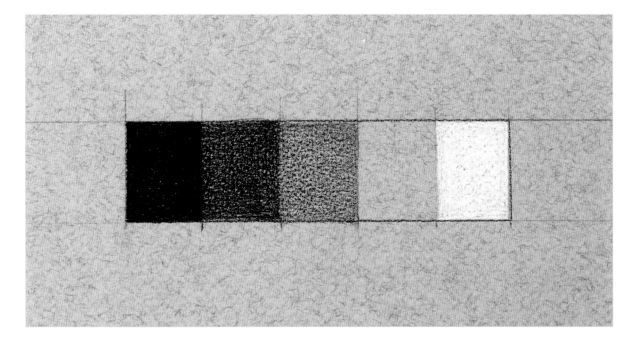

Once you have established your darkest and lightest values, fill in the other three values. On white paper, the lighter the value, the less pressure you will use when drawing it. Your goal is that each value in the scale is distinct and that there is an even step from each value to the next.

I'd like to note that I am using a single pencil for the value scale drawn on white paper. The darker the value the more pressure I exert on the pencil. Some people prefer to use a different value of pencil for each step in the scale. You're welcome to try this, although I find that it's ultimately easier to use a single pencil rather than switching pencils every time you want to switch values.

When filling in the three middle values you can use the overhand grip or the tripod grip. I prefer the overhand grip for all but the darkest value. I recommend starting each value box lightly and slowly darkening the values until you reach the desired darkness for each step in the scale. It's much easier to evenly darken a value than it is to evenly lighten a value. Although you can lighten a value with an eraser, it tends to smear the pigment and lift it unevenly.

As with all drawing skills, you may require a number of attempts before you produce a working value scale. But with each scale you produce, you will make essential distinctions and become more familiar with the process.

Once you have completed a successful value scale, practice replicating these values on another piece of paper. Your goal is to be able to produce any of these values automatically. Later on in the shading process, each of these values will have a specific function.

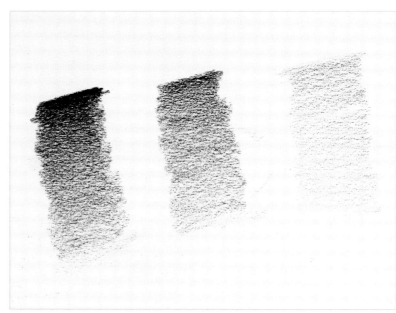

You should also practice drawing smooth gradations from one value to the next. For example, on the left you can see that I begin the value at #5 but it then transitions to a #4 value. The next value shifts from #4 to #3. Practicing these kinds of gradations is a critical skill we will use when we shade actual objects.

Practice making these values over and over. The goal is that they become second nature. This will make the shading process much more manageable.

Now that you have an understanding of how to draw different values and how they operate on a sphere, let's draw one.

# How to Shade a Sphere

## Before you Begin the Shading Process

In this demonstration, I will draw a sphere lit with a single light source. I will shade using the 5-step value scale you practiced earlier in this chapter. Below you can see the sphere I will be drawing. The light source is above the sphere and to its right. This means that the top right of the sphere is catching most of the light while the bottom left is in shadow. The light is also coming from the front of the sphere meaning that the majority of the sphere is in the light with a smaller portion in shadow. You can see that approximately two-thirds of the subject is in light leaving about one-third in shadow.

One of the most common mistakes I see beginners make is rushing to add shading and detail before the subject has been properly established on the paper. Before you begin shading a drawing, it's critical that the drawing is ready to be shaded. This means that your subject should be drawn properly in perspective, be in correct proportion, and that the contours of your subject are well defined. If your drawing doesn't meet these criteria, no amount of skilled shading will fix it.

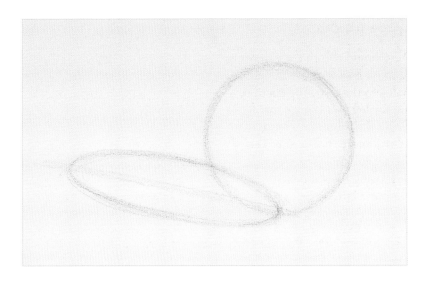

Here, you can see I have lightly drawn the two foundational shapes for this drawing, the circle for the sphere and the oval for the cast shadow. I have used the five questions you learned in "Chapter 1: Basic Skills" to arrive at the size and placement of the circle for the sphere as well as the length, openness, and axis of the oval for the cast shadow.

When I am confident these elements are properly drawn, I am ready to begin the shading process.

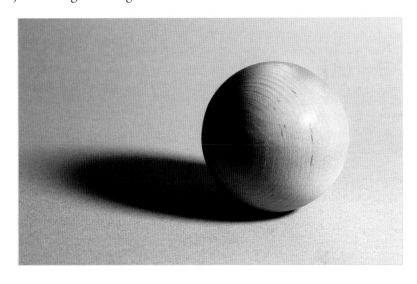

## Step One: The Line of Termination

A well shaded drawing keeps a clear division between light and shadow. Everything on the lit side of the line of termination is hit with light directly from the light source. Everything on the shadow side of the line of termination is not being hit with direct light and is therefore in shadow. Although each side of the line of termination contains different values, the darkest value on the lit side of the line of termination is still lighter than the lightest value on the shadow side. Conversely, the lightest value on the shadow side of the line of termination is still darker than the darkest value on the lit side. Organizing your values this way ensures a clear division between light and shadow.

Many people assume that the shift from light to shadow happens in a long gradation, but this is not generally the case. Although the line of termination is a soft boundary, it is still easily recognizable. As you learned earlier in this chapter, the line of termination is half of an ellipse.

Keeping all of this in mind I will draw the half ellipse for the line of termination using a soft, light line. To do this I have actually drawn the entire ellipse but darkened only the left side.

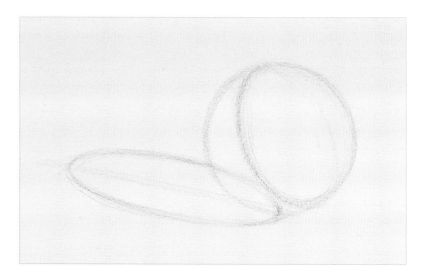

Next, I will darken all shadow areas with a light value made with the side of my pencil. Beginners often assume that shading is done in a single pass, but most artists build up their values, starting with lighter values and darkening them throughout the shading process. This gives us some room to correct any issues and make sure the shading is working before rushing into dark values that are hard to lighten or remove once drawn.

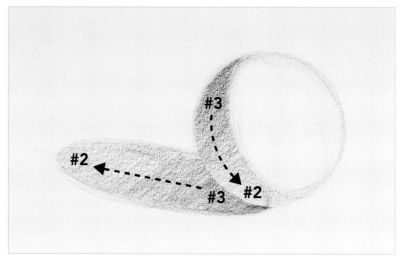

On the sphere itself I have used a #3 value at the top of the shadow shape that transitions into a #2 value at the bottom of the sphere. In the cast shadow shape, I have begun with a #3 value directly underneath the sphere and transitioned to a #2 value as the cast shadow moves toward the left. The reasons for this will become clear in the following steps. This creates a clear division between light and shadow. You must maintain this division throughout the entire drawing process. Even with this simple division between light and dark, the drawing already begins to take shape. Before moving on, make sure the light and shadow shapes do not require any adjustments. Even while shading, I encourage you to ask yourself what changes you can make after each step.

## Step Two: The Cast Shadow

The cast shadow contains the darkest values you will draw. Right underneath the sphere is the darkest part of the cast shadow called the *occlusion shadow*. The occlusion shadow is where light is blocked entirely from hitting the surface the subject is sitting upon. It is the only part of the shadow you will draw entirely black. As the shadow travels away from the sphere you will notice it becomes lighter due to the ambient light in the environment. You will also notice that the edge of the cast shadow as hardest directly underneath the sphere and softens as the shadow travels away from the sphere. This softer, lighter part of the cast shadow edge is called the *penumbra*.

When I darken the cast shadow, I begin by using the tripod grip to bear down on the tip of the pencil to create the #5 value. This is the only time I will push the pencil to its darkest limits. The cast shadow moves from a #5 value at the occlusion shadow to a #4 value as it nears the penumbra, before fading altogether. I switch to the overhand grip as I draw the penumbra to give it a softer edge. We have now defined the darkest value in the drawing.

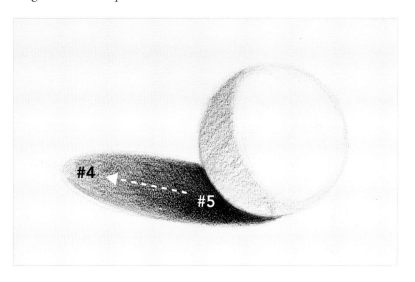

Our goal is not yet to perfect the shadows. At the end of the drawing, we will refine the values, shapes, and edges of the shadow. For now, we just need a first attempt. Remember, it is easier to darken a value than it is to lighten one. If you are unsure of how dark a value should be, draw it a step lighter and darken it later if needed.

## Step Three: The Core Shadow and Reflected Light

Although not as dark as the cast shadow, the core shadow is the darkest shadow on the sphere itself. As you learned earlier, you can see the core shadow most clearly as a curving triangle on the upper left of this sphere. The core shadow also has a secondary band that curves its way to the bottom of the sphere. It is not as dark as the triangular core shadow above and is therefore more difficult to see but is still an important shadow to include in your drawings.

I will first define the triangular upper section of the core shadow. I only need to draw a single line to do this as one side of the core shadow is at the line of termination and another is at the edge of the sphere itself. I will define the boundary between the core shadow and the reflected light using a soft, light line.

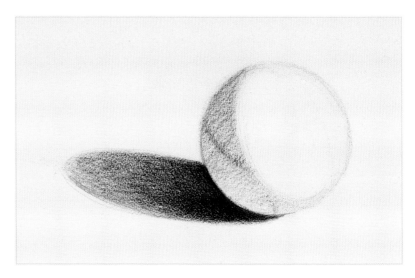

Next, I will darken the core shadow moving from a #4 value at the upper left and moving toward a #3 value at the bottom. It's important to note that these values are approximate. Later in the shading process we will refine them.

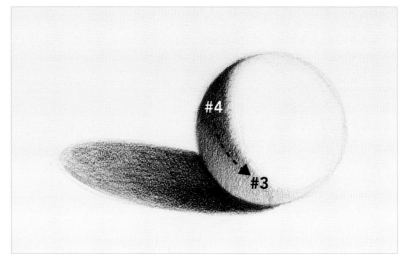

Darkening the core shadow divides the form shadow on the sphere into two distinct areas: the core shadow, which we just discussed, and reflected light. Although we already darkened the area where the reflected light is, I will darken it a bit more moving from a #3 value just below the core shadow and will transition to a #2 value near the bottom of the sphere. As you know, the shift from light to shadow at the line of termination is drawn as a soft edge. The shift from the core shadow to the reflected light should be even softer.

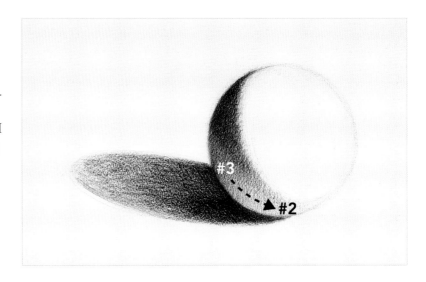

We have now made a first attempt at all of the shadows. It is now time to shift our attention to the lit side of the line of termination.

## Step Four: The Midtone and Center Light

There are two primary lighting conditions on the lit side of the line of termination: the center light and the highlight. The center light begins as a #2 value near the line of termination and becomes lighter as it moves toward the edge of the sphere closest to the light source. Although the center light begins at a #2 value and gets lighter, it does not get quite as light as a #1 value, or pure white. The highlight is the only area where we will use our #1 value. I find the 5-step value scale to be the most straightforward scale to use when shading, but the closer we get to completing the drawing, the more we need to be flexible with these values. The center light will be approximately a #1.5 value at its brightest near the light source. It may need to be darkened before the end of the drawing, but remember, I am just making my first attempts here and will refine the drawing later. The center light is a subtle lighting condition but one that enhances the verisimilitude of a drawing.

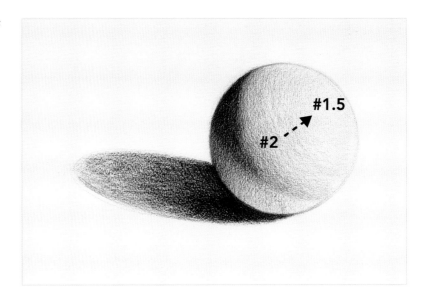

The midtone occurs right before a form turns away from the light and goes into shadow. It occurs at the line of termination, at the transition between the center light and the core shadow. A midtone is not a shadow because it is still receiving a small amount of direct light from the light source, but it is receiving so little light that it does not register as being lit. The midtone occurs at the location where the object turns away from the light but has not yet gone into shadow. The midtone will help soften the edge of the line of termination.

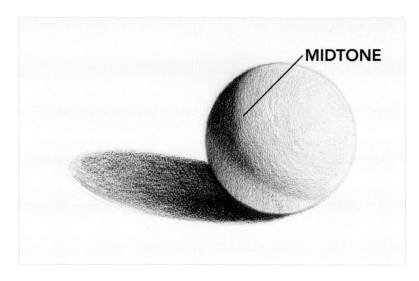

## Step Five: The Highlight

The highlight is the final lighting condition we will address before refining the drawing. The highlight is the brightest light in a drawing. It is the only place we will use our pure white, #1 value. A highlight occurs when light from the light source ricochets off the surface of the sphere and travels directly into your eyes.

On white paper the highlight is created with the unsullied white of the paper. When we added the center light, we added value in the area where the highlight should be. But not to worry. We will erase out the highlight, restoring the white of the paper.

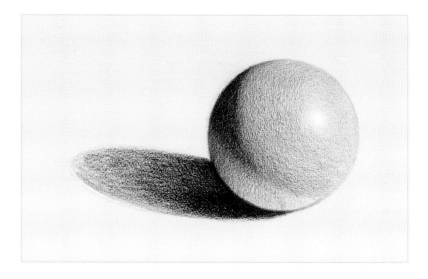

# Refining Values

We have now made our first attempts at drawing all of the light and shadow conditions of the sphere. It is now time to refine the values. The specific values will depend on the subject you are drawing, how it is lit, and even personal preference. In this final drawing I have darkened the upper edge of the core shadow to an approximate #4.5 value. Additionally, I darkened the reflected light because I thought it appeared too bright. I also darkened the center light to make the highlight stand out more.

For the highlight to truly gleam, it is important that it is the brightest value in the entire drawing. Therefore, I added some value in the background so that the only white of the paper visible in the drawing is the highlight.

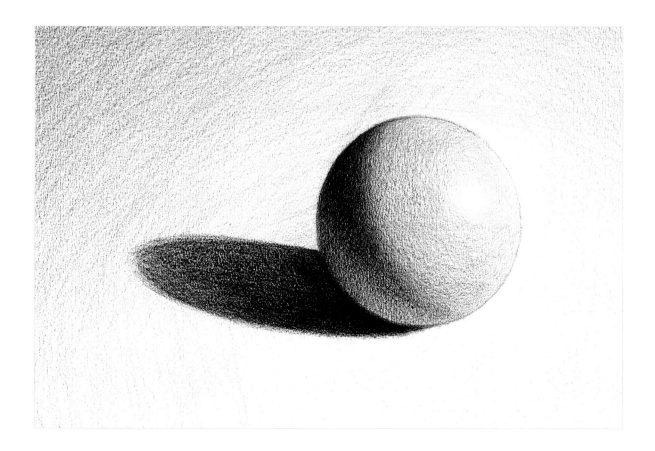

## Shading on Colored or Toned Paper

Here is a drawing of a sphere done on toned paper, rather than white paper. The process for drawing shadows is the same on toned paper as it is on white paper. However, draw-

ing on toned or colored paper requires you to add white for the highlight and center light. Practicing shading on toned paper, in addition to white paper, is an excellent way to study the shading process.

Now that you have been introduced to the shading process for the sphere, let's see how this process differs when drawing a cylinder and a cube.

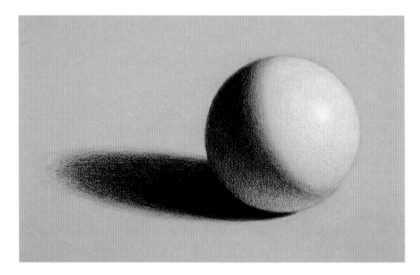

## Shading the Cylinder

The cylinder, like the sphere, is a rounded object, and light operates on these two volumes in a very similar way. The biggest difference is that a cylinder only curves in one direction. If we were to draw a line around the circumference of a cylinder it would make a circle. But if we drew a line along the shaft of the cylinder, it would make a straight line.

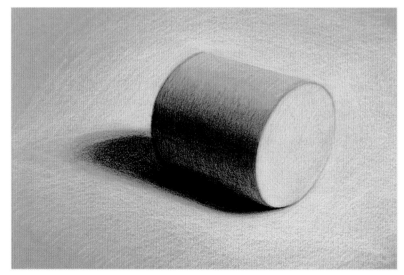

This means the cylinder still has the same shadow conditions as the sphere, although they present somewhat differently. You can clearly see a core shadow and reflected light. But unlike the sphere, these shadows on a cylinder appear as straight bands of value that run along the shaft of the cylinder. The shape of the cast shadow is, of course, determined by the object casting the shadow. Here we can see the curved ends of the cast shadow connected by a straight edge, mimicking the shape of the cylinder itself. We can also see an occlusion shadow underneath the cylinder.

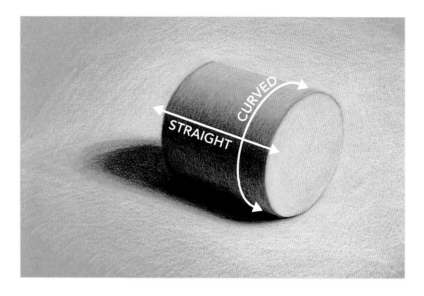

The lit areas on a cylinder can operate somewhat differently from the lit areas on a sphere. For example, depending on the cylinder's relationship to the light source, sometimes you will see highlight, other times you will not. But even without a visible highlight, the center light should be present in most circumstances, as it is in this drawing. The biggest difference between a cylinder and a sphere is the flat, circular plane at either end of the cylinder. The value of this flat plane will change depending on how the light

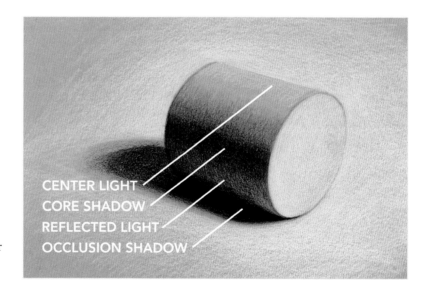

is hitting it. The value of this plane should be determined on a case-by-case basis by comparing it to other values on the cylinder. In this drawing the flat plane is one of the brightest values in the drawing because it is facing the light source rather directly.

## Shading the Cube

In many ways, cubes and boxes are easier to shade than spheres or cylinders. Cubes and boxes are made up of flat planes that come together at right angles. The line of termination on a cube occurs at plane changes and is therefore hard edged. Because the planes of a cube are flat, we will not find core shadows, highlights, or reflected light as we would on curved surfaces. In fact, we see almost no gradations at all.

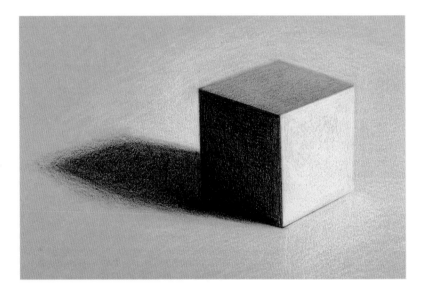

Flat planes receiving light directly from the source tend to be illuminated evenly across their surfaces. In this drawing the plane on the right side of the cube, as well as the top plane, are both receiving light directly from the light source. The value on each lit plane is distributed evenly across each surface. You will notice, however, that although both planes are being hit with light directly from the light source, the side and top are different values. The plane on the right side of the cube is much brighter because it is being hit with light more directly. The top plane is still being hit with light directly from the source, but it is not facing the light source as directly and is therefore dimmer.

While the values of the lit planes are distributed evenly across their surfaces, the shadow plane has a darker area near the bottom, right next to the occlusion shadow. This is a reflection of the cast shadow.

As you practice drawing and shading cubes, the value of each plane should be compared to the 5-step value scale to see which best describes each plane. For example, on this cube the right plane of the cube is closest to a #1 value, the top plane is closest to a #2 value, and the left plane is closest to a #4 value. If the location of the light source is changed, it can change the values of each plane. The 5-step value scale is an excellent starting point for your initial attempts at shading the planes of a cube. The values can be refined as the drawing progresses.

# Summing Up the Shading Process

The shading process I have just described works for basic volumes, like spheres, cylinders, and cubes, as well as more complex subjects like still-life subjects and even the human figure. The specifics of this process can be adapted to suit the subject.

Here is a summary of the shading process:

- **Step 1:** Draw the fundamental shapes and volumes that make up your subject. Before you shade, make sure your subject is in proportion, is in proper perspective, and has accurately drawn contours.

- **Step 2:** Once your subject is properly drawn, determine what direction the light is coming from and divide the lights from darks with the line of termination. This line will be soft edged on curving surfaces, and hard edged where flat planes meet at angled edges. More complex subjects may have multiple lines of termination.

- **Step 3:** Simplify the light and shadows into one light value and one dark value by darkening all shadow conditions and leaving the lightest values the value of the paper. If done correctly, you will begin to see the illusion of light and shadow in a nascent form.

- **Step 4:** Darken the cast shadow and establish the darkest dark in the drawing.

- **Step 5:** Darken the form shadows. For curved surfaces this requires darkening the core shadow thereby revealing the reflected light. For flat planes this requires darkening any plane not receiving direct light and darkening the reflected shadow, if visible.

- **Step 6:** Once the shadows have been addressed you will draw the light. On curved surfaces this may include the center light and the highlight. For flat planes this includes determining the value of each lit plane by comparing it to the values in the 5-step value scale. Lit planes will most likely be between a #1 and #3 value.

- **Step 7:** Refine the values by looking back and forth from your subject and then adjust the values until you feel you have captured the values and relationships you observe.

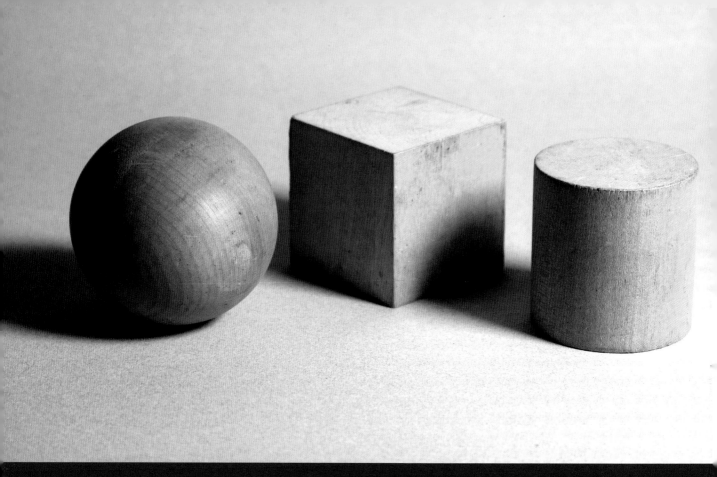

# Shading Basic Volumes

The best way to learn how to shade is to light your own objects and draw them from observation. Find a spherical object, a cylindrical object, and a cube-like object. You can purchase geometric volumes made of wood at many hardware stores. Wood is an excellent material for studying the effects of light because it is just reflective enough to have clear highlights but not so reflective that its surface becomes mirror-like. You can also find these volumes around your house. An orange or a ball could work as a sphere, a coffee cup or cylindrical pitcher would work as a cylinder, and a cardboard or wooden box could work as a cube. It is best if these objects do not have any text, images, or patterns on their surfaces.

Using a single light source, light each object as demonstrated earlier in this chapter. One by one, observe the effects of light on the object and draw what you see.

The best lighting for most subjects is when two-thirds to three-quarters of your subject is in direct light, leaving the remainder in shadow. Although this is the most common form of lighting you will draw, I encourage you to experiment with lighting. See what happens when you pull the light behind the object or place it directly above. Although you will rarely use this kind of lighting in your drawings, it will teach you how light operates and familiarize you with the logic and laws of light.

*Although it is best to draw from observation, here is a reference photo you can draw from if you have trouble finding or lighting basic volumes.*

# Beyond the Basics

Once you are able to draw and shade fundamental volumes like spheres, cylinders, and cubes, you can work your way up to more complex subjects. It's important you don't rush into advanced subjects after shading a few spheres. Stay away from figures and faces at this stage. Instead, try grouping basic volumes together and shade simple objects that challenge you to adapt the lessons you learned earlier in this chapter. Here are some examples.

Here we see a cone and an egg. They are lit with a single light source coming from the upper right. Although we have not addressed shading cones or eggs directly, hopefully you already recognize all of the shadow conditions on these objects.

The cone is a variation on a cylinder. Like a cylinder, if we were to draw a line around the cone laterally, we would get a circle. If we drew a line from the tip to the base it would be a straight line. We can easily identify a core shadow, reflected light, cast shadow, and center light on the cone. The biggest difference, of course, is that a cone tapers as it travels upward to a point at the top. The values do the same: Each band of value on the cone itself begins larger at the bottom and narrows to a point at the top.

The egg, also known as an ovoid, is a variation on the sphere. We can easily identify a curving core shadow similar to the one found on a sphere, although the core shadow on the ovoid is elongated. We also see reflected light, a cast shadow, a center light and a highlight. The biggest difference between an egg and a sphere is that an egg is elongated. This can seem to stretch the shapes of the values when compared with a sphere.

When drawing two objects next to one another, one may cast its shadow onto the other. Here you can see the cone casting its shadow first on the ground plane and then over the egg. Notice that this cone's cast shadow maintains the triangular shape of the cone, but it curves as it moves over the surface of the egg. Cast shadows maintain the shape of the object casting it, but they also take on the characteristic of the surface on which their shadow is cast. This is a critical lesson that is easy to miss if you advance too quickly to complex subjects.

Now let's take a look at another subject: a simple bowl.

This seemingly simple object has a lot to teach us about light and shadow. The basic volume of a bowl is closely related to a sphere. Imagine a sphere with its top half removed and a portion of the bottom removed. Now imagine the remainder being hollowed out. Because this bowl is a modified sphere, we would expect to find evidence of this in the light and shadow. Indeed, we do! We can clearly identify a core shadow and reflected light on the left side of the bowl along with a center light on the right side. We do not see a highlight because the top part of the sphere, where the highlight would be, is not there.

The entire rim of the bowl is receiving light directly from the light source. Because the entirety of the rim is in the same plane, it is a single, even value all the way around. I say the rim is in one plane because if we placed a flat object, like a book, on top of the bowl, the book would rest on top of the entire rim of the bowl. The entire rim of the bowl would come into contact with the flat plane of the book.

Because the light source is on the right, the bowl casts its shadow toward the left. But you'll notice that the right side of the rim is actually casting a second cast shadow into the hollow of the bowl itself. As your subjects become more complex, you will often see them cast shadows onto themselves. This is particularly common in figure drawing.

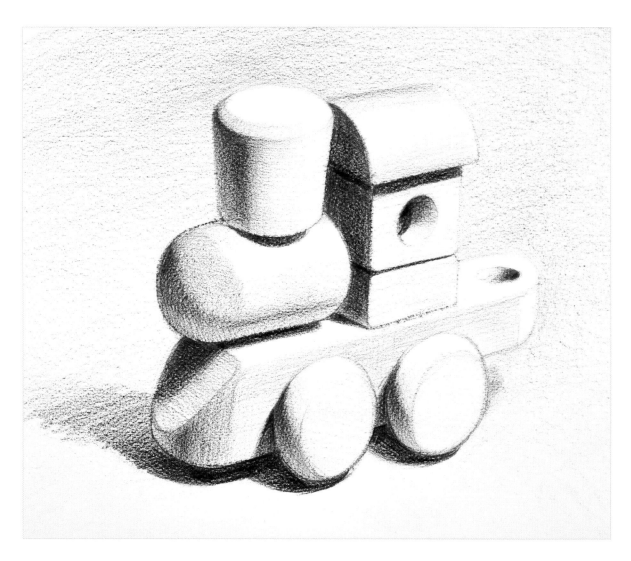

Next let's take a look at a subject that contains numerous volumes: a wooden toy train. This subject contains eight individual volumes.

Most of these volumes are compound or have been modified in some way. For example, the smokestack of the toy train is a truncated, upside down cone. The edge of the circular plane at the top of this cone is beveled. Underneath that volume is a horizontal cylinder with a half-sphere attached to its left side.

Each of these volumes still follows the light and shadow patterns you learned from more basic volumes. Let's focus for a moment on the cylinder with the half sphere on its left side. We can clearly see the curving core shadow and reflected light on the spherical portion of the volume, but they transition seamlessly into straight bands of value on the cylindrical portion.

As you study this drawing, see if you can identify where the light source is and the resulting light and shadow conditions. Ask yourself why they appear the way they do.

# Organic Form

Now let's take a look at how light operates on organic or irregular forms. Organic forms, like fruit, vegetables, animals, and people are still derived from basic volumes, but these volumes often have irregularities on their surfaces. To see what I mean let's look at this drawing of a pear.

The largest volume at the bottom of the pear is spherical. Above this sphere is a smaller cylinder and on top of the cylinder is a half sphere. While pure spheres and cylinders have smooth, consistent surfaces and curves, organic forms have depressions, furrows, protuberances, and other surface irregularities. Despite these irregularities, we can still use the same light and shadow patterns found on basic volumes to inform the more complex patterns found on organic forms. Here is a simplified drawing of the basic light and shadow patterns found on this pear.

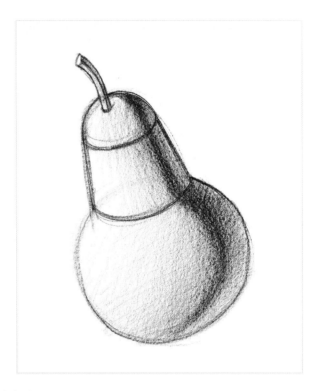

Compare the completed pear drawing with the simplified version. Hopefully, you can see that, despite the surface irregularities depicted in the finished drawing, the shadows are still organized along the same light and shadow patterns found on basic spheres and cylinders.

It's important not to lose this primary organization of light and shadow when shading smaller details. For example, look at the small, ovoidal protrusion at the very bottom of the pear. Notice that protrusion has its own core shadow and reflected light just as we would see if we were shading an ovoid on its own, but it also joins with the shadow patterns at the bottom of the larger spherical volume on which the ovoid is located.

As you look at the drawing of this pear, notice there are many deviations from the basic light and shadow patterns depicted in the simplified version, but none of these smaller details are as visually prominent as the light and shadow patterns of the larger volumes.

If you're not confident you can capture all the details in your first attempt at the line of termination, I recommend simplifying it. Once you have drawn a simplified line of termination, you can go back over it a second time to address smaller details.

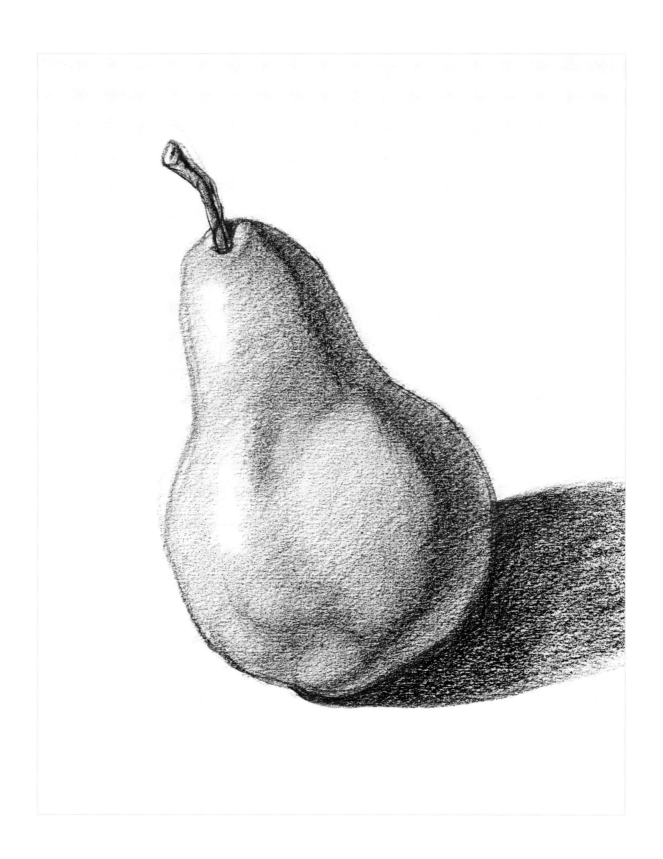

Next, let's take a look at this drawing of a butternut squash.

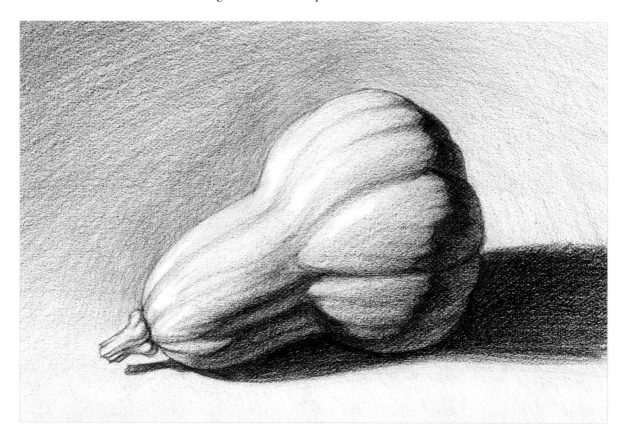

The simplified volumes of the squash are similar to the pear. The squash can be simplified into a large ovoidal volume, seen here on the right, which is attached to a smaller cylinder with a half sphere on the left end. Note that the squash has a more substantial stem than the pear. I have simplified the stem into a conical volume with a cylinder at its small end.

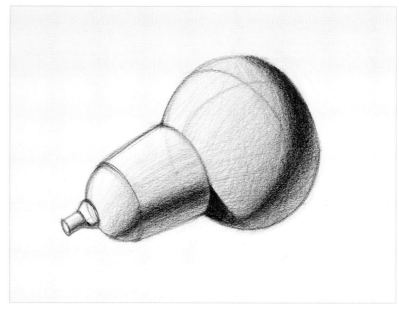

In this simplified drawing we can see the familiar light and shadow patterns found on spheres and cylinders. Note that the cylinder of the neck of the squash is casting a shadow onto the large ovoid.

The biggest difference between a pear and a squash is that the squash has numerous segments with a depression between each segment. On the large, ovoidal volume on the right side of this squash the segments present as smaller, elongated ovoidal shapes. On the cylindrical neck of the squash the segments are closer to cylinders that run straight before curving over the surface of the half sphere at the left end of the squash.

We can think of this squash as having two levels of light and shadow patterns. When we look at the simplified, geometric version of the squash we can clearly see the overall values of the larger forms. But there's also a secondary level of light and shadow. Each individual segment of the squash has its own light and shadow pattern that operates independently from the larger patterns, but are still organized on top of them.

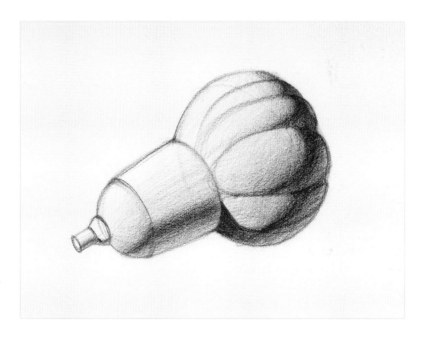

In this drawing I have divided the large, ovoid segment of the squash into segments. Observe how the core shadow of each segment helps communicate its roundness. Together these shadows line up on top of the larger curvature of the core shadow pictured in the previous, simplified drawing.

Once you've had a chance to observe the two simplified versions of the squash, look again at the finished drawing on page 162. Hopefully, you can see that the final drawing includes many more details and irregularities that are common on organic forms. The core shadow of each individual segment appears serrated, communicating to the viewer that there are even smaller, more subtle topographies. But even with all of this surface detail, we can still clearly see the larger light and shadow patterns on which all other details are organized. No matter how complex your subjects, it is essential you maintain a clear division between light and shadow.

# Shade Complex Objects

Select two objects: one human made, like a cup or bowl, and one organic object, like a fruit or vegetable. One at a time, light each object as shown earlier in this chapter, and draw them using the shading process you just learned. Make sure you slowly work your way up to increasingly complex subjects. Perhaps begin with a simple organic object like a pear before attempting something more complex like a pinecone or an antelope. Moving on from shading simple spheres, cylinders, and cubes can be challenging, but remember, all form, no matter how complex, is made up of basic volumes. By understanding how to shade basic volumes, you have all the knowledge and experience you need to shade more complex subjects.

Now that you have an understanding of how the shading process works, let's apply everything we've learned so far to the human figure.

# AN INTRODUCTION TO
# FIGURE DRAWING

The human figure is one of the most challenging and rewarding subjects you can draw. A successful figure drawing finds a relationship between the mechanical complexities of anatomy and the tempestuous passions within each individual.

Before you begin figure drawing, it is essential that you develop both a competence and comfort with all the previous skills taught in this book. If you struggle to properly shade a sphere, then rendering the complex topography of the human torso will be an infuriating and impossible endeavor. Students who begin figure drawing before they are ready very often quit out of frustration. The figure should be a subject you work your way up to after developing strong fundamental drawing skills.

Humans have been pictorially representing the figure for tens of thousands of years. Each culture has developed their own styles and methods of depicting the figure. Figurative art is still relevant and evolving to this day. No single book can possibly teach you everything about figure drawing, but this chapter will introduce you to the core concepts of figure drawing. By focusing on the following skills, you will have a solid foundation upon which you can build more advanced figure drawing skills.

This chapter is by no means an exhaustive treatise on figure drawing, but rather a distillation of the crucial tools and techniques of the craft. This introduction to figure drawing will provide practice exercises that will lay the foundation for further figure study. Here are the three core concepts you will learn in this chapter.

## Gesture

Gesture drawing aims to capture the dynamism and action of a pose. Gesture drawings are usually done quickly and are often exaggerated to evoke an emotional response in viewers. These drawings usually have a simplicity and vitality to them that is often lost in more polished figure drawings.

## Volume and Structure

The human body is like a machine with thousands of moving parts. Before we get caught up in the mechanical details of the body, we must first understand and construct the figure from fundamental volumes like cylinders, ovoids, and boxes. Only then will the smaller details make sense.

## Light and Shadow

Our goal is to create the illusion of a living, three-dimensional figure on the flat surface of the paper. Rendering believable light and shadow is one of the strongest tools we have to do this. By understanding how to shade fundamental volumes like cylinders, ovoids, and boxes we will be able to capture the more complex light and shadow patterns of the figure.

# Gesture Drawing

Gesture drawing is one of the most important but least understood parts of the figure drawing process. A gesture drawing captures the dynamism and action of a pose. Gesture drawings simplify the figure, prioritizing the larger forms and relationships over detail. They tend to be done quickly from short poses ranging from 10 seconds to 10 minutes. To help you understand gesture let's focus on some key concepts.

Earlier in this book you learned that each shape and volume has a particular tilt in space called an axis. We find this axis by drawing a line through the longest dimension of the volume. Each part of the body has its own axis. Most axis lines of the figure are curved. Capturing these axis lines and how they curve, and flow into one another, is what will help your drawings appear alive, instead of robotic.

To see this in action, let's look at a set of three drawings starting with the most finished drawing (right).

This gesture drawing was done in about 10 minutes. The short pose times of gesture drawings force us to simplify the poses, distilling them down to their essence. In a 10-minute gesture drawing some detail and shading may be added, but they are not the main purpose of gesture drawings. The goal of a gesture drawing is to create a spirited, lively drawing that captures the action and energy of a pose. I know descriptions like these can seem esoteric, but bear with me as I deconstruct what makes gesture drawing unique and vital.

Take a look at the leg on our right. The leg as a whole has an S-curve that flows through it. This curve is slightly exaggerated in this drawing, but it helps reveal the fluid gesture that runs through the upper and lower parts of the leg. Now take a look at the torso above it. The torso has a C-curve that is more dramatically arched than the S-curve of the leg. I have isolated these two lines in this drawing (right).

Gesture is most beautiful and dramatic when it finds the relationships between these parts. Not only are most parts of the body subtly curved, but they often flow into one another. For example, notice that I drew a line that connects the C-curve of the torso and S-curve of the leg that lets them flow right into one another. In a figure drawing we want to emphasize these flowing curves and find relationships between the various parts of the body. Without this sense of flow and unification, figure drawings often have an awkward, disjointed quality about them with each part of the body seeming separate and erratic.

The torso and leg each have their own curving gesture that can be unified to create a single, sweeping gesture that runs through both of them. This is often referred to as the primary action line, a line that drives the most prominent action of a pose.

Let's take this idea even further. Notice that the C-curve of the torso extends upward into the neck and head. Additionally, the S curve of the leg extends into the foot ending in a sharp curve as the toes bend and press into the ground plane.

This gesture line runs through the body, pulling multiple volumes together like beads on a string. Sometimes gesture lines run through the inside of volumes, other times they seem to flow along their edge. A gesture line can travel anywhere it needs to in order to unify the body.

Of course, not every part of the body is accounted for in the primary action line. The leg on our left projects forward at a perpendicular direction to the primary action line and the arm on our right projects backward in an entirely different direction. These provide tension, and contrast to the otherwise unified gesture.

Another common goal in gesture drawing is to find the tilt of the shoulders and pelvis. In the drawing above, you can see a line going across the top of the shoulders to illustrate the direction between them. Notice how oblique it is.

This drawing has distilled the pose down to its essential lines. You can see the primary action line running from the head down to the foot with the remaining limbs simplified into individual lines.

Each and every pose will have a different gesture. The goal is to seek out the parts of the body that flow together in a single, sweeping movement, and unify them.

Not every line flows into another. Often, two lines will come together at a sharp angle, particularly in the arms and legs. In this drawing, note that the upper and lower sections of the leg on our left meet at the knee at a sharp angle. All the lines come together to help establish a basic sense of proportion.

You can see in the more finished gesture drawing on page 167 that even when limbs don't come together at sharp angles, I still denote the location of each visible joint, including the wrists, elbows, knees and ankles.

There is no single *correct* way to do a gesture drawing. A different artist may have seen and drawn a different primary action line or focused on different relationships between the various parts of the body. For example, take a look at this gesture drawing.

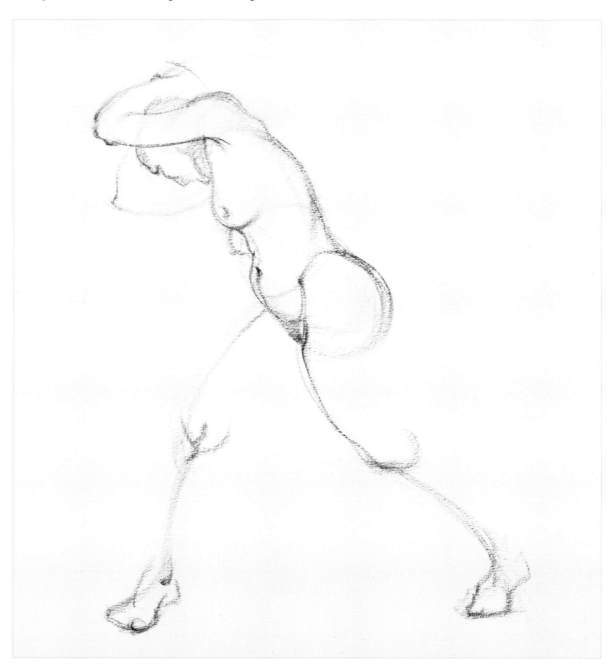

This was drawn from a five-minute pose. Notice that, despite its simplicity, it describes the entirety of the pose from the position of the arms to the grounding of the feet.

Let's look at two possible gestures that distill this pose down to its essence. In this drawing you can see the primary action line traveling down the front of the torso all the way down the front of the leg on our right and on down to the foot. Although this line is not drawn explicitly in the more finished drawing, hopefully, you can see how this line describes the way the torso flows into the leg. The other leg and the two arms have been simplified into lines that depict the position, direction, curvature, and length of each part of each limb.

Now let's look at a different solution. Here we see the primary action line flows down the curvature of the spine, cuts trough the torso and then down the leg on our right. The top of this line even hints at the lowered head. Once again, the other leg and arms have been simplified into directional lines. But notice that, in this gesture, the arm closest to us seems to flow directly out of the primary action line.

Both of these simplified gesture drawings are perfectly acceptable outcomes for this pose, and there may be many more versions! Take a moment to compare the simplified gestures to the more finished drawing on page 169 so you can see how each simplified gesture captures the action of the pose in a different way.

There's no clear dividing line between a gesture drawing and a more finished drawing. Every figure drawing you do should be gestural, meaning that it should appear dynamic and alive. Some gesture drawings can incorporate anatomical detail or even shading. But remember, the primary goal of a gesture drawing is to capture the dynamism and action of a pose and to focus on the relationships between the parts of the body.

Many students don't understand why they must learn gesture drawing. They just want to draw the literal figure. To understand the importance of gesture drawing, compare these two drawings done from the same pose.

The drawing on the left depicts the basic pose but it is not nearly as dynamic as the drawing on the right. In the drawing on the right, the torso is leaning back more, the legs are bent at more acute angles, the hip is thrusting further out, and the limbs are more curved. The drawing on the right has a sense of vitality and excitement that is missing from the drawing on the left. By comparison, the drawing on the left appears stiff and lifeless. The vast majority of viewers prefer drawings like the one on the right.

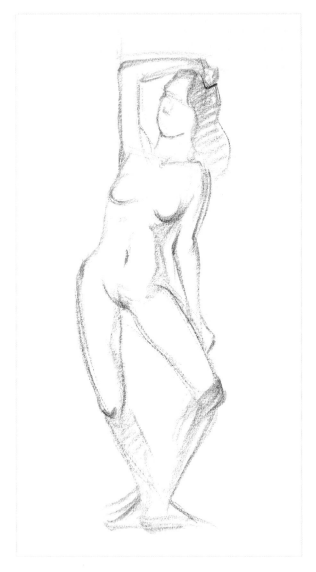

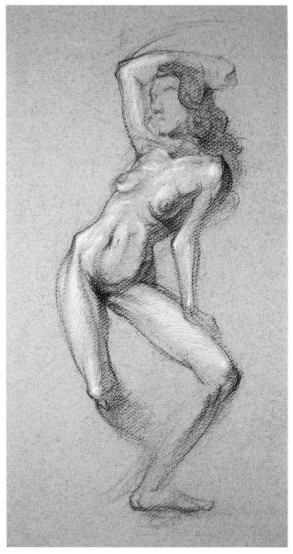

Gesture drawing is the art of capturing the dynamism and action of a pose. The energy and spirit of a vibrant gesture drawing will be carried through to the end of a more finished drawing, imbuing it with a sense of life. Without making a study of gesture drawing, your figures will most likely appear robotic and stiff. The more you practice gesture drawing, the livelier and more dynamic your figure drawings will become.

Although gesture drawing can be difficult to define, it tends to share some common elements: simplicity, dynamism, fluidity, and exaggeration.

## Simplicity

A gesture drawing aims to simplify the pose into a collection of basic forms and relationships. Often, the limbs of the body are simplified into single lines capturing their direction, length, and curvature, rather than a contour traced around the outside of the limb. These simplified drawings allow us to focus on the body as a whole and the forces that make a pose dynamic and exciting.

## Dynamism and Action

A gesture tries to capture the dynamic forces of a pose. In addition to focusing on the various parts of the body a gesture drawing tries to capture what these parts of the body are doing. A gesture drawing depicts actions like twists, extensions, bends, and lifts.

## Fluidity

Nearly every part of the body has a subtle curve to it. These curves often flow into one another, unifying the various parts of the body. In gesture drawing we endeavor to capture these curvatures to create drawings that appear fluid.

## Exaggeration

Gesture drawings are often exaggerated. This is because we have a tendency to stiffen poses when we draw them. Human beings crave stability. The human body is most stable when it is standing perfectly vertical or lying horizontally on a ground plane. When the figure begins to take more dynamic poses, our minds register a loss of stability. Some of the most beautiful and dramatic poses we will draw appear unstable due to their difficulty to hold. When we draw these poses, we tend to stiffen the pose in an unconscious effort to try and stabilize the figure.

This tendency to straighten curves and bring oblique angles closer to horizontals or verticals is so pervasive that I actually push students to exaggerate the curves and angles in their drawings.

Even after 25 years of serious figure drawing I still find this tendency within myself. I regularly feel as if I've exaggerated the curves and angles in a gesture drawing too much only to find upon reexamination that I have just barely captured the drama of the actual pose.

When most students draw, they tend to stiffen poses in a misguided attempt to make poses feel more stable. To counteract this common issue, I recommend exaggerating the dynamics of a pose. For example, if one shoulder is lifted higher than another, increase the difference between them. If the torso is slightly twisted, twist it a bit more. If a leg is extending, extend it a bit more. Because the temptation to stiffen a pose is so strong, by attempting to exaggerate the parts of the body we are more likely to capture the angles and proportions of the actual figure in front of us.

Let's take a look at another set of gesture drawings starting with the most finished drawing in the set. This was drawn from a 10-minute pose.

Because of the short pose times, gesture drawings are not intended to be finished. We must make decisions about what to include in a gesture drawing because we do not have the time to include everything. In the limited time you have it's a good idea to ground the figure. In many poses, one leg will bear the most weight. We call this the weight-bearing leg. In this drawing the figure is standing on

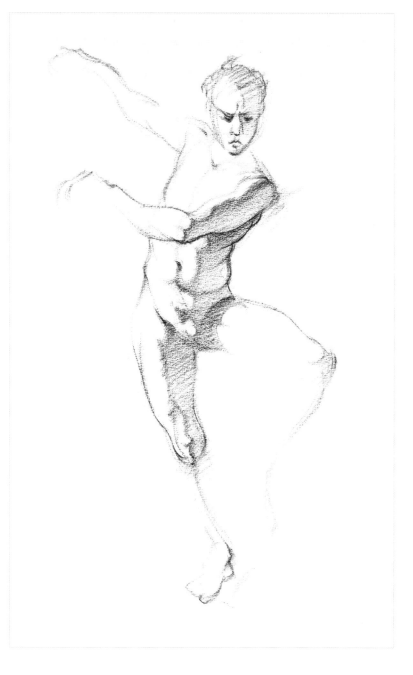

one leg. This leg is bearing all the weight of the figure. This is the leg I chose to focus more attention on. The weight-bearing leg is more defined than the raised leg, and the foot is clearly positioned on the ground. The raised leg is not bearing any weight and is drawn with light, airy lines.

Now that you have a sense of the pose, let's take a look at an extremely simplified drawing of it focusing entirely on direction and flow.

I've drawn the primary action line running from the side of the torso on our left, all the way down the body toward the foot. To the right of the primary action line, you can see evidence of an early attempt at a different primary action line that runs down the centerline of the torso, between the pectoral muscles of the chest. I often try out different action lines while drawing. Remember, gesture drawing is an opportunity to experiment and explore. These are not precious drawings. They are just exercises.

Each of the limbs has been simplified into curved lines. Notice that I have shown where the joints are in all limbs except the arm on our left, which goes back into space in the shape of an S-curve. Also note that I have simplified the head into a single line showing that it is simply going straight up, not tilted. Remember, in this kind of gesture drawing you are not drawing a torso or arms and legs literally, you are simply indicating in which direction they are traveling. This is more a diagram of movement and direction than it is a drawing of a figure.

Here is another drawing of the same pose showing a different way you can approach gesture drawing.

In this drawing, I have simplified the head, rib cage, and pelvis into simple volumes. The head and rib cage are ovoids and the pelvis is a half sphere. The limbs were simplified into lines because they are much longer than they are wide, but the head, torso, and pelvis are better understood as shapes. This approach allows you to bring a sense of volume to your gesture drawings while still keeping them simple. Once the shapes of the torso have been established, you can attach the directional lines for the arms and legs.

Gesture drawing is not a rigid system. There are no rules in gesture drawing, only a few basic guidelines, and even those are flexible. These are the most important points to keep in mind:

- Simplify the figure.
- Focus on dynamism and flow.
- Capture the action of the pose.
- Capture the curvatures of the body.
- And above all, experiment to discover what you find most interesting and exciting about the figure.

The following drawings will help demystify the gesture process and illustrate why it is so important.

Many figure drawing classes begin with the model taking a series of short poses so students can practice gesture drawing. During these poses I often draw multiple gestures on each page. These two gesture drawings were drawn from three-minute poses.

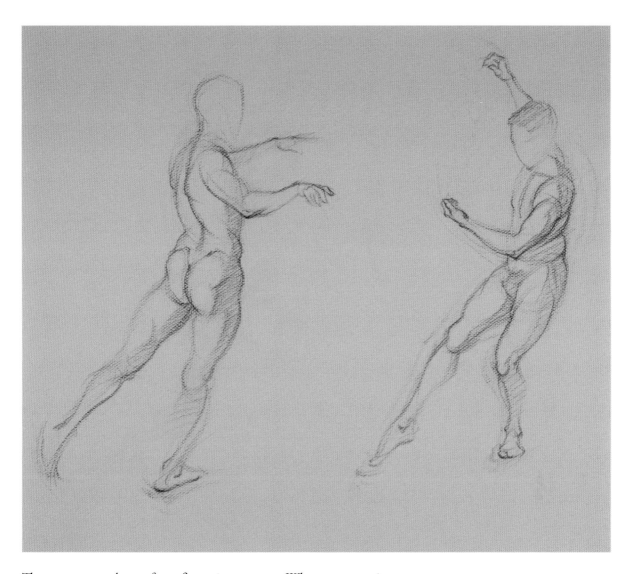

These two were drawn from five-minute poses. When a gesture is used as the foundation for a finished drawing, it should be drawn very lightly. Here you can see how the light gesture informs the more finished areas of this drawing.

This gesture was drawn from a five-minute pose. You can see that I've solidified the weight bearing leg on the right more than the leg on our left. The rib cage and pelvis are drawn as volumes, but the limbs were drawn more linear.

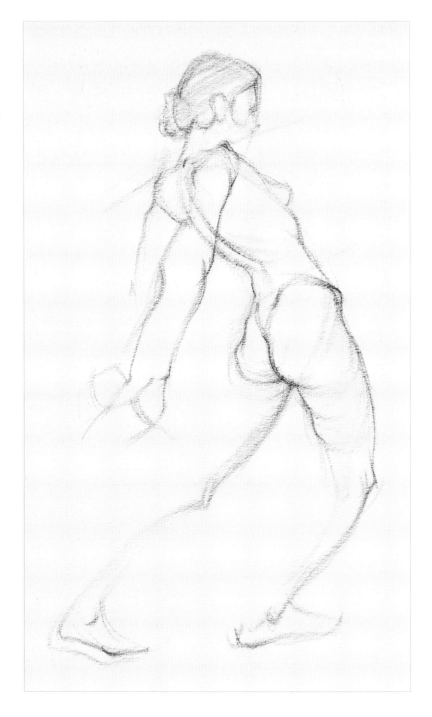

In this 10-minute gesture drawing I had time to draw the general light and shadow patterns. You can see evidence of my exaggerated gesture drawing up and down the left side of the body. I often leave these kinds of gesture lines visible, even in more finished work. I think they create a sense of energy and movement that would be lost if I erased them.

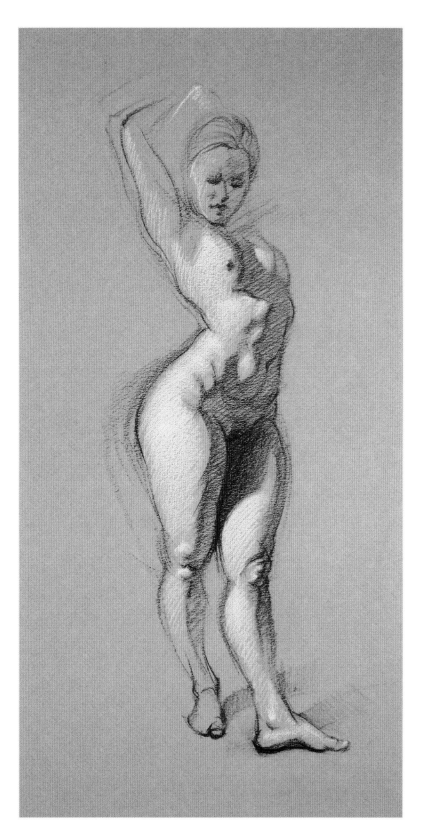

This drawing of a pregnant model focuses primarily on the torso, emphasizing the protrusion of the abdominal area. I had to pay particular attention to the balance of the pose. The way a pregnant woman balances her body changes throughout pregnancy. Drawing this model challenged my assumptions about how to balance a pose.

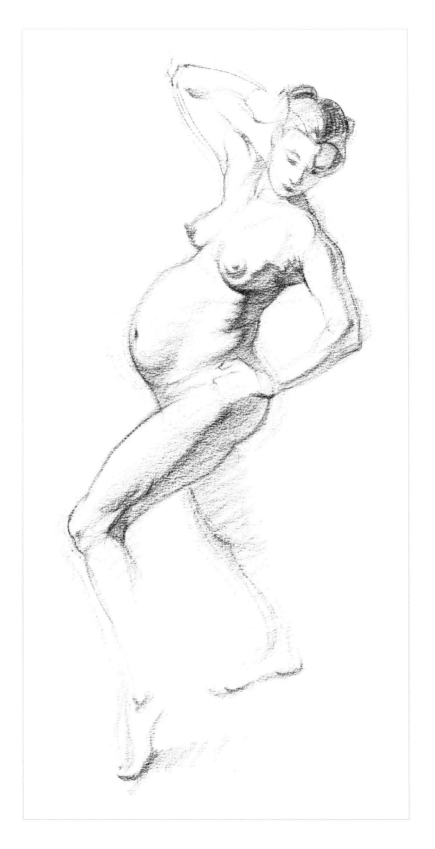

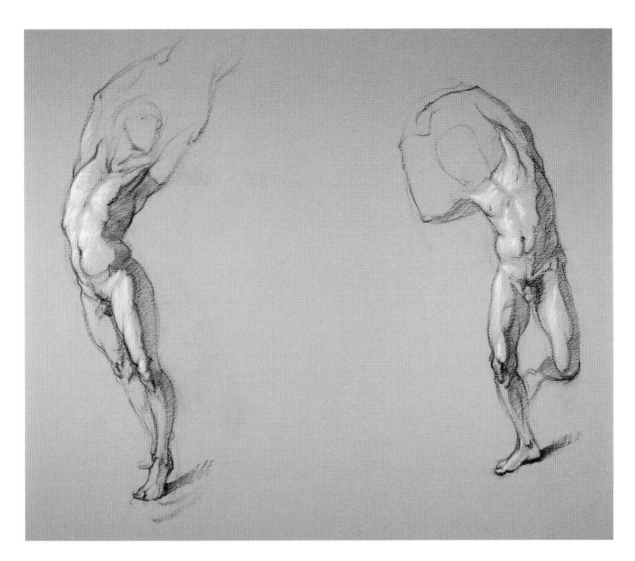

Often, the most exciting poses to draw are the most difficult for the model to hold. These were drawn from seven-minute poses. In that seven minutes the model had to break pose for a few seconds at a time because of the difficulty of the positions.

This 10-minute gesture focuses on light and shadow. Although there is no requirement to include shading, gesture drawing is flexible and should include anything you find interesting about a pose.

No drawing in this section on gesture drawing took more than 10 minutes, and many took only one to three minutes.

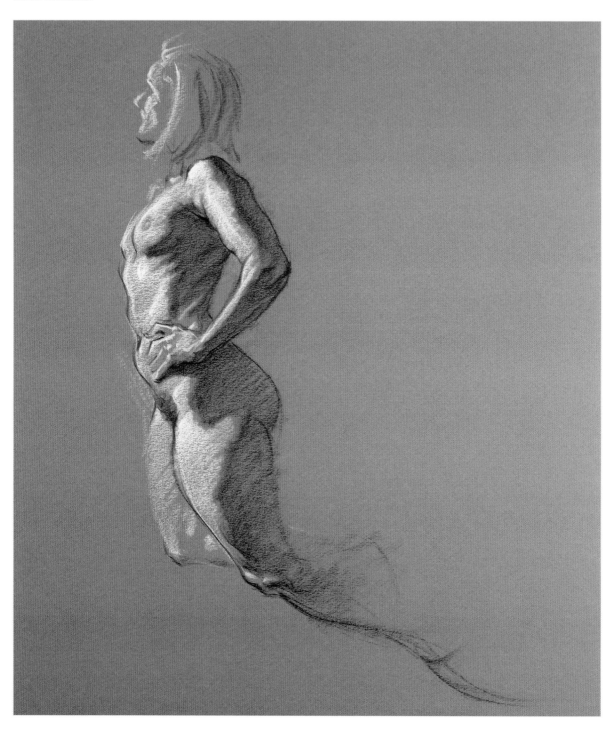

## A Note on Figure Models

There are very few people with the skill of striking dramatic, expressive poses and holding them long enough to be drawn. There are even fewer who are willing to do it nude. In order to participate in the projects for this chapter it is best to work from nude models. But to make this book accessible to a wide range of drawing students I chose not to include photographic nudity. Here are some ways you can find nude figures to draw from.

Check to see if there is a figure drawing group in your area. Most towns and cities have figure drawing meetups where like-minded people pool their resources to pay a professional art model to take poses and be drawn or painted. Figure drawing and painting groups are an excellent way to build a community with other students going through the same learning process as you. If your local area does not have a figure drawing group, consider starting one.

You may have friends or family members who are willing to pose for you, if not nude, then in a bathing suit or leotard. They might not be able to hold dramatic poses the way a professional model can, but it is a great way to get experience observing and drawing from real figures.

Although working from a live model is best, you can find many tasteful collections of photos of nude figures for artists in books and online. Finally, if you're unable to find a live figure model to draw from, and you're uncomfortable with photographic nudity, you are welcome to draw from the figure drawings in this book.

---

If you're new to figure drawing you should focus more on gesture than any other part of the figure drawing process. Students often struggle with the ambiguity of gesture drawing. Instead, try to embrace the freedom that is native to the gesture drawing process. Gesture is the key that will unlock the rest of the figure drawing process. The following projects will provide a variety of gesture drawing experiences.

# Gesture Drawings

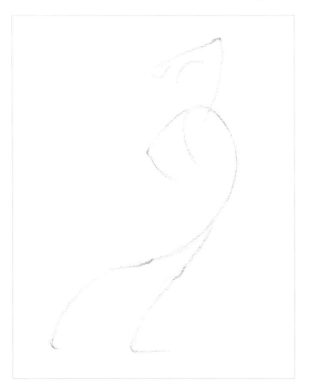

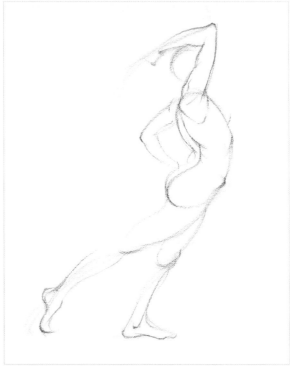

## One-Minute Poses

Most figure drawing classes being with one-minute poses in which students distill the figure down to its essential lines. In the first 10 to 20 seconds, try to capture the primary action line of the pose: the single line that best unifies the action of the pose. Next, add any lines necessary to capture the direction and length of any part of the body not addressed in the primary action line. One-minute gesture drawings should contain only a few lines. Because these kinds of gesture drawings should be used as the first steps of more finished drawings, you should practice drawing them very lightly. You may draw from a live model, photos of a model, or the figure drawings in this book.

## Five-Minute Poses

Five-minute poses offer the opportunity to flesh out the figure. However, the first minute of a five-minute gesture drawing should be treated the same as a one-minute gesture drawing. In fact, whether a pose goes on for five minutes or five hours, you should still begin with a primary action line and a dynamic distillation of the figure. After that, feel free to flesh out the gesture, adding any contours or details you feel emphasize the action of the pose. You may draw from a live model, photos of a model, or the figure drawings in this book.

# 10-Minute Poses

The first five minutes of a ten-minute gesture drawing should be treated the same as a five-minute gesture drawing described on the previous page. The additional time can be spent adding finer details and even shading, should you so desire. If you add shading, this too should be simplified. Remember, there are no hard rules for gesture drawing as long as you are prioritizing dynamism, action, and simplification. Even 10-minute gesture drawings are not intended to be finished drawings. Use this to your advantage. Focus your energy on any part of the body you think is driving the action and let other parts of the body fade into the background. You may draw from a live model, photos of a model, or the figure drawings in this book.

Before attempting more-finished figurative work, you should do hundreds, if not thousands, of gesture drawings. Even after 25 years of serious figure drawing, I still produce hundreds of gesture drawings each year just to make sure my more finished work is vibrant and alive. The final two sections in this book will show you where to go once you have strong gesture drawing skills.

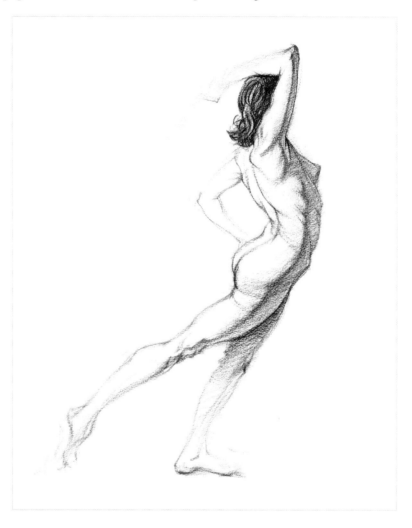

## A Note on Proportion

Gesture drawing prioritizes action and dynamism over detail and accuracy. However, we still want to make an effort to draw the figure in proportion. Many teachers require students to memorize the general proportions of the body which include things like the head being two-thirds the height of the rib cage, or the hand being half the length of the forearm. I'm not against learning these proportions, but they are not nearly as useful as most students assume.

These generalized proportions only apply when the figure is standing upright with weight distributed equally on both legs and with arms straight. As soon as the model shifts his or her weight, raises an arm, or bends forward or back, the general proportions no longer apply. When any volume of the body tilts forward or back, its proportions change and, along with it, the proportional relationship to all other parts of the body.

Instead of learning rigid proportional relationships that only apply to extremely limited poses, I recommend mastering proportional comparisons which you learned in "Chapter 3: Measuring and Proportion." This technique will allow you to capture the height or width of any part of the body and compare them to any other part of the body.

Proportional measuring can help you reign in the expressive excesses of the gesture drawing process. In a one-minute gesture drawing I do not measure. I focus only on dynamism, action, and flow. In a five-minute gesture drawing I may make simple proportional comparisons, like the length of the torso compared with the length of the legs. In a 10-minute gesture drawing I often increase the amount of proportional measuring I do. The amount of measuring you do is a personal decision that is derived from how important accuracy is in your drawings. If you desire a greater degree of accuracy, measure more. If you prioritize expression or stylization, you can measure less.

# Volume and Structure

In the previous section you learned how to capture the action of a pose. In this section you'll learn to draw the figure as a three-dimensional object moving through space.

The human body is a complex, three-dimensional machine that is constantly changing its shape and position in space. But this complex construction can still be simplified into cylinders, boxes, and ovoids. By first understanding the body as basic volumes, the smaller anatomical details become much easier to understand and draw. Additionally, understanding the figure as a collection of basic volumes will reveal how light and shadow operate on the body, making it much easier to shade.

All too often, students assume that figure drawing begins with a detailed study of anatomy. It does not. In fact, anatomy only becomes useful once the artist can simplify the figure and draw it gesturally and volumetrically.

Look closely at this drawing. Here you can see that each and every part of the body has been simplified into one of the basic volumes you learned to draw earlier in this book. For example, take a look at the raised arm. The shoulder is an ovoid. The upper arm is a cylinder. The forearm has been divided into two volumes. The wrist is a box and the section of the forearm nearer the elbow is an ovoid. Even the individual segments of the fingers are drawn as small cylinders. Take a moment to examine this drawing to see how I have used volumes to draw each part of the body.

It's important to note that there is not a single *correct* way to translate the body into volumes. While some parts of the body will reliably present as one volume—such as the rib cage, which will always be an egg-shaped volume with the narrow end pointing up—other parts of the body may present differently from pose to pose and model to model. The wrist for example, may sometimes appear box-like, and at other times it might look more cylindrical. There is no *one-size-fits-all* solution.

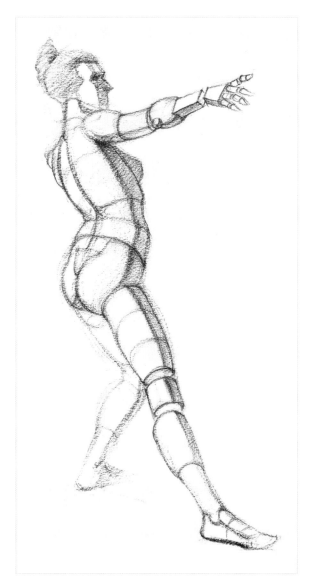

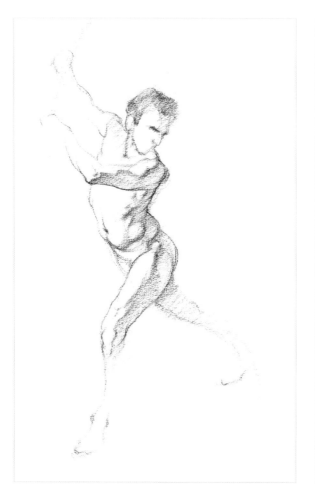

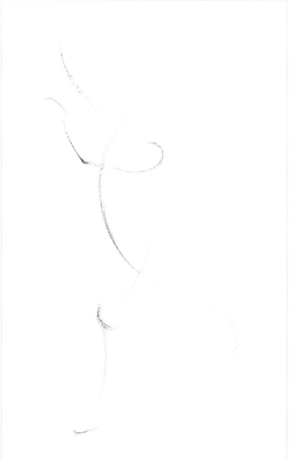

Let's look at how volume and gesture work together. Here is a 10-minute gesture drawing.

The primary action line of this drawing begins at the head and curves its way down the torso and down the back leg toward the feet.

The remaining arms and legs have been simplified into curved lines. This simplified gesture took about one minute to draw. Take a moment to compare the simplified gesture to the more finished 10-minute gesture drawing (left). Hopefully you can see how the simple gesture informs the more finished figure.

Now that you're familiar with the pose and gesture, let's look at a drawing that translates this pose into basic volumes.

In the drawing to the right each and every part of the figure has been drawn as a basic volume. The head is an egg shape with the narrow end at the bottom, indicating the chin. The rib cage is an egg shape with an opening for the neck at the top. The pelvis is a bowl-shaped volume. The upper section of the leg projecting toward us is a tapering cylinder with the narrow end near the knee.

This drawing contains more complex volumes as well. For example, look at the lower section of the leg coming toward us. It is drawn as a modified cylinder that bends and narrows toward the ankle. The lower section of the back leg is drawn the same way.

Now look at the forearms. Instead of separating the forearm into two volumes, I have drawn it as one compound volume that is more cylindrical near the elbow and more box like toward the wrist. Remember, there are no hard rules here. You are welcome to draw the volumes as you see them. Another difference between this drawing and the first volumetric drawing in this section (page 187) is that here, I have drawn the knee as a sphere instead of a cylinder.

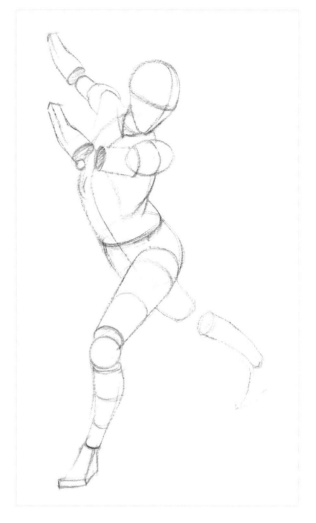

One critical thing to notice is that these volumes are organized in accordance to the gesture. For example, notice how the head, torso, and back leg maintain the dramatic curve and flow of the original primary action line. Gesture and volume must work together to ensure a figure that appears dynamic yet structured.

Now compare this volumetric drawing to the more finished 10-minute gesture drawing on page 188. In the 10-minute gesture, the volumes are not drawn as explicitly, but there is ample evidence of these volumes in the overlaps and contours. For example, you can see that the ellipse at the top of the bowl of the pelvis is clearly visible in the finished drawing. You can also clearly see the boxes of the wrists, the ovoid for the shoulder, and the ellipse at the top of the leg where it meets the torso.

By understanding the volumes that make up the body, I can emphasize these volumes using contours and overlaps. This is the same skill you learned in "Chapter 4: Mark Making and Contours."

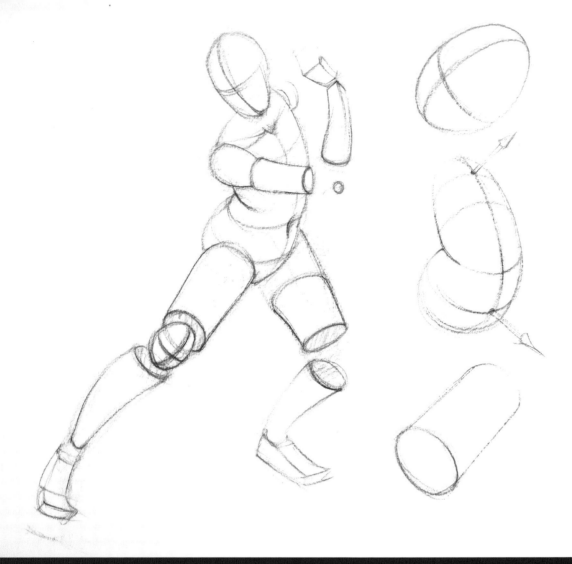

# Volumetric Figure Drawing

Simplify a figure into a collection of geometric volumes like ovoids, spheres, cylinders, and boxes. Remember, there isn't a rigid system of volumes for simplifying the figure. Draw the volumes that make sense to you. This is a challenging project that may require several attempts. You may draw from a live model, photos of a model, or the figure drawings in this book.

This process of breaking down the body into basic volumes works for both large and small parts of the body. Here is a drawing that depicts the basic volumes of the hand. The palm of the hand has been simplified into a box-like volume. The segments of the fingers and thumb have been simplified into cylinders with the tips rounded into sphere-like volumes. The fleshy mass of muscle at the base of the thumb is drawn as an ovoid. The wrist is simplified into a box. These volumes do an excellent job of showing the hand as a three-dimensional object with each part having a specific orientation in space.

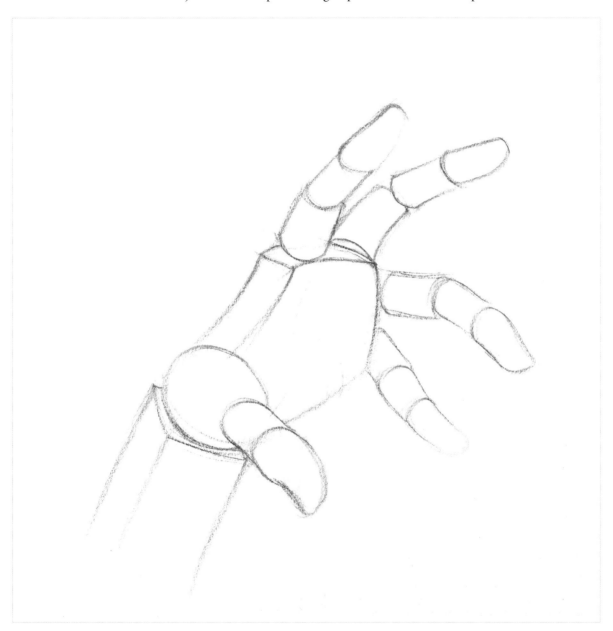

## Communicating Volume Through Contours

Just as gesture informs volume, volume informs shading. But if you are planning on shading and finishing a drawing you should not draw the volumes as explicitly as I've just demonstrated. Instead, you should take advantage of as many opportunities as you can to indicate volume using contours, implied ellipses, and overlaps.

Here is an example of a contour drawing that indicates volumes in a variety of ways. If you look closely, you can see the egg shape of the rib cage and the ellipse at the top of the bowl of the pelvis. You can see the ellipses at the tops of the legs where the legs meet the pelvis. You can also find dozens of overlaps in this drawing indicating that one part of the body is in front of another. Although this is a contour drawing, it clearly indicates the volumes that make up the figure. This is an excellent example of where a drawing should be before any shading is added.

Opposite is another example of a volumetric contour drawing that is ready to be shaded. Examine this drawing and see how many overlaps, ellipses, and other indications of volume you can find. Remember that many of the ellipses will be drawn lightly. A close examination will reveal that nearly every part of this drawing has some indication of volume.

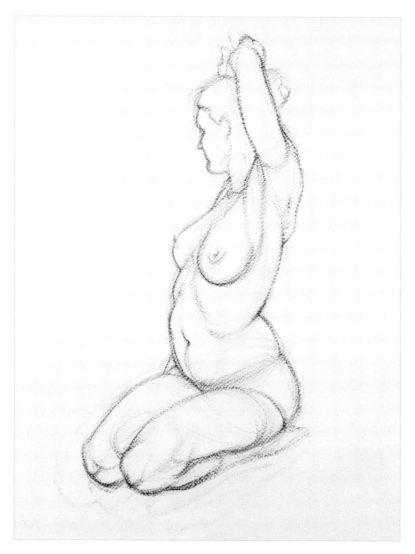

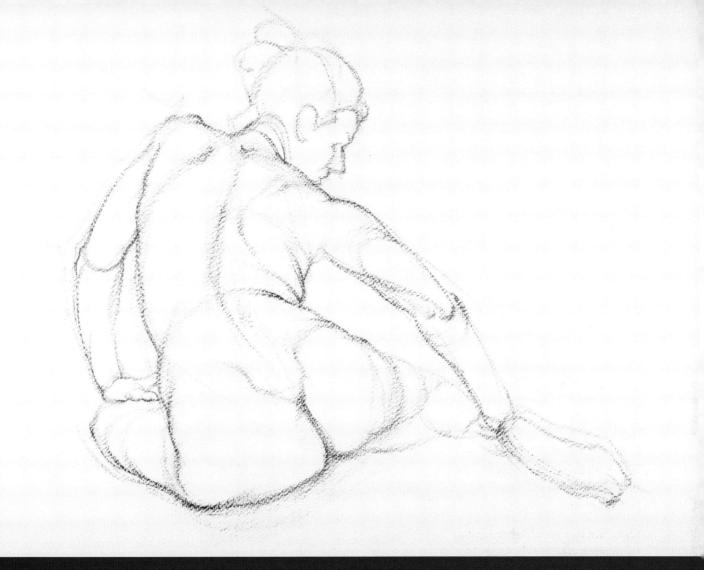

# Volumetric Contour Drawing

Do a contour drawing of the figure. Include overlaps, ellipses and any other indications of volume that are appropriate. For a refresher on how to use contours to communicate volume, revisit "Chapter 4: Mark Making and Contours." You may draw from a live model, photos of a model, or the figure drawings in this book.

The ability to see and draw the body as a collection of basic volumes is essential for successful shading. By understanding the basic volumes of the body, you will understand how light operates on these volumes.

Once you can draw the figure volumetrically, you're ready to learn to shade the figure.

# A Note on Anatomy

Many of my beginning figure drawing students show up to their first day in the studio with anatomy books in hand. Although I recommend studying anatomy eventually, I discourage it for beginners. This may sound counterintuitive, but anatomy is only useful once you have studied gesture and volume. Students who study anatomy without a proper figure drawing foundation tend to produce stiff and mechanical drawings without an understanding of the figure as a dynamic, volumetric whole. Introducing anatomy too early can also result in beginners feeling overwhelmed. They are intimidated by terms like *lateral epicondyle*, *tensor fasciae latae*, and *anterior superior iliac spine*. It's best to wait until the fundamentals of drawing are second nature before folding anatomy into the mix.

Although I encourage the study of anatomy for intermediate and advanced figure drawing students, it is not an absolute requirement. There are many master figure drawers who have not mastered anatomy. Instead, they have relied on their drawing and observation skills. But there are no masters of figure drawing who have an expertise in anatomy but no fundamental drawing skills. Refined observational drawing skills are more important than anatomical knowledge.

In my artistic anatomy classes I have had medical doctors and surgeons as students. Although they know the names of all of the bones, muscles, and tendons, they are no better at drawing anatomy than anybody else. This is because medical anatomy and artistic anatomy are very different studies. When you're ready to learn anatomy, skip the medical books. Instead, work from anatomy books for artists. There are many excellent anatomy books for artists available.

I have studied anatomy extensively from books, living models, and even cadavers. Once you can consistently draw figures that are gestural, volumetric, and in proportion, a knowledge of anatomy will enhance your drawings and offer new opportunities for beauty, drama, and expression. Once you have strong fundamental figure drawing skills the study of anatomy can be a profoundly engrossing endeavor.

# Shading the Figure

There is a logic at work in all light and shadow patterns. When shading simple volumes like spheres or cylinders, this logic is obvious and capturing it in a drawing is straightforward. When dealing with a subject as complex as the human figure, this logic can get lost or confused. To ensure that your drawings clearly demonstrate the logic of light, I recommend doing a simplified study before you start a more finished figure drawing. In this study you should simplify your subject into its most basic volumes and then shade these volumes. This will allow you to see from the smaller details to the larger organization of light and shadow. What you learn from the study can be used in your more finished work.

For example, here is a finished drawing of a male figure. It's easy to view a drawing like this and get caught up in the details, but the details should be treated as secondary to the overall light and shadow patterns. On page 196 is a simplified study of the volumes and light and shadow patterns seen in the more finished drawing below. You can clearly see that the light is coming from the right leaving the left sides of the various parts of the figure in shadow.

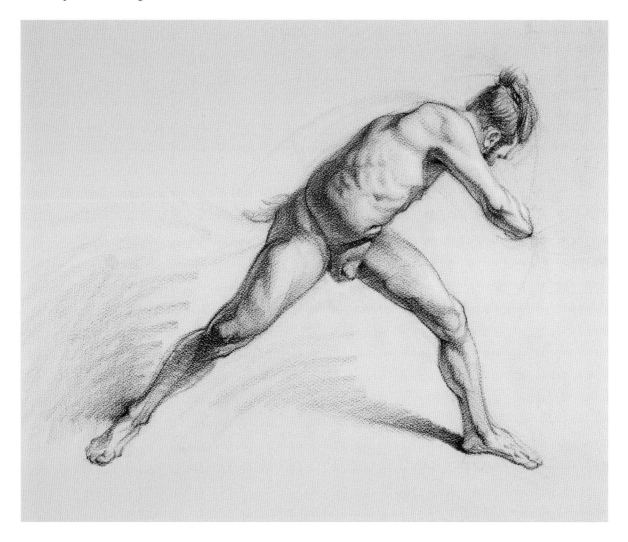

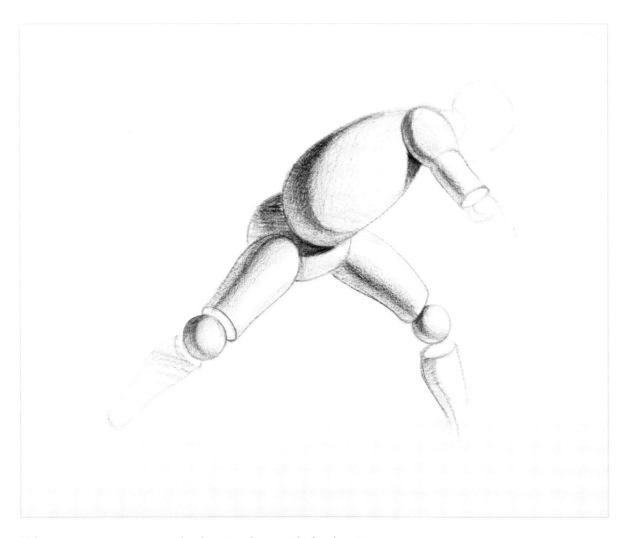

Take a moment to compare the drawing above with the drawing on page 195 to see how well the simplified study captures the larger light and shadow patterns. All too often students will engage in what I call *shadow chasing*. The students' eyes dart around the surface of the model and they darken any area of value their eyes fall upon, focusing on trivial details instead of the larger patterns. This reliably results in muddy, unfocused shading. The best way to avoid shadow chasing is to have a clear understanding of the larger light and shadow patterns. The best way to understand them is to do a simplified study.

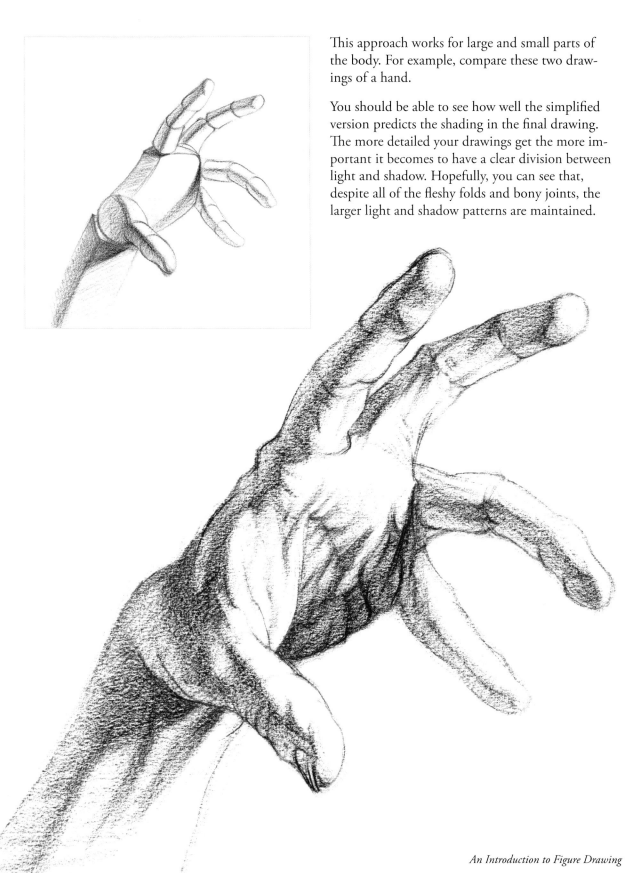

This approach works for large and small parts of the body. For example, compare these two drawings of a hand.

You should be able to see how well the simplified version predicts the shading in the final drawing. The more detailed your drawings get the more important it becomes to have a clear division between light and shadow. Hopefully, you can see that, despite all of the fleshy folds and bony joints, the larger light and shadow patterns are maintained.

# The Figure Drawing Process

It is often said that once you can draw the figure, you can draw anything. I have found this to be true. Figure drawing will test every skill and technique you have learned. It will challenge you to think and draw your way through soft flesh, tense muscle, and hard bone. Figure drawing will also teach you to find balance between human emotion and the mechanical systems of anatomy. The lessons learned in figure drawing will provide the core skills necessary to draw nearly any other subject.

A fully shaded figure drawing is the culmination of all of the skills taught in this book. Finished figure drawings require a mastery of volumetric drawing, proportional measuring, contour drawing, and shading. In this final section, I will illustrate the figure drawing process from start to finish. The process I'm about to describe is, in essence, the same process you learned in "Chapter 5: Dramatic Light and Shadow." But here, this process has been scaled up to accommodate the complexity of the figure. This process works not only for figures, but for any complex subject as well.

Drawing is not a step-by-step system. Rather, it is a process of problem-solving that loosely follows a set of predictable phases. But this process can, and should, be adapted to fit the needs of the subject and the aims of the drawer. In this book I have tried to supply you with the tools necessary to draw. How you use these tools is ultimately up to you.

## Phase 1

You should begin with a light gesture drawing that simplifies the figure and captures the action of the pose. Once you have captured the basic forms and proportions of the body, you can add contours to solidify the figure and communicate volume. In this phase I use the measuring techniques you learned in "Chapter 3: Measuring and Proportion" to make sure the figure is in proportion compared to the model in front of me. In this phase you should draw using light, soft lines. You

will likely need to make numerous corrections as you work out the forms and proportions of the figure. Around the edges of the figure, you will see numerous early attempts that have been moved or otherwise adjusted. I rarely erase these lines as I think they add visual interest and a sense of time, process, and motion. Once I have solidified the forms of the figure and I am confident they are reasonably accurate and in proportion, I begin the shading process.

## Phase 2

Divide light from shadow using the line of termination and fill in all shadow areas with a light value. The line of termination should be drawn with a soft, light line. Don't try to capture all the details on the first pass. The line of termination shown here is simplified and attempts to capture the basic light and shadow patterns but ignores most anatomical details. When in doubt you should simplify first and add complexity later. In this drawing, the light is shining down from the upper left,

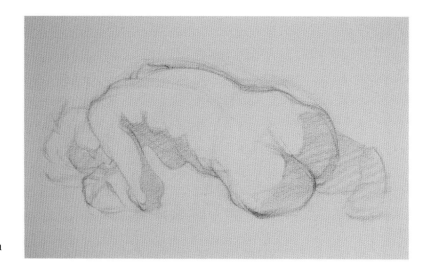

meaning the shadows tend to be on the lower right of the forms of the figure. As your subjects become more complex, you will often need to draw multiple lines of termination. For example, this drawing has three lines of termination: one on the head, one that stretches from the arm all the way down the torso, and one on the buttocks. But despite the fact that these areas are separate, they all follow the same light logic with the upper-left sides of the forms in the light, and the lower-right in shadow.

## Phase 3

Darken the core shadow and add any detail to the line of termination you may have missed in the first attempt. This will separate the core shadow from reflected light. This is not only an opportunity to add anatomical complexity, but a chance to correct any issues in the initial, simplified attempt at the line of termination. At this stage the drawing is still faint and therefore malleable. Before you darken the values any further, check for any adjustments you want to make.

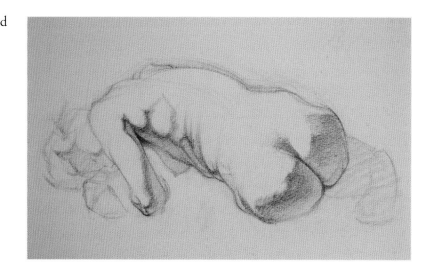

## Phase 4

Darken the cast shadows. These will be the darkest values in your drawing. The shape of the cast shadows should be drawn with as much care as the figure itself. Notice that the cast shadows appear darker and harder edged nearest the part of the body casting them. At this stage I would like you to note that the drawing still appears quite rough. Nothing has been refined or detailed. Don't be in too much of a rush to fine-tune details. We are still primarily focused on the overall forms and values.

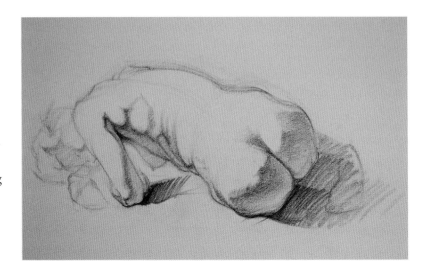

## Phase 5

So far, we have focused on the shadow side of the line of termination. Now we will darken the details on the lit side of the line of termination. These will be areas that are beginning to turn away from the light but not so much that they go into shadow. These details will be in the value range of midtones and center lights. They are drawn using soft marks. Remember, these areas are not technically shadows as they are still receiving light directly from the source. It's also important to remember that the

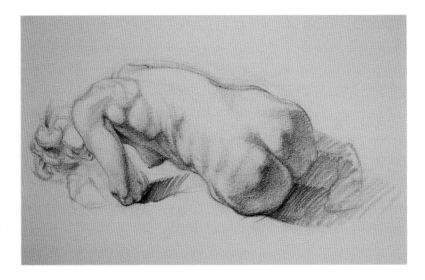

darkest value on the lit side of any line of termination should be lighter than the lightest values in the shadows. By following this guideline, you will ensure a clear separation between light and shadow.

## Phase 6

Finally, we will address the center lights and highlights. It's important to note that on white paper, the entire lit side of the line of termination should contain a very light value with the highlights left bare, letting the white of the paper shine through. On toned or colored paper, the white highlights and center lights must be added with white pencil, as shown here. Before adding white pencil, I recommend erasing the areas where white pencil will be applied to make sure no stray, dark pigment sullies the white. I generally use a kneaded eraser to do this. The lights should be drawn with the same care as every other part of the drawing. White pencil should be used sparingly so as not to blow out the values you've worked so hard to capture thus far. Remember, white pencil is used only for highlights and the brightest parts of the center light.

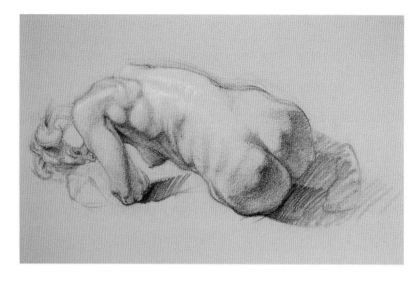

## Phase 7

Finally, we will refine and complete the drawing. How you determine what *finished* means is a personal decision. For some people, it means every part of the drawing is fully rendered. For others, a drawing is finished when the pose ends. For me, a drawing is finished when the parts I find the most interesting have been addressed.

Drawing is a form of communication. I think of a drawing as a way to show a viewer what I found fascinating about a subject. In this drawing I loved the bend of the back and the twist of the torso. I loved the core shadow jogging back and forth along the torso revealing the subtle curves of the flesh and muscle. I want to show the roundness of the forms of the body both big and small.

When working with a model, the drawing ends when the pose comes to an end. When working from photographic reference it's often difficult to tell when a drawing is finished because you have all the time you want to fiddle with it. I will often leave a mostly finished drawing pinned up in my studio for days and will make small adjustments as they occur to me. The more drawing experience you have, the easier it will become to tell when a drawing looks finished to you.

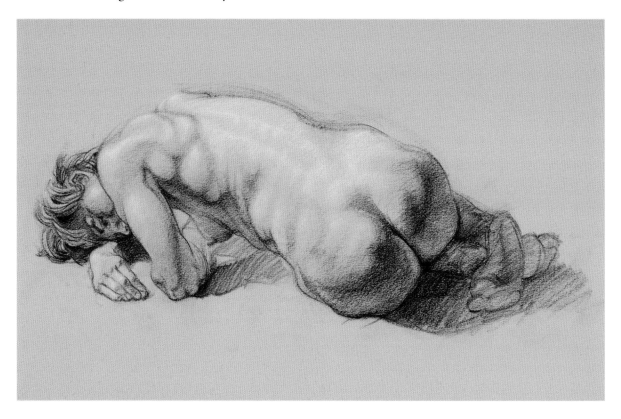

# A Note on Realism

Well-meaning friends and family will often send me images of photorealistic drawings, assuming these represent the pinnacle of drawing achievement. But I think hyperrealism misses the point of drawing. In my view, drawing should not be a test of how well someone can painstakingly replicate reality. Most master artists—from antiquity to contemporary comic artists—revel in exaggeration, emphasis, expression, and drama. What these elements have in common is that they edit or deviate from reality. Instead of obsessively copying details, figure out what you want your drawing to communicate. How do you want viewers to feel when they see your work? What do you want them to think about? Use the tools of drawing to connect with your viewers, not to overwhelm them with endless amounts of detail.

All that being said, if hyperrealism is what thrills you, don't let the opinions of one teacher dissuade you. Remember, drawing is both an art and a science and is therefore somewhat subjective. We all have our preferences, but you must decide for yourself how you want to draw.

The final pages in this chapter contain examples of my finished figure drawings. My hope is that they will provide you with instruction and inspiration.

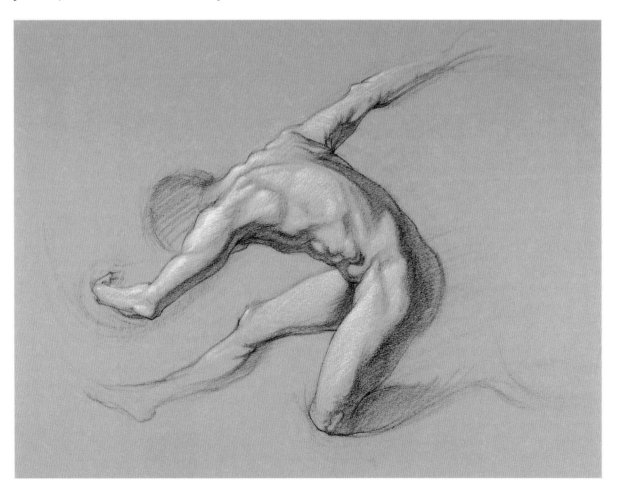

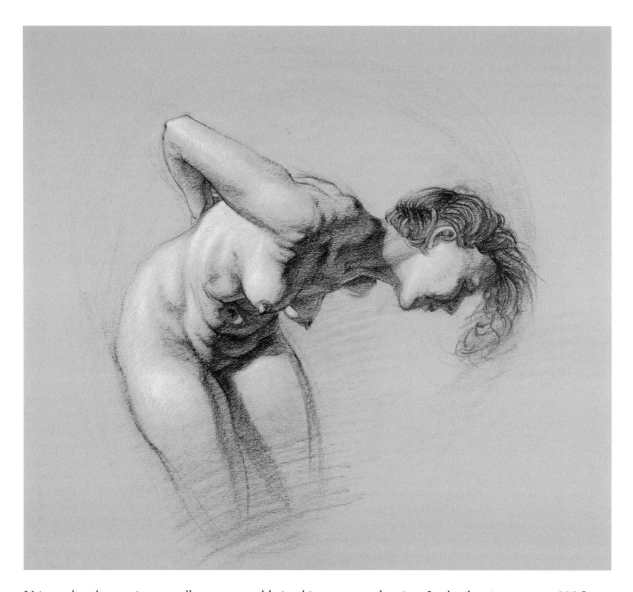

Using colored paper is an excellent way to add visual interest to a drawing. In the drawing on page 203 I wanted to emphasize a sense of motion and action. I left the ends of the limbs gestural and unfinished. This almost creates a motion-blur effect. This is an example of a drawing where I addressed the areas I felt were most fascinating and left the rest to the imagination of the viewer. Leaving areas of a drawing unfinished invites the viewer to consciously participate in the illusion that arises when pigment is arranged on the paper just right.

When I draw, I am most interested in gesture. Even my more finished work reveals the initial gesture lines. I rarely erase my early attempts. These artifacts of early attempts that are visible at the end of a drawing are called *pentimenti*. In the drawing above you can see my initial sweeping gesture lines as well as numerous light attempts at the contours. I love seeing *pentimenti* in drawings and I always leave them in my own work. Pentimenti tell the story of the drawing and add a sense of dynamism and excitement that is often lost when process lines are erased.

In the drawing on this page and page 206 I let the cast shadows play a lead role. The cast shadows are drawn expressively, with a sense of rhythm making the drawings appear to vibrate with energy.

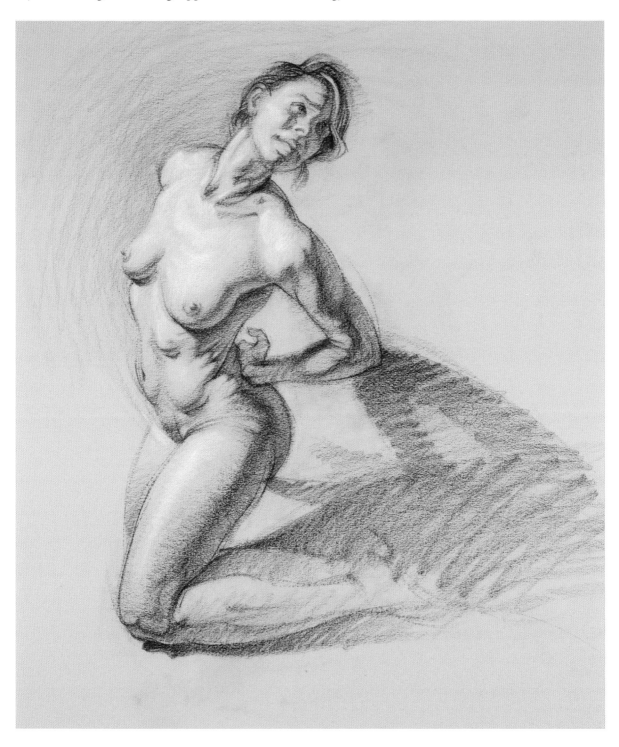

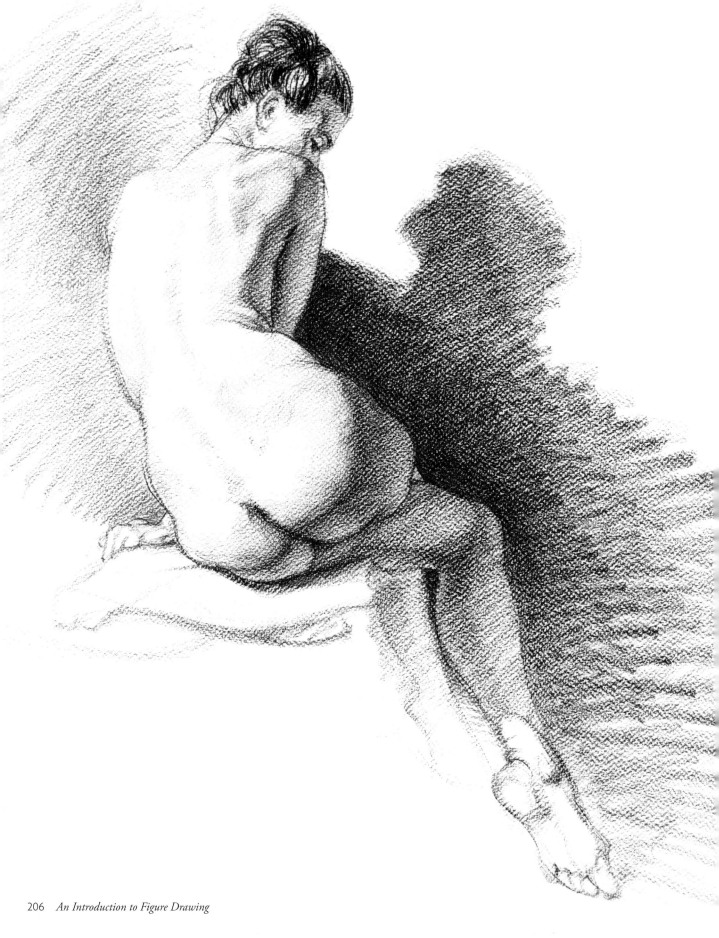

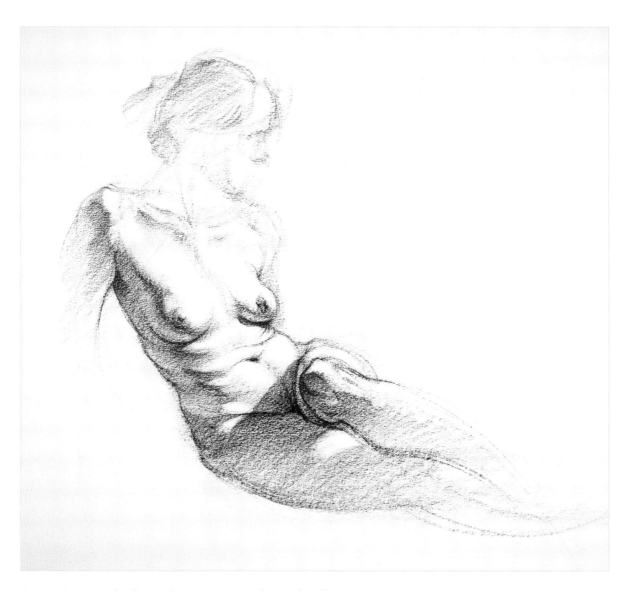

In this drawing the figure almost seems to float. This illusion is created by the absence of a cast shadow, and the way the head, arms, and legs fade out as they extend outward.

These two drawings were created with three different colors of pencil on gray paper. I used a white pencil for the highlights, a dark sepia pencil for the #5 value, and a red pencil for the #2 and #3 values. The #4 value contains both red and dark sepia. The red pencil warms up the figures, helping them seem more alive.

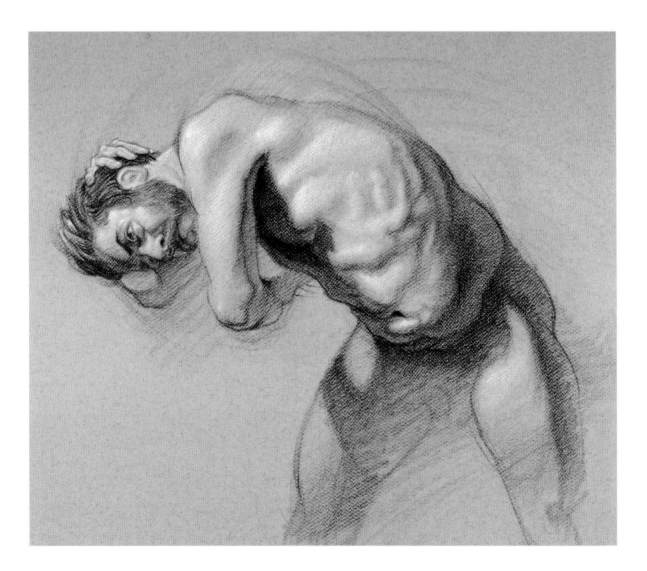

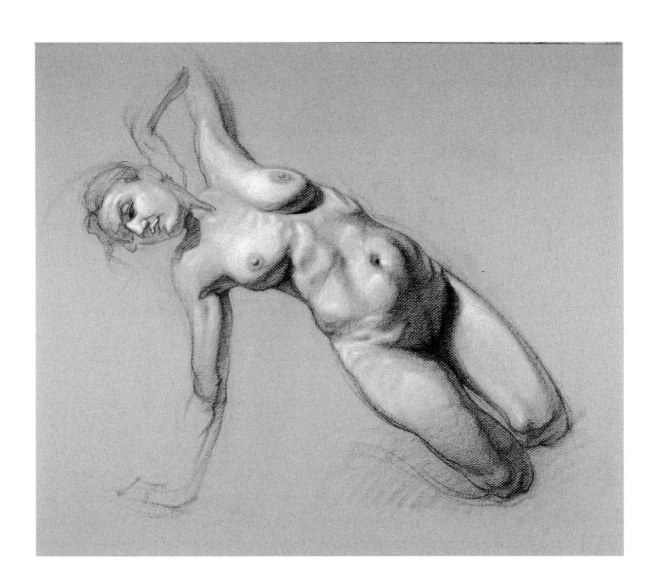

# Conclusion

Figure drawing is the culmination of all of the skills you have learned thus far. When you practice the skills you learned in the first five chapters of this book, you are practicing the fundamentals of figure drawing.

Figure drawing takes many years to master. You are going to do hundreds of figure drawings before you begin producing *good* drawings. This is perfectly normal and should be expected. I don't say this to discourage you, but rather to give you a realistic idea of the learning curve. When first learning a musical instrument, most students intuitively understand that you don't start off playing Hendrix licks or Paganini arpeggios. You start with "Twinkle, Twinkle Little Star" and work your way up from there. But art students often have unrealistic expectations on how quickly they should advance when learning to draw. My advice to you is to learn to love the process of figure drawing. Revel in the joy of drawing without being overly concerned with how good or bad your work is. Instead, focus on developing your fundamental drawing skills and establishing a regular habit of drawing. Good drawings are the result of a solid process. By focusing on fundamental skill building and refining your drawing process, good work will follow.

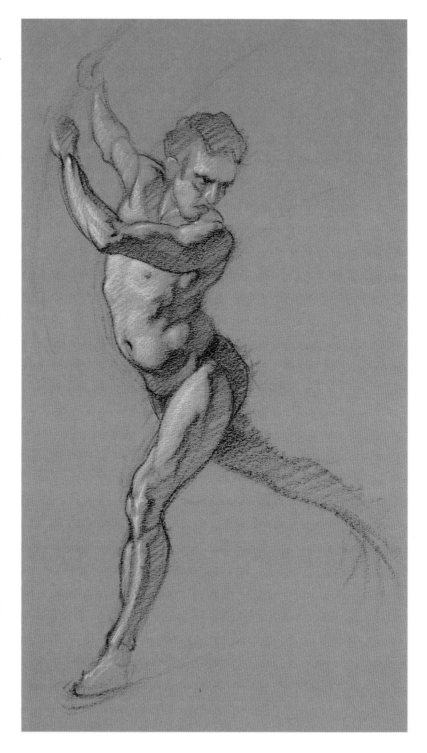

# CLOSING THOUGHTS

I absolutely love to draw. I have been drawing for as long as I can remember. I am one of those people who, from a young age, people often referred to as *talented*. I have been told how lucky I am to have been gifted a natural ability to draw. But my drawings from early childhood do not suggest any special abilities or talent. They don't stand out from any other little kid's drawings. The difference is that when other children stopped drawing and moved on to other things, I didn't. I drew nearly every day. I haven't stopped yet.

Do you want to know the secret to talent? Here it is: Practice. A lot. More than what seems rational. Practice to the detriment of other aspects of your life. The more you practice, the more *talented* you will become in the eyes of others. But you will know that drawing is a skill you worked to develop, not a talent that is granted to a lucky few.

In this book, I have introduced you to the fundamental skills and concepts that are at the root of all good drawing. But no single book can teach you everything you need to know. This book is designed to serve as a jumping off point for anyone who wants to learn to draw for any reason. Whether you want to illustrate children's books, draw comics, paint, design, or just experience the joy of creative expression, this book will provide you with a strong foundation upon which you can build further skills.

Knowledge and an intellectual understanding of drawing are essential, but they are not enough to master the craft. You can memorize every word, drawing, and diagram in this book, but without consistent practice, your drawings will not improve. To excel at drawing you must make it a regular experience in your life.

Learning to draw comes with some unexpected benefits. In addition to gaining a skill, drawing deepens how you see the world. Drawing students often report that colors seem more vivid, lights appear brighter, and shadows seem deeper. Their surroundings seem to become more detailed. Learning to draw will reveal the vibrant intensity of the world around you. Drawing is more than a skill: It is a way of being in the world.

It's been an honor and a privilege to share my love of drawing with you. Now go draw, and let it change your life.

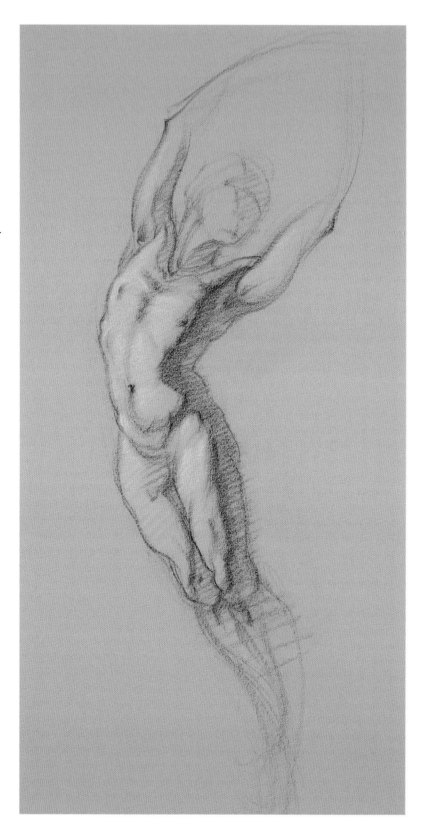

# INDEX

# ACKNOWLEDGMENTS

I love to draw, but I also love to teach. The apex of these two experiences have provided me with some of the most meaningful and valuable experiences of my life. I'd like to thank the people who have been instrumental to my drawing and teaching.

Thank you…

To Sarah Fay Philips who married me when I was poor and out of work because she believed I could be more. You are my advocate, my team member, and my love.

To my most important teachers, Gary Geraths and Rush White, who challenged me to improve my drawing and myself.

To my parents, John and Linda Eviston, who took me to my first art museum and gave me my first drawing book.

To my in-laws, Andy & Vicki Philips, who spent countless hours talking with me about drawing and teaching.

To the figure drawing models I have worked with. You have been inspiring collaborators to me as well as countless students.

To Ryan Emenaker, who challenged my way of thinking and provided a model for the kind of thinker and writer I strive to be.

To the staff at Rocky Nook including Kelly Reed, Lisa Brazieal, Joan Dixon, Danielle Foster, and Aren Straiger. Your editing and design elevated my work.

And finally, to my students: working with you and watching you evolve has been an absolute joy and privilege. There is a co-evolution that occurs between teacher and student. As a result of working with you all, I have grown as a drawer, a teacher, and as a human being. Thank you to each and every one of you.

# ABOUT THE AUTHOR

Brent's love of teaching matches his love of drawing. He believes that learning to draw can transform the lives of students, changing how they think and how they see the world.

Throughout his 25 years of teaching, he has taught thousands of students of all ages through studios, schools, and museums. He spent these years cultivating the most effective ways to teach drawing. Brent took what he learned and created The Art & Science of Drawing series, a collection of online drawing courses. The Art & Science of Drawing has become a bestselling, award-winning series that has enrolled more than 100,000 students in 170 countries. These powerful lessons are now available here in his first book.

Drawing is at the root of all of Brent's work. He has studied numerous forms of drawing including architectural drafting and anatomical drawing as well as more experimental explorations. Brent divides his creative efforts between traditional drawing instruction and contemporary art projects.

To learn more about Brent's teaching visit www.evolveyourart.com. To learn more about his contemporary work visit www.brenteviston.com.